BEGINNER'S GUIDE TO PHOTOGRAPHING PEOPLE

ALSO BY RALPH HATTERSLEY

Beginner's Guide to Photography
Beginner's Guide to Darkroom Techniques

Beginner's Guide to Photographing People Ralph Hattersley

To Robert C. Lautman, who is as crazy as they come

The material contained in Chapter Two on Formal Portraiture was originally published in slightly different form in *Popular Photography*. Thanks is given to Ziff-Davis Publishing Company for allowing me to reprint it here.

Unless otherwise indicated, all of the photos in this book are by the author.

Library of Congress Cataloging in Publication Data

Hattersley, Ralph.

Beginner's guide to photographing people.

1. Photography—Portraits. I. Title.

TR575.H28 778.9'2

ISBN: 0-385-12689-1

LIBRARY OF CONGRESS CATALOG CARD NUMBER 77-12860

COPYRIGHT © 1978 BY RALPH HATTERSLEY
COPYRIGHT © 1975 BY ZIFF-DAVIS PUBLISHING COMPANY
ALL RIGHTS RESERVED
PRINTED IN THE UNITED STATES OF AMERICA
FIRST EDITION

BOOK DESIGN BY BEVERLEY GALLEGOS

CONTENTS

Preface	9	Split Lighting	42
 HOW TO SHOOT CANDID PORTRAITS 		Double Back Lighting	43
		Ghoul Lighting	44
		Side Bounce Light	45
The Ethical Foundation	13	Overhead Bounce Light	46
Some Wrong Reasons for Portraiture	14	Consider the Fill Light	46
Some Right Reasons	14	Shooting Space	47
Unconscious Telepathy	15	Model-Background Tonal Relationship	47
People Are Mirrors	17	The Model Holds Still	47
The Fear of Being Photographed	19	Cosmetic Lighting	47
The Meek Shall Inherit	19	What, No Poses?	48
The Virtues of Snapshots	20	What About Electronic Flash?	49
The Technique of the Snapshot	23	Using the Information	49
Environments	23		
Outdoor Lighting	24	• HOW TO PHOTOGRAPH BAB	BIES
Flash	24	The All-Important Schedule	51
Floodlight	27	This Chapter Is for Men	51
Natural Light	28	Please the Mother	52
You and Your Models	31	Watch the Mother	52
Poses	33	Early Show Points	53
		Later Show Points	53
• FORMAL PORTRAITURE: LIGHTING		Wall Pictures	54
		Backgrounds	54
The Functions of Portrait Lights	37	Posing Babies	56
Some Functions of Lighting Contrast	38	Light Sources	56
The Names of the Lightings	38	Lightings	56
Narrow Lighting	38	Posing Play	58
Broad Lighting	40	The Distortion Problem	59
Front Lighting	41	Good Baby Pictures	59
From Eighting	41	Good Daby Fictures	35

CONTENTS

PHOTOGRAPHING CHILDREN	V	 HOW TO PHOTOGRAPH 	
The Snapshot, the Noncriticizing Picture	63	STRANGERS ON THE STRE	ET
The Noncritical Eye: A Credo	65	Shoot for the Right Reasons	107
Poses	66	The See-Through Technique	108
Mug Shots	68	Don't Look at People	109
Tying Children Down	68	The Catcher's Mitt Trick	112
The Focus Problem	69	The Swing Shot	112
Zone Focusing	69	Shoot from the Waist	112
Outdoor Lighting: Great for Kids	73	Fake Camera Tests	113
The Bounce Light Stakeout	73	Mirror Attachments	114
If You Don't Know What to Do with		Telephoto Lens	114
Children	74	Substitute Exposure Readings and Focus	***
		Target	114
		The Problem with Fear	114
• HOW TO PHOTOGRAPH A PARTY		You Ask Them or They Ask You	115
Children's Parties	81	• HOW TO PHOTOGRAPH SPO	RTS
Adolescents' Parties	82	Picking Your Spot and Laying Claim to It	117
Adult Parties: the General Situation	82	Telephoto and Tele-Zoom Lenses	117
Bashes	83	Tripods, Bipods, Unipods, Rifle Stocks, and	
Passing the Polaroids	83	Bean Bags	118
Ideal Party Cameras	86	Stopping Action: Shutter Speeds,	110
Poses	87	Electronic Flash, Panning	119
		Film Speed Pushing	120
		Motorized Cameras and Special Film	
• 110W TO 114W TO 114W		Backs	125
 HOW TO MAKE SELF-PORTR 	AITS	More About Electronic Flash	125
Equipment	89	Flash or Push?	130
Mirror Self-Portraits	89	What Should You Shoot?	130
Depth of Field	94		
For Total Picture Control	96	 HOW TO PHOTOGRAPH THE NUDE 	
• HOW TO MAKE STAGED		Art and Pornography	131
CANDID PICTURES		The Figure as Sculpture	132
		Finding Models	133
Non-Pose Poses	99	Emotion and Ritual	133
Diversionary Tactics	100	Backgrounds and Posing Environments	134
Staged Emotion	101	No-Seam Paper	134
Psycho-Drama	104	Abstracts of Nudes	136
The Walkaway Technique	105	Posing the Nude	138

Lightings	140	Making Exposure Readings	177
A Primary Justification for Figure		Compensating for the Reciprocity Effect	182
Photography	143	A Flashlight Exposure Chart	182
Miscellany	146	Handling Your Lights	183
		A Serious Business	184
 HOW TO PHOTOGRAPH A GHOST 			
How to Deaden Your Friends	147	A WHAT IFNEES DO	
Preparing Your Ghost	147	• WHAT LENSES DO	
How to Make Double Exposures	147	Telephoto Lenses	187
Exposures	149	Wide Angle Lenses	192
Backgrounds	150	Sharp and Unsharp Foveal Images	196
Ghosts and Non-Ghosts	151	The Fear of Unsharpness	196
Other Tricks for Making Ghosts	151	Zoom-and-Unzoom Lenses	197
Some Potentials of Photography	151	How Large Is Photography?	199
		From Science Fiction	199
		Just a Beginning	201
 AVAILABLE LIGHT PHOTOGRAPHY AFTER DAIL 	RK		
More Information for Sports Photography	155	A WILLT DUCTOOD ADULY CAN	200
If You Don't Have a Supersensitive		• WHAT PHOTOGRAPHY CAN	DO
Exposure Meter	155	FOR YOU	
Available Light Categories and Exposure		An Aid to Memory	203
Chart	155	Involvement in a Creative Process	205
Figure Things Out in Advance	161	Nonverbal Talking to Yourself	206
The Kodak Exposure Dial	161	How You Really Feel About People	209
Using an Exposure Meter	162	What Others Think of You	210
Substitute Readings	162	Fear of Others	211
The Commonest Nighttime Metering		Actively Experiencing a New Language	212
Errors	167	What Things Look Like	214
Meter Stretching: the White Card Method	168	Heightened Visual Perception	214
Film and Developer Combinations for		Awareness of Time and Space	216
Film Speed Pushing	169	Insights into Visual Communication	216
		Hidden Levels of the Self	217
		Meditation While Printing	220
 PAINTING WITH LIGHT 		A Harmless Experience with Power	220
The Gist of It	173	Expanding Your Awareness of Beauty	221
Darkness and Light	173	Expressing and Overcoming Repressed	
Holding the Shutter Open	176	Anger	221
Selecting Your Flashlights and Batteries	176	Not the Half of It	222
Preparing Your Flashlights	176	Conclusion	222

PREFACE

This is my third Doubleday book for beginners in photography and is thus somewhat more advanced than the others. Beginner's Guide to Photography is a general introduction to the subject. Beginner's Guide to Darkroom Techniques is a basic textbook on black-and-white printing. As you will see, this book deals mainly with problems involved in shooting pictures, not printing them. These problems are examined from basic technical, aesthetic, and psychological points of view, with the accent on technique.

However, the last two chapters are mainly for people who are already hooked on photography and beginning to wonder what happened to them. Photography is looked at from a very broad overview that includes some of its occult and metaphysical aspects. The objective is to provide the reader with a basis for seeing what he or she is really involved in and deciding whether it is worth while. Some of the ideas are very far out, but nobody is asked to believe them.

BEGINNER'S GUIDE TO PHOTOGRAPHING PEOPLE

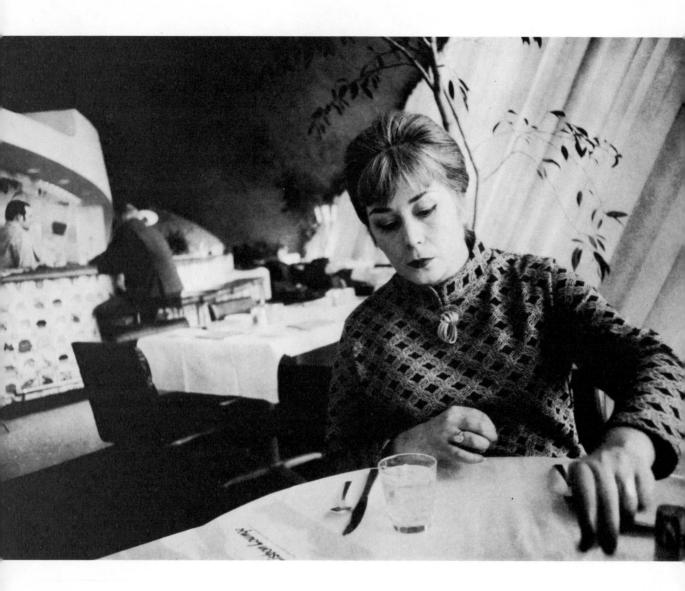

My wife Lisa Lu contemplates an extra-dry martini on the rocks at the airport restaurant in New York where we began our vacation. Daytime with natural (or available) light, shot with a 28mm lens, from an incident light reading. This is an elegant young lady, you can bet your life.

HOW TO SHOOT CANDID PORTRAITS

The term "candid portrait" usually refers to informal pictures of people—as distinct from formal portraits, such as those made by professional portrait photographers. Candid portraits are said to have special virtues that formal portraits don't have, and they have long been popular with the public. Basically, the word candid means open, frank, unguarded, honest, or truthful. Ideally, candid portraits should have these qualities, and they very often do. They should reveal the inner person, not the outward role-playing.

The Ethical Foundation

Unless your photography is based on attitudes and behavior which your inner self recognizes as deeply ethical, you are very unlikely to get any happiness from it. Such happiness as you do achieve will certainly be spurious and fleeting. The truth of this is most obvious when one sets out to make portraits: if you do it for the wrong reasons you will surely pay the price in inner conflict and self-condemnation.

Many photographers seem to think that making candid portraits is entirely a matter of clever tactics: you simply scheme to catch people off guard in self-revealing situations, then photograph them when they are not looking. And then, of course, you make dead sure they never see the photo-

graphs, though you display them for everyone else.

Interesting candids can be made in this manner, but doing it with such an attitude is a serious offense against the inner ethical self—if you still have one, and let us hope that you do. For reasons that will be made clear later, it is quite all right to photograph people who are unaware that you are doing it—but not for the wrong reasons or with the wrong attitudes, for this is a crime against the inner self. It can spoil your photography for you and even damage your life.

Fortunately, there are approaches to candid portraiture in which there is much less risk of offending your own ethics, so we will devote ourselves to them in this chapter. Indeed, portraiture of any kind, rightly seen, can be (and should be) a practice of ethics.

The starting point for any of the approaches is to examine your attitudes concerning the people you wish to photograph and see if you fully respect yourself for them. Make up your mind, and stick to it, that you will never photograph anyone (or even any *thing*) until you respect your reasons for wanting to do it. Search deeply into yourself, don't accept phony ego answers, and you will soon find yourself approaching photography in a deeper, more satisfying way.

With respect to your subjects, do your best to reach this goal: use your photography to help them like themselves better for reasons that they can accept in their inner selves.

Some Wrong Reasons for Portraiture

Though the average person can find literally hundreds of wrong reasons for doing almost anything, I will mention just a few of the ones related to portraiture. You should not make pictures of people for reasons such as these:

- 1. in order to have a feeling of power over them.
- 2. to hold them up to ridicule, either in your own mind or in the minds of others.
- 3. to use the pictures, especially of people of the opposite sex, to stimulate farfetched fantasy in yourself.
- 4. to strip your subjects of privacy by showing things in them that they wish to keep hidden.
- 5. to make a reputation for yourself as photography's big game hunter, with many heads to your credit.
- 6. to prove to yourself, with unflattering pictures, that the human race is no damned good.
- 7. to see if you can outwit unwary models and get them to unintentionally reveal themselves in your pictures.
- 8. to use other people's faces to make pictures of your personal hangups.
- 9. to use the photographer-model relationship as a disguised sexual encounter and as a stimulus to sexual fantasy.
- 10. to undermine the confidence of your subjects in their personality and appearance.

If you will examine yourself very closely you will probably discover at least some of these bad habits: get rid of them! There are many others—get rid of them too!

• Some Right Reasons

In the long run it is much easier to photograph people for the right reasons than for the wrong ones—and it doesn't burden the conscience and lead to self-conflict. Having the right intentions is what counts most, even if you don't always measure up to them. You should make pictures of people for reasons such as these:

- 1. to show that you care enough for them to want their pictures.
- 2. to let them know that you find them interesting or handsome.
- 3. to make pictures to aid your memory in holding people close to your heart.
- 4. to use images of people to show them things of value in themselves about which they may have been unaware or uncertain.
- 5. to show your subjects you are trying to see them in an accurate and kindly way.
- 6. to show them that you are intentionally using photography as a way of honoring them.
 - 7. to let them know they are contributing to

My mother, the late Ruth Claire Hattersley, gazing upon her elder son with a fond look. The light source was a bare photoflood bulb positioned close to the ceiling. Mom put on her best party dress and necklace especially for the shooting session. With Dad around she felt uncomfortable (he had a criticizing eye), so we went into the next room, where this picture was made. I didn't tell her why we moved, but I think she knew.

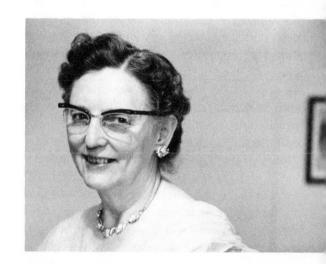

your understanding by permitting you to look at them carefully.

- 8. to let people know that photographing them is helping you overcome your fear of people.
- 9. to make images of people that will help them respect and like themselves more.
- 10. to try to make pictures that will contribute to the humanity of all who see them.

There is an immediate payoff for taking people pictures for the right reasons, provided that you believe in them: your subjects will sense your good will, drop as much of their role-playing as they dare, and reveal something of their inner selves to you and your camera. You can then take portraits that are truly candid, that are open, frank, unguarded, honest, or truthful. Furthermore, you can really believe in such pictures as descriptions of the true nature of the human race, instead of having to fantasize about images made by trickery and motivated by your own egotism.

Unconscious Telepathy

You may have wondered why this book starts with the request that you make photography, especially of people, a practice of ethics. After all, isn't photography simply a matter of mechanics? Well, you know better than that, don't you? Photography is actually many things, including a relationship between people in which one person attempts to define the other. Unless such a relationship is ethically conducted it can only lead to grief. Ethics asks that we care for people, but liking one or two is not enough. You should do your very best to learn to like the whole world, yourself included, for that is the basic ethical imperative.

Some people think that this good will, this caring, can be faked and that a clever bedside manner is the only requirement for fine portraiture. Well, it ain't that easy, and clever fakers usually end up making dull, superficial portraits and ruining photography or themselves. Perhaps the main reason for the superficial portraits is that subjects who are being lied to are well aware of it on the unconscious level and respond to the lies projecting only masks for the photographer.

I don't ask you to believe that people are fully telepathic on the unconscious level, but it is true nevertheless. Even as a nonbeliever you can make good use of this information if you will go so far as accepting it as at least a remote possibility and behave accordingly. Assuming that people can actually tell whether your motives are good or bad, despite your skill as an actor, examine these motives with great care and gradually replace the negative ones with positive. Whether you believe in unconscious telepathy or not you will find that this procedure will add immensely to the meaning and joy of making people pictures.

My father, the late Judge Ralph M. Hattersley, Sr., a kindly man with an eagle eye. I think I unconsciously knew he wouldn't live much longer, though I didn't suspect this till later. So I shot literally hundreds of pictures of him that summer. Here he is in his office in one of his four county seats, waiting for court to get into session. Light coming from the sky, entering from a large window to his left. Hand-held Kodak Medalist, a splendid but awkward camera, at f/3.5.

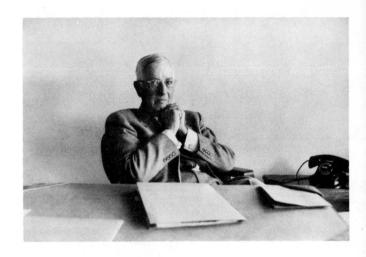

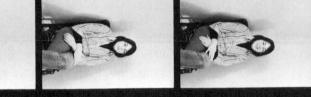

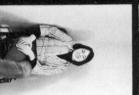

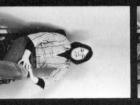

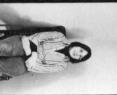

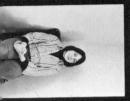

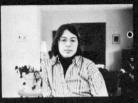

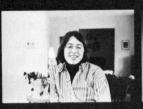

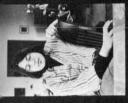

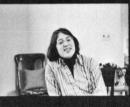

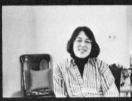

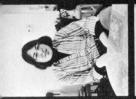

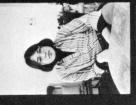

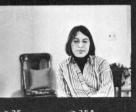

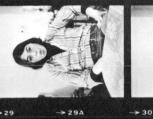

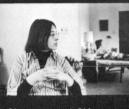

KODAK SAFETY FILM

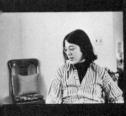

• People Are Mirrors

For a moment I will stretch your credulity still further, then pass on to more everyday matters. One strange consequence of unconscious telepathy is that it enables people to act as mirrors for one another—in fact, they do it more often than not. We do this mainly with gestures and facial expressions very carefully but unconsciously selected for what they can communicate to people who are looking at us. The objective is to inform these people very specifically concerning their own feelings, motives, and attitudes, which are mainly unconscious and not easily uncovered otherwise. In doing this we are mirrors of a sort.

This has an important bearing on photography, because when we portray other people they are simultaneously portraying us. Thus every people picture is a double portrait, though this may not be true of snapshots. Many experienced serious photographers are well aware of this, but it is also something you should know as a beginner.

Reading a photograph as a mirror may be difficult, though sometimes the mirroring is obvious. For example, I once had an extremely paranoid student who every week brought to me dozens of people pictures shot on the streets of New York. Without exception, every one of them

My stepdaughter Kathi Turner, visiting us during a vacation during her senior year at the University of Rochester in upstate New York. This contact sheet shows rather well how I shot—very fast, almost with my eyes closed—running through the 36-exposure roll in about ten minutes. This was for a reason: she didn't like the pictures I had shot of her the year before—"too mature, too sexy, too much like Sophia Loren" (yeah, she actually looked that way). So I worked very fast so as not to superimpose my visual opinions on her face, and Kathi was very pleased with the results. The pictures fitted her self-image well. As for the sexy pictures—well, it wouldn't be nice of me to print them against her wishes, would it?

looked as paranoid as he. And I remember a lonely, morose, alienated photographer—well known in the field—whose pictures reflected no feelings but these. On the other hand, there have been numerous happy people, whose pictures reflected nothing but joy and good will for the world. I remember one, call him Tom, who could make a dirty garbage can look like the throne of England. The thing is that all kinds of photographs can be mirrors, not merely portraits.

The reason for people mirroring us is simple enough, though you may find it hard to accept. At that level of being at which we are all fully telepathic we all wish well of one another as spiritual brothers and sisters. And what greater kindness can you do for a kindred soul than to operate as a mirror in which he can see himself better? Racially, we have always accepted this mirroring as a spiritual duty, so that every person you really look at, in life or in pictures, is telling you something you need to know about yourself, the knowledge of your need having come telepathically from you.

There are literally thousands of experienced photographers who know that they are reflected accurately in their work, but many wouldn't accept the explanation given here. It doesn't really matter one way or the other. Whatever be the truth, such a photographer can often look at another person's photographs and tell very well what kind of a human being he is. Many have learned to do this without questioning how it could even be possible. In this so-called visual age, many who are not even photographers are also onto the trick, probably as a useful byproduct of years spent in front of the television set.

So, you leave clear tracks whenever you make pictures and will instantly be found out by all who have really learned to see—all the more incentive for making pictures for the right reasons. And consider this: if you want to know what kind of a person you are, look at your own photographs. Singly or together, they are all mirrors of your life.

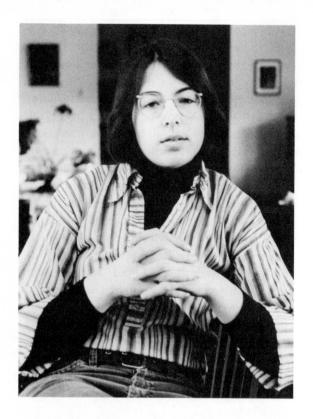

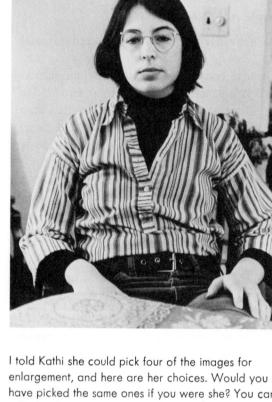

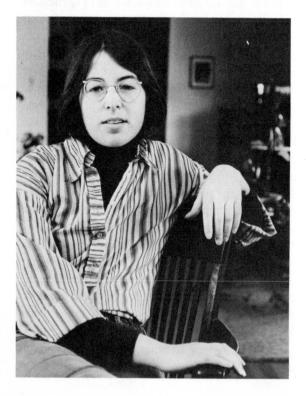

I told Kathi she could pick four of the images for enlargement, and here are her choices. Would you have picked the same ones if you were she? You can tell a lot about people by the pictures of themselves that they pick. Here we see a young woman healthy in body, mind, and spirit, reasonably pleased with herself in a very sensible way. I see this in her choices.

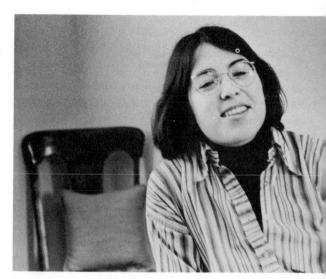

• The Fear of Being Photographed

Except for children, most people are afraid of being photographed, though they may not be consciously aware of it. Many are aware, however, but this doesn't help matters a bit. Since the photographer himself may be afraid too, you can see that the fear must be dealt with in some manner. The first step is to examine its nature; we will start with the model's fear.

By its very nature, visual perception is a process of criticizing visual reality, and photographing something is the act of bringing your critical faculties to bear on it. The process involves mental dissection and analysis, for when you photograph something you want to know what it is (to give the act meaning), and this is the customary way of finding out.

But people don't want to be dissected, analyzed, and accurately seen—for fear of being found out. Once found out, they will certainly be reviled and rejected. This is the unconscious supposition that many people make, based primarily on their own lack of respect for themselves. Thus a person who sees them well must necessarily come to share the disrespect.

Most people fear visual aggression, and a camera can be used for this purpose. They feel that an aggressor may discover their fear and use it to further lower their self-esteem. With respect to eye contact, a primary source of the fear, most of us are abject cowards and very unwilling to have others see it. Though we repress the fear of eye contact as best we can, trying to never even think of it at all, it affects all our relationships with other people. Naturally, it affects people being photographed, for this involves being looked at. Since photography can arouse so much fear in people, numerous photographers have looked into the problem in depth. Some feel there may be good reason for the fear, because very powerful psychological forces operate through the eyes. If this be the truth, the photographer should take great care not to bring these forces into play, for example in visual conflicts of will with his subjects.

Half-conscious fear of the photographer's fear may be the greatest problem of all, for people unconsciously interpret it as sheer hostility, repressed but still capable of wreaking havoc on the emotional level. Since most people are afraid of those whom they photograph (if they really try to look at them), the average adult in the course of a few years has the opportunity to experience at least one emotional beating from this fear which he perceives as hostility. Naturally, he doesn't look forward to more of it.

And fear infects many, many levels of the self, sometimes even ancient fear carried over in the racial memory. I consider it highly probable that we have all preserved the atavistic fear that photographers can capture our souls in their cameras; and many people seem to respond to this particular fear when they are being photographed. Whether one believes in them or not, such ancient terrors linger in people, influence their feelings and behavior, and make them skittish when confronted with cameras.

So, what to do about all this? Perhaps the most important thing is to always remember that people tend to apprehend the camera as an instrument of visual aggression and regard being really looked at as a form of torture. Though the photographer can hide behind his or her camera, the subject must stand naked and defenseless. The act of photographing people gives you a certain power over them. The thing to do is to surrender this power as quickly and quietly as you can.

The Meek Shall Inherit

You won't have to involve yourself very deeply in portraiture before beginning to suspect that the things you have just read may be true. As you will see, repressed fear is the big bugaboo. Some would-be photographers naïvely suppose that the way to deal with the problem of reciprocated fear is to come on to their subjects with bravado and fancy talk. Not so. This only forces models to

HOW TO SHOOT CANDID PORTRAITS

hide within certain protective roles they have learned to adopt in times of emotional distress.

The real solution, the opposite of bravado, is to come on meek and mild—even at the grave risk of not absolutely astonishing people with your charisma. If you are a true scare cat, as so many beginners in portraiture are, it may even be wise to permit yourself a short line of patter—but never say it unless you really mean it:

"I'm sorry, but I'm afraid of people, including you. If you are willing to put up with my fear—which is a lot to ask of you—I would really like to photograph you. It would help me overcome my fear, and I think you would like this."

Well, this kind of talk won't get you elected captain of the football team, but it will do wonders in encouraging people to lower their defenses and take you into their hearts. But you have got to mean it: remember that.

If you are not a scare cat—which I don't really believe—you should still come on meek and mild out of courtesy to others. Then you don't force them to don their armor and pick up their spears. The fact that you hold a camera and may be directing another person puts you in the psychologically dominant position, whether you are afraid or not. Surrender this dominance as quickly as possible. If your ego doesn't like the lesser role, tell it to go jump in the lake. However, it will like the pictures that result when fear is banished from a shooting session. With fear, you get pictures of masks; without it, a real human being.

My elder stepson Jonathan Turner in the dining room, where I do most of my portraiture. Chairs and things are already there, and I don't get in anyone's way. Now, this Jon is really some cat—I call him the King of Con. He has his elbow propped on the dining room table, in case you want to know. Bounce floodlight from his right. Shot with a hand-held Nikkormat, though I frequently use it on a tripod, too. Beautiful young man, this Jonathan.

• The Virtues of Snapshots

Now, the very best solution to the fear problem is the simple snapshot. Though it is said to be beyond definition, I will try it anyway. A snapshot is: (1) any photograph that looks like a snapshot (which assumes that you can easily recognize one without being taught); (2) a print that looks like it belongs in somebody's wallet; (3) the kind of picture that you mount in a family album with photo corners; (4) the type of photograph that Uncle Jack always makes of Aunt Gertie on their annual trip to Yosemite. You get the idea.

The snapshot is the typical output of an amateur who knows practically nothing whatever about photography. Of this person we can safely say:

1. He never really looks at the people he photographs.

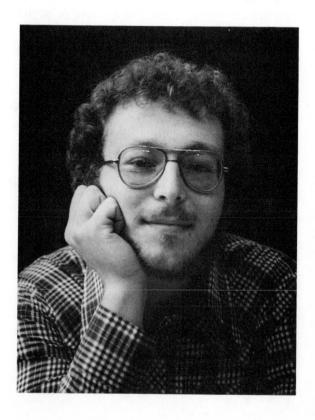

- 2. Even if he wished to he wouldn't know what to look for.
- 3. It hasn't even occurred to him that really looking might be an important part of photography, though it doesn't have to be.
- 4. Even if he thought of it, fear would prevent him from trying it.
- 5. For similar reasons, he doesn't really think about people at the same time he is not really looking at them.
- 6. He photographs with the unconscious and self-binding promise to his subjects that he will neither look at them nor think about them.

The things would seem to guarantee the mediocrity of the snapshot, yet it is by far the world's favorite kind of photograph. Many professional photographers and some of our greatest photographic artists adore it. There is even a "school" of so-called serious photographers devoted to trying to make snapshots, though its members—usually very advanced photographers—have had little success. How can we account for all this?

For enlightenment we will turn briefly to neo-Jungian psychology, which has an answer that you may find acceptable. It is as follows: on the level of the racial unconscious (a single great state of superconsciousness shared by all) there is a universal agreement among all people concerning the nature of "reality," including what it really looks like. Without this basic agreement, human communication would be impossible, despite the existence of languages.

One of the truly significant things about snapshots is that they constantly confirm, support, and describe this racial reality agreement, while most other types of photographs do not. That is, snapshots tell us that the world is exactly what we have agreed to think it is. In contrast, most other kinds of pictures are doubles, or mirror images of their makers superimposed on the things that were photographed. This mirroring results in very considerable distortion of the reality agreement. Thus snapshots support our faith in our ability to see reality for what it really is, which is terribly important to us, while other photographs tend to

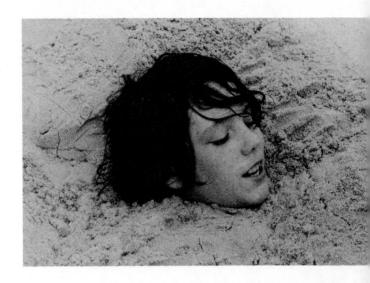

My younger stepson Bob Turner freshly buried on his first visit to the Atlantic several years ago, interment conducted by his brother and sister. I'd call this candid, wouldn't you? Kind of interesting to see a happy head floating around with no body attached.

undermine it. Actually, these things are equally good and necessary, but a full explanation of this fact is beyond the objectives of this book, and a partial one would get us nowhere.

Because the snapshot is just about the only type of photograph that conforms with the unconscious racial decision to see reality in a certain way (as a survival function of the race), it is nearly the only kind of picture that people feel safe in permitting themselves to totally believe in. If they see something in a snapshot they are unafraid to totally believe the following: the thing actually does (or did) exist; when the picture was made it looked exactly like this; it was behaving precisely in the manner indicated by the snapshot; its true nature (in terms of the reality agreement) is accurately recorded; and the snapshot itself is not a contrivance of the photographer, i.e., a mirror of his attitudes, beliefs, and experience superimposed on an image of the exterior world and possibly distorting it considerably.

A later picture of Bob, who is obviously turning ugly in his old age. I could have fixed him with a little paint, window trimming, a hammer, and a few nails, but I decided to photograph him as is. Too bad, Bob, you ugly rat. Overhead bounce light from photoflood in a reflector.

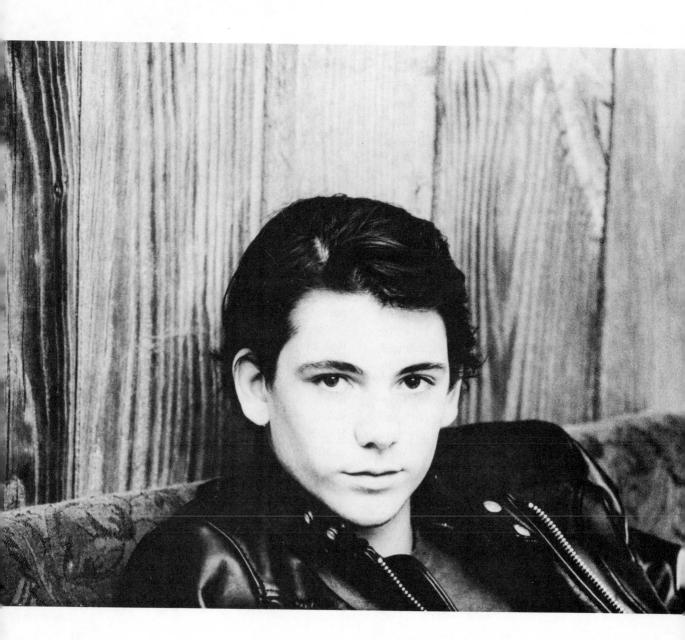

All of this happens because the snapshooter (and this includes most people who take pictures) doesn't really look at or think about his subjects. Furthermore, he simply doesn't know enough about the photographic medium to use stylistic tricks (composition, camera angle, focus control, lens tricks, etc.) to impose his personality on photographic images. Due to shyness and ignorance, reinforced by an unconscious promise, he literally *has* to leave his subjects alone. Left alone, they behave according to the reality agreement, instead of acting as mirrors. Oddly, this is true of both people and things.

Seen in this light, the snapshot surely represents the candid portrait ideal: open, frank, unguarded, honest, or truthful. Only a person who has been left entirely alone feels safe in such self-revelation in front of a camera. Thus we can now state a rule: don't meddle with your subjects! Leave them entirely alone!

As a beginner, this shouldn't be hard for you, as you haven't yet learned to use photography as a tool for meddling and changing people around. That will come in time, and you will lose the ability to make snapshots. Start mourning the loss right now, for it will be a large one, and few who have lost the ability have ever earned it back, though many have tried. The road back has but one signpost: *leave people alone!* You will learn that this is a most difficult art.

• The Technique of the Snapshot

- 1. Stand over there, please.
- 2. Click!
- 3. Thank you.

Environments

It is now time to turn to more technical matters, so we will start with the problem of selecting environments in which to pose people. One approach is to be nonselective and photograph them wherever they happen to be. Though it is a good idea and used by photographers at all levels of at-

tainment, it can be quite difficult for the beginner. Oh, he can get his pictures easily enough, but they tend to be filled with visual distractions, things that get into the viewfinder unnoticed that don't look good in pictures, pictorial garbage that detracts from the people photographed. For the beginner, then, the answer is to be more selective concerning environments.

Indoors or out, the first thing is to check out backgrounds to find ones that are potentially useful. A background is everything that will be behind a model in a photograph, and the questions you should ask yourself are, "Do I really want it there?" and "Why?" While doing this it is helpful to think of backgrounds as having these main pictorial functions: to display your subjects, explain them, or both.

One of the classical tricks for displaying something is to remove everything else from its surroundings to lessen possible distraction. Thus plain walls, skies, lawns, roadways, and the like make good display backgrounds—there is nothing in them to distract from the people you are photographing. However, there are numerous other good display backgrounds, such as doorways, windows, patios, hallways, staircases, and so on. The important thing is to examine backgrounds carefully (through your camera viewfinder) and decide whether you really want to use them.

An explanatory background is one that helps communicate what your subject is or does. For example, if you photograph your mother in the kitchen it communicates the idea that she is both a cook and housewife, whether she actually is or not. If you photograph a man working on his car it suggests that he has a flair for mechanics. There are some people that you don't wish to separate from what they are or do when you photograph them. In such cases explanatory backgrounds may be necessary. Furthermore, the backgrounds may be interesting in themselves.

Whatever kind of background or general environment you use, it is wise to look for visual simplicity. Though visual complexity can be interesting, it is often hard to handle in portraits. You

HOW TO SHOOT CANDID PORTRAITS

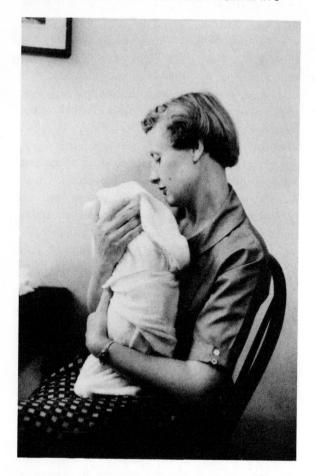

may end up with pictures that look like battle scenes from World War III.

Now, you have just been told that environmental simplicity is generally good for portraits, but for the Lord's sake don't make it into an ironclad rule. Simplicity is easier to work with, that is all. Don't make it any more than that. As for what you should put in your pictures, Picasso had the right answer: "I put the things I like in my pictures."

In choosing backgrounds you should certainly consider whether your subjects would be comfortable posing in them. The ceiling of the living room might make a very good background for Grandma, but would she be happy hanging from the chandelier?

Kris Myers and new youngun. Overhead bounce floodlight. Shot with a primordial Retina II from back in the days when cameras all had wheels and were started by spinning their cranks. Double-X film, yet—ever even heard of it? ASA 200, which wasn't so bad. This picture is somewhat like a painting, but so what?

Outdoor Lighting

In portraiture, lightings are very important, so you should look into what they do. Direct sunlight is often cruel in what it does to people. It makes them squint until their faces look like raisins and casts sharp-edged shadows that make flesh look as hard as stone. These shadows sometimes even look like sword cuts, and facial highlights tend to look pitted and greasy. Even so, you can use direct sunlight for candid portraits, but you had better be on the alert for what it is doing to your subjects.

The lightings most often used for outdoor portraiture are hazy sun, light or heavy overcast sky, and open shade. They all treat faces gently and are comfortable for your subjects. Some beginners feel that they aren't bright enough, but this is simply not true. For modern black-and-white films, which are usually quite fast, there is an amplitude of light. Even for color films, which are usually much slower, there is plenty. Though color films will take on a bluish cast, most people don't mind it. If you do you can correct for it by using a skylight filter.

Flash

Indoors, the light may not be bright enough for portraiture, so many people resort to flash, usually clipped right onto their cameras. This is called "direct flash." Though professionals and advanced amateurs often think that direct flash is rather gross, it is actually a good thing. To use it

is very easy: just follow the instructions with the flash cubes or printed on your flash unit. It really works: if you do what you are told you can hardly fail, provided your flash unit doesn't cop out. It doesn't frighten people: direct flash is the mark of the snapshooter, and no one is afraid of him. It doesn't stir things up: at parties, family gatherings, and so on, nobody gives a hoot how many flashes go off, for everyone is used to them. For these reasons, direct flash is excellent for candid pictures, and I personally use it quite often.

However, the objections to direct flash are valid enough, though you shouldn't permit yourself to be limited by them. Go ahead and use it if you like. One objection is that it is direct: that is, the light rays shoot out parallel to the lens axis, fill in all the shadows on faces and things, and leave dark cast shadows behind them or slightly off to one side.

It happens that shadows on faces are mainly what make them look the way they do. Because shadows constantly change, faces do too, which is one of the most wonderful things about faces. Direct flash cancels out this kind of change by wiping out the shadows. There may still be changes of facial expression and pose, of course, but the total number of possibilities for change is indeed severely limited, which some photographers see almost as a crime. It isn't, but that's what they think.

Some facial shadows look best if they *are* filled in, for example, those caused by bags under the eyes, wrinkles, a heavily pitted skin, long noses, abnormally deep eye sockets, and long chins.

Actor Paul Williams looking down that long, long, long, long road. Window light is swell for candid portraiture, as you can plainly see. Also, windows have a variety of symbolic meanings, which is one reason they are used so often in art and photography. The little figure to Paul's right is obviously painfully constipated—but that's what art does to one.

People who have such things are often made to look very good by direct flash.

Another main objection is that a direct flash picture "falsifies" the lighting in the room in which it was made. That is, the lighting displayed in the picture has little resemblance to the room lighting before and after the flash went off. And the lighting in a room does much to give it its character. You can worry about this if you like, but there is really no point to it. Direct flash looks like direct flash, room light like room light. There is room in this universe for both.

Fortunately, a simple technique called "bounce flash" will mainly overcome the objections. You bounce light by pointing your flash unit at the ceiling or a nearby wall, instead of directly at your subject. The light then reflected illuminates your subject and the room in a way acceptably close to room lighting.

Bounce flash isn't nearly as bright as direct flash, so you should use fast films, for example, Tri-X for black-and-white. For color, use a blue flashbulb or electronic flash with either Ektachrome 200 or Kodacolor 400 (the numbers represent their ASA speeds). With the Ektachrome, which is relatively slow, you will prob-

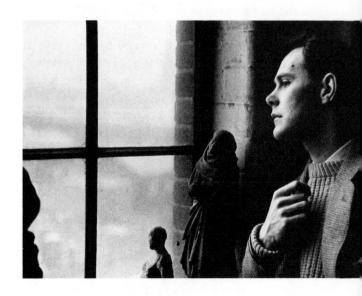

ably need to use rather large lens openings, usually ranging from f/2.8 to f/5.6, but they are quite satisfactory for indoor portraiture.

With bounce flash the instructions with your flash cubes or flash unit will no longer work, because they are designed only for direct flash. It is necessary to personally work out new aperture settings for a given house or apartment. Once you have done this you will be able to estimate the correct settings for other locations. For overhead bounce, which is most often used, the main factor in determining the aperture is the distance of the ceiling from the flash unit. Fortunately, the ceilings in homes and apartments mostly tend to be about the same height, which means that you can use the same setting for nearly all of them. Provided that they are all white, that is. A dark ceiling would require more exposure and a larger setting.

It should be sufficient to work out settings for just one room, say the den or living room. It is quite easy to do. Just stand up and shoot a series of pictures one stop apart of a family member or friend, recording all the apertures used. The picture that comes out with the best exposure will indicate the best aperture setting for a standing shot in that room. When shooting from a seated position, open up an additional stop. This method of determining settings may seem a little guess and by golly, but thousands have used it with success.

So far I haven't differentiated between regular and electronic flash: the things you have read will apply to both. But in the realm of bounce flash some of the electronic types will do things that bulbs and flash cubes can't do. These are the types that embody sensor units and thyristor circuits and that are specially designed for semi-automatic operation for both direct and bounce flash.

With such a unit you don't have to worry very much about your distance from the ceiling or a reflecting wall. Functioning as a sensing computer, it does your worrying for you. It controls the exposure by limiting the duration of the flash discharge, which is very bright. When the unit flashes the sensor starts measuring the light reflected from the subject to discover the point at which there has been enough of it to properly expose the film. At that point the thyristor circuit takes over and instantly turns off the flash. Thus the flash duration for a given unit may vary from, say, 1/500 to 1/10,000 of a second. This gives the photographer a very considerable range of exposures, selected for him electronically.

The sensor couldn't care less where the light reflected by the subject comes from—direct from the flash tube, or from the ceiling, wall, or floor—because it only measures quantity. Thus it makes no differentiation whatever between direct and bounce flash. Your flash unit is a sensor-computer that works out and controls your exposures for you, which is very reassuring and convenient. These outfits are real beauties and they work like a charm, but they still come with instructions that must be read and followed. We

C. B. Neblette, photography's great educator, in his old office at the Rochester Institute of Technology. Overhead bounce flash.

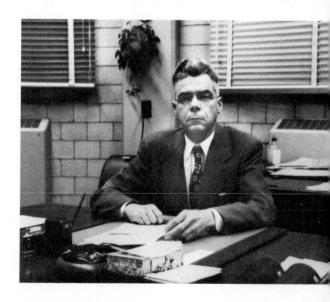

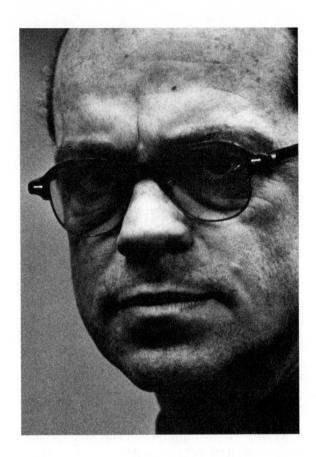

Frank Harris looking like the man who clobbered Attila the Hun. Now, the overhead bounce flash hitting the ceiling directly over his head has given us this very strong lighting. And Frank has a strong face, too, of course. Bouncing the light from more of an angle would have filled the shadows in (see next chapter).

have yet to see a unit that a bona fide moron can operate. Sorry.

Because people are used to it nowadays and don't seem to mind it at all, flash (ordinary or electronic) is especially good for portraiture. Since it will stop action, you don't have to ask people to hold still but can catch them moving around. Equally important, it creates no tumult. It's just on, off, and goodbye.

One problem with flash is that you can't actually see the light and shadow patterns that it

creates on the faces of your subjects and thus cannot know how they will look in pictures. A way around this is to own an electronic unit with a built-in modeling light but such units are usually large, expensive, and cumbersome. Thus if you really want to see what light is doing—a commendable idea—it might be best to turn to floodlight or natural light.

Floodlight

The main reason for floodlight is to raise the level of indoor light to a point where you can stop your camera lens down a bit and use fairly fast shutter speeds. You can do this best by having your light, say a 500 watt photoflood, very close to your subjects and pointed right at them. However, this is very disconcerting to people, because the light is very hot and extremely bright. Furthermore, you will probably get ugly light and shadow patterns on faces, unless you already know how to "see light," which takes quite a while to learn.

In terms of doing justice to the faces and bodies of your subjects, the best bet is to bounce your floodlight (one is usually enough) from the ceiling or a wall—any surface that is light in color will do if it is large enough. However, if you use a fast film such as Tri-X you should be able to expose around 1/60 of a second at f/2.8, which is not at all bad for candid portraiture.

You can even shoot color, using High Speed Ektachrome B (balanced for tungsten light), but you should use it only with a 3200 K lamp. This lamp gives off exactly the right color of light for this brand of film. With an ASA speed of 160, this film is quite a bit slower than Tri-X (ASA 400), so you may find yourself using shutter speeds as slow as 1/15 second. But this doesn't have to be a problem, as you will see in a moment. The answer may be a tripod.

At a speed of 1/30 second you should be able to use your camera hand-held, provided that you

brace it tightly against your forehead, slow down your breathing a bit, and depress the shutter release by gradually *squeezing* it, not by punching at it. Such things counteract camera movement and make for sharper pictures.

At f/2.8 you will get enough depth of field to get a full or half figure acceptably sharp at the distance required to fit such figures into your viewfinder. It is also a small enough aperture for a close-up, or head shot, provided that you focus on the eye closest to your camera. If you focus on the farther eye or the contour of the head, the front of the face will be out of focus. Even if you decide to stop down to f/4 or f/5.6 you should still focus on the nearest eye—unless the eyes are equidistant from you, of course, in which case either one will do.

The safest kind of floodlighting is bounce from the ceiling, for it is gently flattering to nearly everyone. Furthermore, it distributes light rather evenly over a fairly large area, so that you don't have to take a new light reading every time a subject moves a foot or two. As you move away from the light stand the illumination will gradually fall off, of course. Even so, there is a circle of illumination around it about eight feet across in which you can stick with just one aperture and shutter speed setting. Not having to constantly change the settings will make it possible for you to be more casual and relaxed about what you are doing, which is just the thing for candid portraiture.

Light bounced from a side wall is generally more dramatic, with the drama gradually increasing as you move your subject closer and closer to the wall. However, by moving him or her away from the wall you can lessen the drama (contrast, really) to any degree you wish. Side bounce usually produces pictures with a much more three-dimensional feeling than those made by overhead bounce, mainly due to the effects of lighting contrast.

With side bounce you should take a new exposure reading every time your subject changes position more than a foot or two. It is usually safe

to read the face, provided that the meter reading covers both the light and dark side of it at the same time. If you read only the light side you will get underexposure. And reading only the dark side will give you overexposure. For overhead bounce a good way to get a dependable reading is with a Kodak Gray Card. Just hold it up to your model's face and slant it slightly upward toward the ceiling. Then take a reading from it and use the camera settings indicated by your meter. This system works because the gray on the card was selected because it reflects an average amount of light, and people (including their hair, clothing, highlights, and shadows) reflect an average amount, too. Thus reading a gray card is equivalent to reading all parts of a person within view of your camera and averaging them, another good way of determining exposure. The card reading is simply faster and usually more accurate. You can use it with either a separate meter or one built into your camera.

Concerning people's reactions to rooms brightly lit by photoflood, they usually don't mind once they get used to it, which may take ten minutes or so. And children couldn't care less. However, there are adults who don't like bright light at all, especially mature women who are aware that dim light treats them more gracefully and gently. Such a person may get uptight when you drag out your floodlight, so in this case you should leave it in the closet and settle for natural light.

Natural Light

In photography, natural light is often referred to as "available light," meaning whatever light you encounter indoors when you decide to photograph somebody there—light from doors, windows, table and floor lamps, ceiling fixtures, and so on. Each room or interior area has its own unique lighting scheme, usually created after a lot of thought, and the natural light photographer chooses to pay his respects to the creator by using

the lighting as is, though he may turn on a floor lamp or raise a window shade.

Now, a thoroughly familiar lighting gives people a great deal of comfort and security, and a radical change is not always welcome, even though temporary. And it is for this reason that many candid portraitists choose to leave the lighting undisturbed, though it may make things difficult for them. However, they also know that many kinds of fine pictures can be made with natural light and that it often does wonderful things they themselves would never think of doing with light sources fully under their own control.

In terms of what it does to faces and figures, the available light indoors varies considerably in quality from one location to another. For example, near a certain window it may be wonderful, in the center of the living room just so-so, and in

Hollis N. Todd, that rarity—a master teacher. Though I could have draped something over Hollis' rusty radiator I preferred to leave his environment alone. Concern over having pictorial environments is legitimate, surely, but you can easily get carried away by it and miss many a good shot as a consequence. I like this picture of Todd, and I'm the guy I made the picture for.

the utility room downright awful. Aware of this, the skilled photographer tries to stay constantly alert to what light is doing to people, wherever they may be, so that when it comes time to photograph them he already knows the best places for it.

Unfortunately, the light available in many places isn't very bright, because a lot of people like it that way. They may feel that low light levels promote feelings of warmth, security, intimacy, or mystery. For others it may mean privacy. At any rate, the light is dim and we find ourselves with an exposure problem. Color positive films may be entirely out, because they are so slow, but an ASA 400 color negative film is just fine.

Even with fast black-and-white films such as Tri-X we may find ourselves using exposures in the order of 1/4 second at f/2. At 1/4 second it is difficult to hold a camera steady, and f/2 gives us little depth of field. Another difficulty is that many of the meters built into cameras won't give readings in dim light, while some types of separate meters give readings too low on the meter scales to be dependable.

The best answer to this exposure problem is to have a supersensitive light meter such as the Gossen Luna-Pro, which will produce accurate readings even by moonlight. However, there is a special metering technique that will work with separate and built-in meters of less sensitivity. It is called a white card reading and the technique is easy. You divide the ASA speed of your film by five to get its "white card speed," then set this new speed on your meter. Then hold an 8×10-inch sheet of white cardboard or paper in front of your model and take a reading from it; its whiteness will help you get a good reading. Then use the exposure setting (aperture and shutter speed) registered on the meter. Or with a built-in adjust the shutter speed and/or the aperture until the needle is positioned correctly. That is all you have to do, because dividing by five compensates in advance for the fact that models are much darker than white cards.

HOW TO SHOOT CANDID PORTRAITS

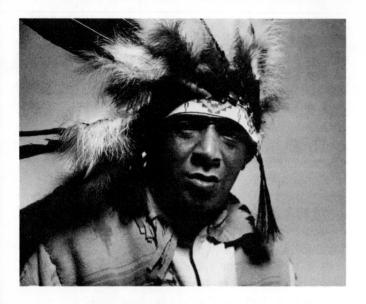

My good friend Arion Chief Suwarrow, who has spent thirty years trying to prove he is a full-blood Indian—which he ain't. For about five years I was his press agent. Studio shot: one very large floodlight bounced off a reflector on the right side of the picture. No fill light. The Chief made the headdress himself.

The slow shutter speed may cause fuzzy pictures due to camera movement, subject movement, or both. The camera movement can easily be eliminated with a tripod (which every dedicated photographer should most certainly have), provided that one uses it with a cable release. This is a thin, flexible tube-like device embodying a plunger for depressing the shutter release without jarring the camera. However, the cable release should be at least ten inches long, and you should make a loop in it before depressing the plunger. Acting as a shock absorber, the loop absorbs your body movement so that it won't be transmitted to the camera.

Having to tie yourself down with a tripod will slow up a shooting session very considerably, but it is sometimes all that you can do. It may also force you to ask a subject to hold a position while you adjust the tripod, focus, and shoot. Then if you take too long at it he or she may stiffen up from muscle fatigue and start looking very pained. With practice, however, you won't have to ask people to hold still. You will just wait patiently until they settle down for a moment, then immediately focus and shoot. Unless a person has St. Vitus dance or burrs in his britches he is bound to hold still every now and then, so you just wait. You can even do this with children, no matter how bouncy they are.

In addition to using a tripod when necessary you should also work to develop a steady camera hand, because you can photograph much more flexibly with a hand-held camera. Three of the secrets for this have already been mentioned: breath control, squeezing the shutter release, and pressing the camera very firmly against your forehead. In addition, brace your elbows firmly against your rib cage (instead of letting them stick out like wings). Whether standing, seated, or lying down, take a position that you think you could comfortably hold for five minutes; it will very probably be a posture steady enough for good camera handling. Also, wrap the camera neck strap around the hand that carries most of the weight of the camera in such a fashion as to virtually weld the hand and camera together.

Hold your camera in such a way that the finger or thumb used for depressing the shutter release carries none of the camera's weight; the finger's sole function should be to move freely in squeezing the release. Use any available supports to help you brace yourself: lean against a doorjamb; sit in a chair and brace your elbows on your knees; prop your elbows on a table; rest your camera on a friend's shoulder, using him as a mobile tripod; and so on.

A proper mental attitude is possibly the most important camera-steadying trick of all. Don't permit yourself to feel like the avid young cave man getting his first shot at a pterodactyl; you will surely get the shakes if you do. Remember that the people you photograph won't be going anywhere right away, so if you miss three or four shots there will be lots of others that you don't miss. So when you are ready to shoot, think about something quieting, such as grocery lists. A thought that I have personally used with good effect for self-calming goes something like this in the expurgated version: "Bugger all, I don't really want this blank blank picture anyway." Another one, again addressed to myself, is: "Look, you bloody idiot, you won't actually drop dead if you miss this shot." Sometimes you have to talk roughly to yourself to catch your own attention.

Before leaving the frustrating problem of camera steadying we must pay tribute to the humble martini, for it has steadied even more hands than virtue has. And so have Miltown and its cousins, of course. As for avoidances, be sure to steer away from strong coffee and other stimulants—if you are more interested in shooting pictures than in climbing the wall.

With practice in using these steadying tricks you will frequently find yourself using a handheld camera at speeds below 1/30 second, sometimes as low as 1/4 or 1/2. When you are well braced and in the right frame of mind you may even be able to use the B (bulb) setting for exposures as long as two or three seconds.

Let us return to dim illumination and the need for large f/stops, such as f/1.4 or f/2. Using a tripod, you can generally stop down a bit (to f/2.8, f/4, or f/5.6) and safely use shutter speeds as low as one second. Even at this slow speed you don't necessarily have to ask people to sit still, though it is easier if you do. If you watch a person for a while you will see that his or her movement and stillness alternate in a kind of rhythm. This permits you to anticipate moments of quiet so that you can shoot pictures when they occur. This may sound difficult, but it isn't—and it is an interesting little game to play.

Another problem in low illumination levels is a nervous and fidgety model—you can't use a fast enough shutter speed to stop the movement. We will get to this problem in the next section.

You and Your Models

In candid portraiture it is important to make your models feel comfortable and relaxed. To help in this you should learn to recognize the signs of nervousness, try to understand its causes, and accept the possibility that you yourself may be the chief cause. For example, you may be talking too

Art Gorman, when he was a student of mine about ninety years ago. For candid portraits, distractions are very useful, music being one of the best, closely followed by naked women. Art couldn't have cared less what I was up to, so I bounce flashed his picture without disturbing his mood or expression.

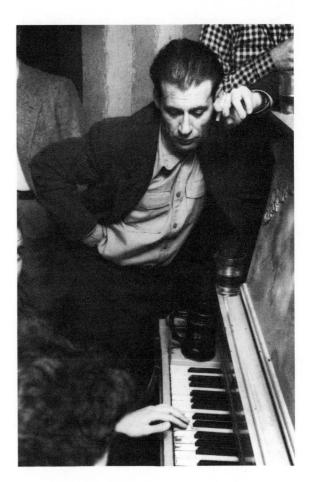

fast, coming on too hard, and hopping around like an agitated rabbit—to demonstrate your competence as a photographer and cover up your own nervousness. Such behavior will make your model as nervous as yourself.

The solution to this particular problem? Slow your speech way way down, abandon your sales pitch, and imitate the slow, deliberate movements of a tortoise. Such behavior is very, very calming to another person.

Do your best to be a downright bore for a while. Oddly, being a deliberate bore is a very effective move used even in professional photography. Ken Heyman, one of our finest photographers, is the master. He can be so boring that his models actually forget he is in the room with them. The thing is that bores practically never come on as threats, so that they are easily forgotten

In yet another way you may cause your subjects to squirm—if you move inside their invisible defense perimeters. Unconsciously, each person draws an imaginary circle around himself, marking the minimum distance he feels he must keep between himself and others for his own emotional security. By observation you can usually tell how far a person's perimeter has been extended for you at a given moment. Then it is your duty to respect the defense perimeter and stay outside of it. In order to do this you might shoot half-figure poses instead of head shots. Or you could use a lens of fairly long focal length, such as a 90mm lens (very popular for portraiture) on a 35mm camera.

I once had a female student who was very leery of me as a threatening father figure, so her perimeter was very important to her when I was around (it was a minimum of four feet in radius). Whenever I would intentionally invade it she would make a two-foot backward jump, like a sparrow hopping along a branch. One day when I was paying very little real attention to anyone I managed to jump her the length of a large room before I awoke to what I was doing.

Well, it is usually not this easy to discover the

radius of someone's perimeter, but you can usually figure it out if you keep track of such things in your model as rapid eye blinking, a sound of dryness in the voice, speeded-up speech, compulsive yawning, clenched fingers, strained neck muscles, stiffness in the back position, knees pressed tightly together, evasive eye movements, and so on. All are indicators of nervousness, often caused by the invasion of one's perimeter.

Even better, you can learn to detect nervousness in another person by its effect on your solar plexus. Anxiety is broadcast like radio waves and human glands are excellent receivers, especially those in the head, neck, and solar plexus. If you learn to listen to your glands they will tell you how your models feel. If they really hurt you have got a problem with someone.

And be sure to remember that adults are generally afraid of being really looked at, especially if it involves eye contact. When you do look someone in the eye, always look down first. Always be the loser in the unspoken contest for visual dominance. If you want to really look at a subject, do it through your camera viewfinder. Otherwise, confine yourself to briefly glancing at facial features other than the eyes—forehead, nose, chin, cheekbones, hair, and so on.

Earlier, you read about the great importance of making portraits for the right reasons, which includes the correct attitudes. For their self-assurance your models need to be constantly told where they stand with you, and you can tell them in subtle, indirect ways. Taking lots of pictures is one way. Another is to frequently use the word "yes" and other little sounds of approval or satisfaction (mmm, yeah, yep, fine, etc.). Though muttered half under the breath they give a model assurance that everything is all right.

Though you may not believe in unconscious telepathy, you would be wise to behave as if you did by controlling your thoughts. Thus when you are photographing people you should be on the constant lookout for things you like about them —in their appearance, personality, behavior, attitudes, or whatever—and mulling them over in

your mind. Such thinking is somehow communicated, and it will do much to reassure your models and make shooting sessions relaxed and joyous.

On the other hand, when you see things in others that you dislike, don't dwell on them in your mind, for that too is communicated. As an aid in dismissing such thoughts, remember this psychological law: the things that we dislike in others are almost invariably reflections of the very same things in ourselves. Otherwise, they wouldn't bother us so much. If this doesn't work and your thoughts are still negative, try remembering something you liked very much, for example, a joyous walk in the woods with your dog. Though this has nothing to do with your model it will give a positive emotional charge to the atmosphere, which is what you both need.

Now, you must realize that there are times in a shooting session when you shouldn't take pictures, even though that is its purpose. You may have to refrain from taking some really interesting shots, possibly the best of all. But you should give them up anyway. This is the problem: most people constantly do things they don't want recorded in pictures, and you should respect their wishes in this. For example, they frown, scowl, grimace, pick at their faces, make ugly gestures, rub their eyes, stretch, cough, sneeze, pick their noses, and so on. And they are instantly aware of it if a photographer photographs such behavior. Doing so is a violation of a confidence and your model's right to select the facial expression he or she wishes to present to the world. If you do it even once your model will lose all trust in you, though nothing will be said-and the whole shooting session will slide right down the drain.

The author as a young man. Or: old author with young wig, beard darkened with eyebrow pencil. I asked Dennis Martin to snap some shots of the rejuvenated me—studio electronic flash with an umbrella—and this one I found most beguiling.

In a more positive vein, it often helps a shooting session if your model is accompanied by a friend or two. Then you can shoot your subject while he or she and the friends are talking and enjoying one another. You can get some really wonderful pictures this way.

Poses

In formal portraiture, standardized poses are of some importance, because they are an accepted part of the game. This is not true of candid portraiture, however. Here you should be ruled by a single axiom: if the subject is comfortable the pose is just fine. You can ask people to do things—sit, stand, lie down, lean, etc.—but encourage them to be comfortable while doing so.

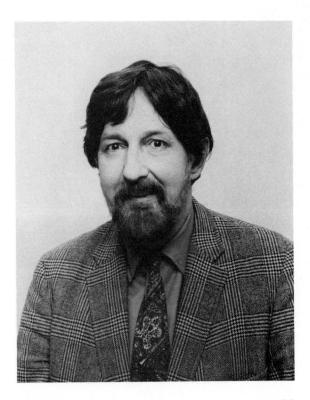

HOW TO SHOOT CANDID PORTRAITS

Now, many subjects will assume that you want poses as stiff as boards and will do their best to look like wooden Indians. With such a person try this approach, which is much better than a lengthy explanation of what you want from him or her: "Relax in this chair while I work on my camera a while." Then start fiddling with the camera and muttering good-naturedly to yourself, watching your subject out of the corner of your eye.

As soon as he or she tires of being a wooden Indian and relaxes into a comfortable position, make your next move. "Aha, very good pose; hold it for just a second while I get a picture." And, of course, you should be all prepared to do it just that quickly.

Even if you don't like the pose, make a picture of it anyway—film is cheap. Indeed, you should take a picture of every pose the model takes, provided that it is a comfortable one. The important

thing is that this teaches your subjects in the quickest possible way that you are more interested in their comfort than in poses out of *Vogue* or *Captain Marvel*.

An even easier way to work is to say nothing

An even easier way to work is to say nothing whatever about poses. When you have permission, spoken or unspoken, to photograph someone, just wait around quietly and unobtrusively until he or she is doing something you like. Then walk up and make your pictures. When you work in this manner people soon get the idea that you are interested in them as they really are, not as actors playing roles from grade B movies.

Returning to the idea of pictures full of wooden Indians: there is nothing really wrong with them; most people shoot such pictures; and you should go right ahead and shoot as many as you like. However, you may also be interested in people behaving more naturally. So why not take both kinds?

If you are inclined to be shy and find that the information in this chapter makes portraiture more a threat to you than an interesting challenge, why just forget all of it—except for the comments on the snapshot. If you prefer to photograph people without really looking at them or even thinking about them, go right ahead—you will probably make excellent snapshots. And that is nothing to sniff at.

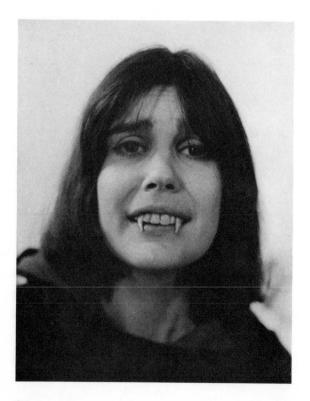

Kip Petticolas says that eyeteeth are sexy and has grown a new pair just to prove it. Portraits don't *all* have to be serious, you know. Available (natural) light from lamps and windows.

FORMAL PORTRAITURE: LIGHTING

Formal portraiture is the kind practiced by commercial portrait photographers, who have in many ways refined the art to a high degree. Certainly, they know what people like in portraits, for their livings depend on it. Thus their knowledge should be of interest to you. Their work is formal in the sense that it follows set forms, or ways of doing things, that are in universal use throughout the world. That is, they all use the same tricks and techniques, mainly because customers have found them pleasing. For you, the most useful of them is their approach to portrait lighting, which we will deal with in this chapter. Since you probably do not have professional lighting equipment, the techniques will be explained in terms of light sources that you can afford. However, the things that you will learn can also be used with more expensive equipment.

In the last chapter you were introduced to bounce light, that is, a light source pointed at a wall, ceiling, or other reflecting surface. For beginners, this is a very good start, because it doesn't demand acute perceptual awareness, or the ability to "see light." Even if you are not very conscious of what you are seeing, your pictures will usually come out pretty good, your subjects looking as you think they ought to.

However, the lightings in this chapter practically insist that you begin developing your ability to see and will be a great help for you in this direction. If you do not, your subjects may look very bad in their pictures and may even seem like strangers. Do not avoid these lightings, however, because they are very good ones and are an important part of the living tradition of photography. As the philosopher said: "He who manages to avoid all mistakes learns nothing, for mistakes are our teachers. Anyway, complete avoidance is only possible after your funeral." So, you will certainly make mistakes with the lightings, but they will really help your visual perception.

Most of the lightings involve pointing one or more light sources right at the model or in that general direction. The effect on his or her appearance is usually very different from that of bounce light. The amount of light that falls upon your subject is considerably increased, so that you can use faster shutter speeds and/or smaller f-stops. It is also easier to work with the slower color films. In contrast, when light is bounced from a wall or reflector, much of it is absorbed or scattered, which reduces the intensity of the part that reaches the model.

The chief difference in visual quality between direct and bounce lighting can be explained in terms of shadows and shadow patterns. In terms of learning to see better, shadows give us something rather tangible to work with. In bounce lighting you are usually not very aware of either shadows or their patterns, because the shadows have such soft edges. Without well-defined edges to attach your perceptions to, you may not even

be aware of any shadows at all, though there actually may be an abundance of them. And if you can't see the shadows, you will certainly be oblivious to the patterns they make. This is the problem with bounce lighting.

In comparison, direct lighting may produce shadows with edges ranging from fairly sharp to extremely sharp. Then you will have no doubt that the shadows are actually there, both on your living subject and in your pictures of him or her. Once you know they are there for sure, you can start to learn what they do. You will even learn to see the shadows and shadow patterns in subtle bounce lighting.

(The model for the illustrations in this chapter was my younger stepson, Bob Turner. My objective was to show shadows and shadow patterns in such an unmistakable way that you would be sure to see them and to sense how they affect the appearance of Bob's face in various ways. The pictures work well enough as portraits, to be sure, but their main function is to describe what light does to a face.)

The factors that determine the edge sharpness of shadows are the size of the light source and its distance from your subject. The *smaller* the source—and the *greater* the distance—the sharper will be the shadow edge. Conversely, the *larger* the light source—and the *less* the distance—the *softer* will be the shadow edge.

For example, small sources such as a candle, flashlight, miniature spotlight, or the sun are naturally good for producing sharp-edge shadows. However, as they are moved progressively closer to your subject the sharpness is gradually diminished, whereas increasing the distance adds to the sharpness of the edges.

Large sources such as big reflectors (or walls used as reflectors for bounce lighting), large skylights or windows, an overcast sky, or the blue sky when the sun is not in sight, are naturally good for producing soft-edge shadows. Closeness to the subject increases this softness, while distance adds sharpness.

The light sources best for beginners (3200 K

bulbs in reflectors—good for both black-and-white film and Ektachrome 160 color film) fall in between the large and small sizes and in some situations can be used for either soft or sharp shadow edges. For example, if such a unit is used within one or two feet of a subject it will make soft-edge shadows. However, at a distance of four or five feet the edges become more obviously defined, and at ten feet or more they are very sharp.

Lighting contrast affects the apparent sharpness of shadow edges and is the main factor controlling how obvious the shadows will be, on your living model and in your pictures. High contrast increases our awareness of shadows and their edges, thus making them seem sharper. With moderate contrast we are less aware, and with very low contrast we are hardly aware of shadows at all (all of these things can be seen in the illustrations if you examine them closely).

Furthermore, shadows have a considerable influence in making things look the way they do (notice how Bob Turner's face changes with the lightings). And they are primary creative tools in all stages of photography, from beginning to very advanced.

Earlier, I said that bounce lightings (most of them) don't require much visual perception in the photographer. Because they usually combine very soft-edge shadows with moderate to low lighting contrast, they treat human faces very gently. No matter how your subjects are positioned geometrically with respect to the light source (a reflecting surface), they come out looking pretty good, even if you don't really see what they look like while snapping your pictures.

When we shift to direct lighting with light sources much smaller than the ceilings and reflecting walls used in bounce light, the situation changes drastically, especially if we use fairly high contrast. Now the geometric relationship of subject and light source become very important. If the head is turned in one position, it may look good; in another, it may look awful. Sometimes the difference between good and awful is repre-

sented by a very slight turning (or raising or lowering) of the head, perhaps an inch or less. The thing is that with direct lighting you are working with fairly obvious shadows on your subject's face. With your two light sources (recommended here) you can create many shadow patterns, but relatively few will look pleasant and flattering to your subject.

The question now arises, why bother trying something in which the risk of failure is so high? Well, we *learn* from failures—remember? Another answer is that you will find your successes very rewarding after you have earned them. Again, experimenting with these lightings will enable you to see for the first time in your life what a face really looks like. And you will tend to develop a much better grasp of the difference between the beautiful and the ugly, an important factor in learning photography and a much more sophisticated problem than you might suppose.

Perhaps the most important possibility is that you may find a way of drawing on your emotional energies in your efforts to learn to see better. This is a tremendous help. In photographing friends or family you make an unspoken promise to see the best in them and express it in your pictures, which would make failure very embarrassing. The fear of this will build up enough emotional tension to motivate an effort to really see. This requires a lot of energy and is very difficult and tiring.

Your emotional commitment can also help you confront your photographic failures long enough to analyze their nature and figure out how to correct them. Otherwise, you might not even notice them. As the Chinese sage Chuantze once said, "Man learns mainly from his errors, but he isn't even aware of them until they bite his nose, steal his purse, or turn his friends against him."

• The Functions of Portrait Lights

Portrait lights are used mainly in a traditional way, so we will use classical terminology (photographic jargon) in naming them and describing their functions. In a standard portraiture lighting setup the light sources are called, in order of their importance, the key light, fill light, background light, and hair light. You should work only with the key light and the fill, because the others are not especially necessary and would add to your equipment costs. The two are identical light fixtures, but the ones you will omit are different and sometimes quite specialized.

The key light gets its name from the fact that it is positioned closer to the model than the fill, thus it has a stronger effect on his or her appearance. We can say, therefore, that the key to what your picture will look like is in what the key light does to your subject's face. The higher the lighting contrast, the more this is true.

The experienced photographer always begins his lighting procedure with the fill light turned off, using the key light alone. With it he tries different light positions and asks the model to change the pose (or the tilt or turn of the head) in various ways, until he is satisfied that he has found the best combination for the particular type of face he is photographing.

Without the fill light the shadows are dark and obvious, so that the light and shade patterns created by the key light are very easy to see. Furthermore, the difference in patterns caused by shifting the light position or changing the pose is also fairly obvious. With quite a bit of experimentation it is easy enough to see that some combinations are more becoming to the model than others, so be sure to experiment enough. Only when you are satisfied that the key light and the pose are working together in the very best way should you then turn on the fill light; this is the way the professional works.

We call it the fill light because its primary function is to fill the shadows on the face and figure, which means to lighten them to some degree. The fill light gives us control over lighting contrast, which in turn permits us to make dynamic (high contrast) or static (low contrast) pictures—or something in between.

We get high contrast by using no fill light at all,

by having the fill light fixture far away from the model, or by using just the edge light. This means to point a light in front of, or behind, a subject in such a way that only the edge of its light pattern falls upon him or her. Since the edge light is relatively dim it doesn't lighten the shadows very much. To gradually *lower* the contrast we move the fill light toward the subject. When the key light and the fill light are equidistant from the model, the lighting contrast disappears altogether, so that both sides of the face and figure are of the same tone, or brightness.

Some Functions of Lighting Contrast

Lighting contrast is very important in photography, because it mainly controls the dimensional feeling in pictures and has a strong effect on the apparent solidity and realness of our subjects. These qualities are usually created with contrast ranging from average to fairly high. However, extreme contrast wipes out both three-dimensionality and the feeling of realness. Very low contrast may also do this, but in a different way.

Another thing governed by lighting contrast is the relative obscurity of shadow areas. With black shadows the obscurity is complete, for we can see none of the things within these areas (here I refer to areas in pictures). As progressively more fill light is added, the obscurity gradually disappears, until we can see everything. You should experiment with lights to see how this works. Learn both to reveal and obscure.

Beginners often think that pictures should reveal everything, but this just isn't so. An important part of the art of photography is to know how to reveal some things while simultaneously obscuring others. This is sometimes called "emphasis and subordination." In portraiture, we usually emphasize the front of the face, especially

the eyes and mouth, then subordinate everything else to some degree. Through emphasis we lead people to see what we want them to. Through subordination we divert them from distractions.

• The Names of the Lightings

We started on the nomenclature (or jargon) with the terms key light and fill light. The lightings themselves are usually called narrow lighting, broad lighting, front lighting, split lighting, double back lighting, ghoul lighting, overhead bounce lighting, and side bounce lighting. There are a few additional types used in photographic portraiture, but these are the main ones. In this chapter you will find them defined in four ways: in terms of words, lighting diagrams, photographs of actual lighting setups, and portraits in which they were used.

Remember that the main function of the portraits is to show you in a rather bold way what different lightings will do to a face. If the lightings had been used with more subtlety you might not be able to see this.

Narrow Lighting

For a three-quarter pose (the model's face at an angle to the camera, somewhere between full profile and full front). The key light falls only on the narrow part of the face (the front). From the camera position, the side of the nose, the side of the forehead, and most of the cheek and jaw are in shadow. In a *very* narrow lighting (sometimes called Rembrandt lighting) the shadows are connected, so that the light pattern on the part of the face nearest the camera is in the shape of a triangle.

NARROW LIGHTING

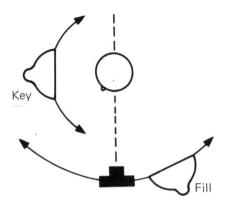

This technique, often called Rembrandt lighting, creates obvious shadow patterns and high contrast without fill light (photo top). With both lights (bottom), shadows are softer. Key light, pointed at camera, is above and slightly behind subject. Fill falls on side of face.

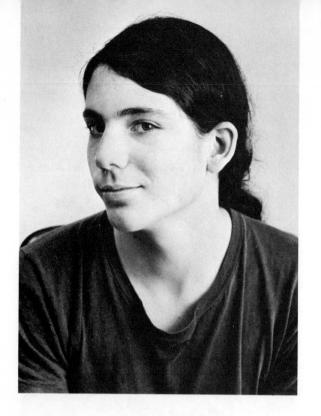

Broad Lighting

For a three-quarter pose. The key light falls on that whole hemisphere of the head and face that is closest to the camera, which makes up a very broad area. The turned-away part of the face may also be illuminated somewhat. To prevent the face from looking too flat, the key light may be positioned high on its standard and angled sharply downward at the model.

Broad lighting fills out thin faces and reduces blemishes. Key light, angled down, is above and near subject. Fill is quite a distance away. Photo (above) was made by using both lights. Shadow edges are soft. More dramatic effect shown without fill (below).

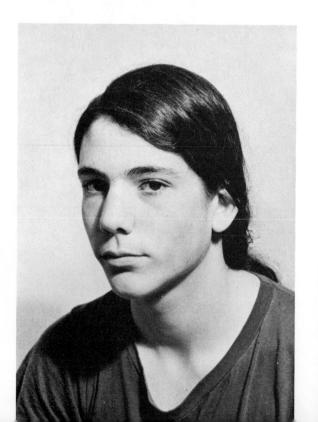

BROAD LIGHTING

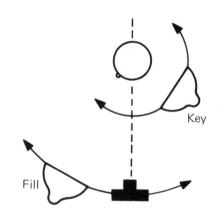

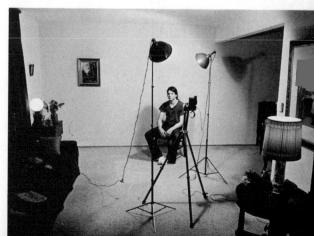

Front Lighting

For a full-front pose (the model's face centered directly on the camera). This lighting has two variations: high-front and low-front. For high-front, the key light is usually very high on its standard and angled sharply downward. The standard may be within one or two feet of the model and positioned very close to the camera axis, so that the light falls squarely on the front part of the face. This lighting creates obvious shadows under the eyebrows, nose, lips, chin, and jaw. For low front lighting, the key light is backed up toward the camera (or even positioned behind it) and lowered on its stand. It minimizes the amount of shadow area on the face, as does also the broad lighting.

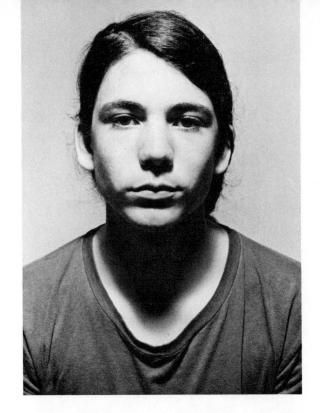

HIGH FRONTLIGHTING

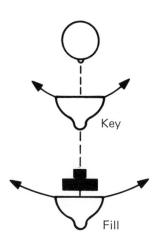

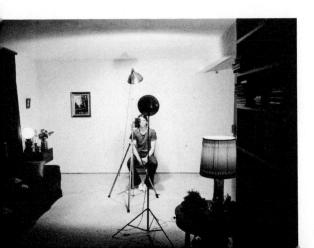

High front lighting emphasizes blemishes—so use with caution. No fill light (photo above) stresses blemishes more. Fill softens contrast, gives warmer skin tones. Key light, close to subject, is shown above model. Fill, almost same height as subject, is pointed toward him.

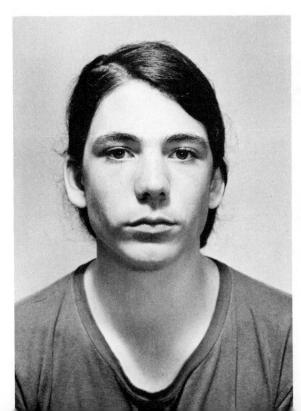

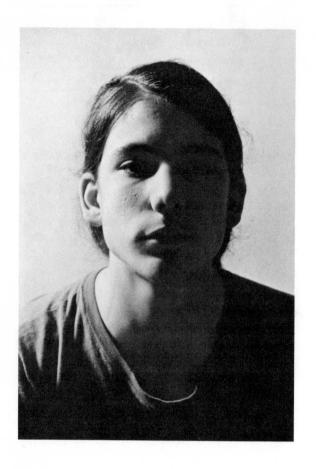

Split Lighting

For a full-front pose. The key light is at the side of the model, and quite a bit behind, so that it strikes only one side of the face. Thus the face is "split" between highlight and shadow. Since the light may also be pointed in the general direction of the camera, there could be a problem with lens flare (strange blobs or shapes in pictures, caused by light hitting the lens). To prevent it, raise the light high on its standard and angle it downward; or use a deep lens shade; or shade the lens with a piece of cardboard while making the exposure.

SPLIT LIGHTING

Split lighting is used mainly for interpretive portraiture. The key light splits the face in two, one half shadows, the other highlights. The key light stands above and to one side of the subject, angled down. The shadows can be lightened with either direct fill light or bounce light.

• Double Back Lighting

For a full-front pose. Use both of your light sources as key lights, with one on each side of, and well behind, your model. To prevent lens flare, follow the instructions given for split lighting. If you should want some fill light in the shadows you will need an additional light source. However, your picture will be more dramatic without one.

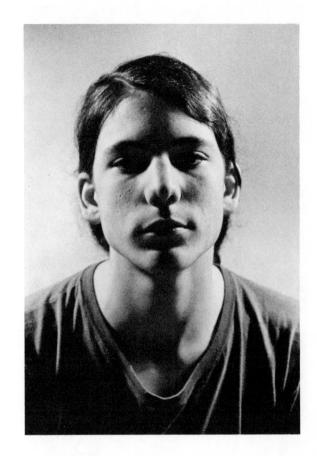

DOUBLE BACKLIGHTING

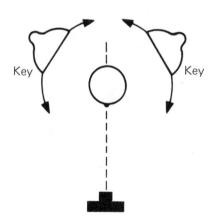

Double back lighting should not be used for everyday portraiture, because it exaggerates facial structures that are seldom seen. Note that both lights are in back of the subject and angled forward in the direction of the camera. This means that in order to prevent lens flare a lens shade should be used.

FORMAL PORTRAITURE: LIGHTING

• Ghoul Lighting

Usually for full-front poses, but will also work for three-quarter poses. Remove the reflector from the light stand and prop it up in a saucepan (or something) so that its heat won't scorch the floor or carpet. Then shove it up very close to your model—but not close enough to burn!

LOW FRONTLIGHTING

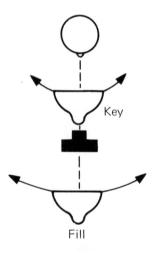

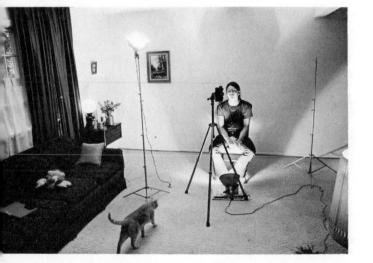

"Ghoul Lighting" is an exaggerated version of low front lighting. The key light is propped up in a saucepan on top of some newspapers—to keep the rug from getting scorched. Fill light is bounced from ceiling. This reduces light's intensity and eliminates sharp-edge shadows.

• Side Bounce Light

Best for full-front and three-quarter-front poses. A fill light is seldom used with this lighting, though it can be. There should be a wall or large reflecting surface at one side of the model, and the key light is pointed at it. Then the wall itself takes over the duty of being the key light. Variations in shadow patterns on the face are created by moving the light source back and forth along the wall. Lighting contrast is controlled by the model's distance from this side wall. Within one or two feet of it the contrast is very high, but it gets progressively less as your model moves away.

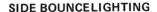

For side bounce lighting the subject is posed next to a wall and the key light is pointed at the wall. The wall itself then functions as the key light. Variations in the shadow patterns on the face are created by moving the light source back and forth along the wall.

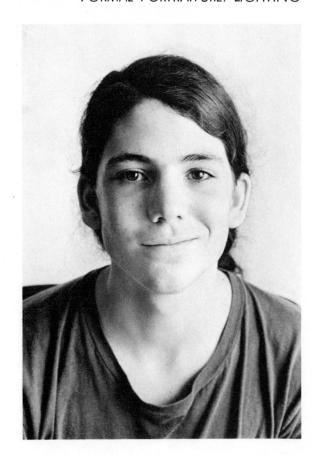

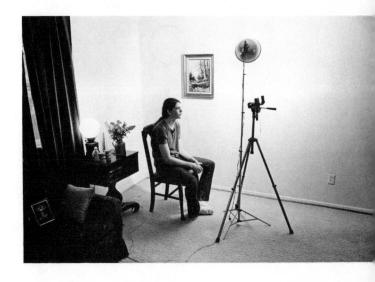

FORMAL PORTRAITURE: LIGHTING

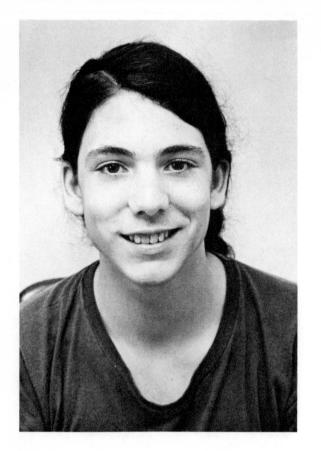

• Overhead Bounce Light

Good for almost any pose. It seldom requires a fill light, because the light reflected from the surrounding walls usually lightens the shadows as much as necessary. For a feeling of solidity and dimension, the key light is positioned within two or three feet of the model and rather high on its standard. It is pointed at the ceiling. For a flatter look it should be farther back, even behind the camera, and on the camera-to-model axis. For even greater flatness, bounce the light off the wall behind the camera.

Overhead bounce lighting produces the softest edge shadows. Note that the light source is close to the subject, positioned above his head, and pointed at the ceiling.

OVERHEAD BOUNCELIGHTING

• Consider the Fill Light

So far, I have said nothing about the fill light, because its main function is to control contrast and the relative brightness of shadow areas. It has nothing much to do with the basic design (in terms of light patterns) of the picture. Using it well is very important, however. The fill light is nearly always positioned close to the camera-to-model axis and can be used on either side of it. The amount of fill that it provides is controlled by moving it forward or back along this axis, to-ward or away from the model. However, pointing it at an angle away from the model (edging it) will lessen the amount of fill, and so will bouncing it from a wall or the ceiling.

Shooting Space

If you work in your home you may have a problem of finding shooting space, unless you are willing to move some furniture. If you can clear about three or four feet of wall space it should provide you a large enough background for headand-shoulder portraits. However, having even more space is much better.

• Model-Background Tonal Relationship

It is a good thing if you can clear lots of wall space for a background, because it permits you to move your model five feet or more from the wall. This gives you quite a bit of control over the tonal relationship between your model and the backgrounds and helps you prevent unwanted shadows from falling on the background.

With enough subject-to-background distance, the center of the light patterns from both the key and fill lights can be kept off the background and be made to fall on, or in front of, your model. This darkens the background in comparison with your model's face (you can even make a white background wall come out black in a picture).

Or you can get the reverse effect by using edge light on your subjects while pointing the centers of the light patterns at the background. You can even make people come out coal black in pictures, though one usually doesn't go quite this far.

The shadow of a model can be kept off the background by positioning both the key and fill lights high on their standards and angling them downward. Though there will still be shadows on the wall, they will be down out of sight behind your subject's body.

The Model Holds Still

I've said that direct lightings (not bounce) create fairly obvious shadow patterns on faces, and that good patterns can be utterly ruined if models move around. This means that you should ask a model to hold still after you have established a direct lighting, until you can focus and shoot your picture. Or you can tell him or her to relax, then move back into position when you are ready to shoot. When you are actually shooting, the model should be holding still, of course, and you might as well freeze your camera too—to get sharper pictures. Put it on a tripod and use a cable release for clicking the shutter.

Always remember that holding still can be very hard work, so don't ask your subjects to do it for long. Otherwise, they will stiffen up and start looking pained, which is very bad for good portraiture.

Cosmetic Lighting

Skilled portrait photographers are adept at using lighting for cosmetic purposes, that is, for improving the faces of their models by correcting supposed defects of all kinds. Since this is very interesting to try and would contribute much to your learning to see better, we will go into the matter briefly. If you develop some expertise in cosmetic lighting you will also please your models more, and that will prove rewarding for you, too.

For any given cosmetic problem there may be quite a few answers, but one or two will be enough to get you started.

Rough or pockmarked skin: The best bet is overhead bounce light, with the light stand positioned behind the camera. Low contrast side bounce is also good. Broad lighting may be good, if you tape diffusers (sheets of white paper, tracing paper, or matte acetate) over both the key and fill lights. These lightings, all very diffuse, will fill in the tiny shadows made by the skin's roughness, smoothing it out very considerably.

Long noses: Use fairly low camera angles and low front lightings with quite a bit of fill. Overhead bounce with the light stand positioned well behind the camera may also be good. These lightings tend to blend the sides to the nose into the face, so that it doesn't stand out very much.

Fat cheeks: Narrow lightings are often best—the narrower the better—with fairly high lighting contrast. The cheek nearest the camera is partly lost in darkness, the other one turned away out of sight. Side bounce lightings, also contrasty, may be good with three-quarter poses.

Very thin faces: They can be nicely fattened up with broad lightings—with quite a bit of fill if necessary. Still using a three-quarter pose, you might also try an overhead bounce lighting, with the light stand positioned well behind the camera.

Eyeglasses: The problem is that they reflect your lights. This can usually be corrected by positioning the lights very high on their standards and angling them sharply downward.

Double chins and neck wrinkles: Lose them in the shadows created by narrow and high front lightings that are quite contrasty (little fill light used). Use diffusers on your lights.

Very deep eye sockets: The problem is to get light into them so that the eyes will show up well. Try low front and broad lightings, also side bounce light.

Protruding ears: Use a three-quarter pose, which puts one ear out of sight. Deal with the other by putting it in the shadow created by a narrow or side bounce lighting.

Very lopsided faces: Use three-quarter poses, so that the two sides of a face can't be compared straight on, with whatever lightings look best.

Heavily wrinkled faces: Use overhead bounce, with the light well behind the camera and possibly bounced off the rear wall instead of the ceiling. Also try a very low contrast side bounce lighting. These lightings provide very diffuse illumination, which will fill in and soften wrinkles considerably.

Weak chins: If you get sufficient light on a weak chin it won't look so small, so use your light sources low on their standards, or try a side bounce lighting.

Shiny bald heads: A bit of face powder or pancake makeup may be the best bet, but you can also calm down a glittering dome with narrow, broad, and low front lightings, provided your light sources are positioned very low on their standards. Side bounce lighting may be even better. With direct lightings, a professional trick is to cast a light shadow on the top of the head with a head screen, which is exactly like a dodger used in printing, only larger. Make one with a round piece of cardboard and a stick.

Pimples: Use no direct lightings whatever, unless your light sources are heavily diffused. Because they are very diffuse to begin with, low contrast bounce lightings are a much better bet, anyway. Diffuse light takes the shine out of pimples and scatters enough light into them to make them considerably less dark.

Well, you now have an idea of what cosmetic lighting is all about. Since it will sharpen your visual perception and help you please your models, you will find it fascinating to work with. It offers more difficulties than you may think, however. For example, you will often photograph people who have more than one of the defects listed, perhaps three or four, and the ways of correcting them may be contradictory. In such cases you just have to move your lights around until something good happens. Fortunately, it usually does in time.

• What, No Poses?

This chapter is about formal portraiture, the kind mainly done by commercial photographers, so you may wonder why nothing has been said about formal poses. Well, most of them are heavily stereotyped and work well only for photographers who have had a lot of experience in using them. Furthermore, they fit into a highly specialized framework for commercial portraiture, which involves such things as special backgrounds, posing furniture, props, heavily stylized but expert lightings, extensive retouching, and soft-focus printing, all working together in a heavily formalized system. Without the whole system, formal poses may not work very well. Used by a beginner, they often look strained, unnatural, and even ludicrous. Even so, it wouldn't

hurt to experiment with them, for you will not always be a beginner.

You can learn what the formal poses look like easily enough. Simply visit a couple portrait studios and look in their display windows. There is no need to visit more, because nearly all commercial portraitists use the same poses (and lightings, backgrounds, printing papers, printing techniques, toners, retouching styles, frames, and so on), though some are better at it than others. For further study, look into the work of the world's great painters prior to 1900, because the poses all originated with them.

For the beginner, the posing instructions in the last chapter are quite sufficient for a while. The main idea is that people usually look their best when they are comfortable and that the photographer should help them be that way. Pose people, yes, but help them be comfortable. And you can also just let models be themselves, and work with whatever poses they naturally fall into. The commercial portraitist might shudder at the last idea, but his problems aren't the same as yours. His subjects expect and want formal, or stylized, poses; yours may not.

• What About Electronic Flash?

Because most commercial portraitists use electronic flash, many beginners assume it is necessary for good portrait lightings. Not so. It works very well, of course, or professionals wouldn't use it, but they were making excellent portraits long before electronic flash was even invented. How-

ever, for beginners it can actually be a bad thing.

Perhaps the very most important thing in photography is to learn to see light, that is, to see how it affects the things that it falls upon. You can learn best with simple tungsten lighting equipment—photoflood bulbs, round metal reflectors, and light stands. But it is very hard to learn with electronic equipment, because you can't actually see what the light is doing. Though some larger units have built-in modeling lights, they are usually so dim that you still can't see what they are doing—unless you are already an expert at seeing light.

For these reasons it is not wise to start out with only electronic equipment—you may never learn to see what light actually does. First, improve your visual perception by using tungsten light, which will make light patterns that you can easily see, *then* turn to electronic flash.

Using the Information

Probably the best way to use all the information in this chapter is to just wing it freely. Shoot lots of pictures so that you will have plenty of lightings to compare with one another, because this is a very good way to learn. You have been warned that some of your pictures may be bloody awful, but that is part of playing the game. Remember that some lightings just don't look good on some kinds of faces, but it is not a crime to make a bad combination. Your job is to discover the lightings that do work well on various faces and to learn to see light while you are doing it.

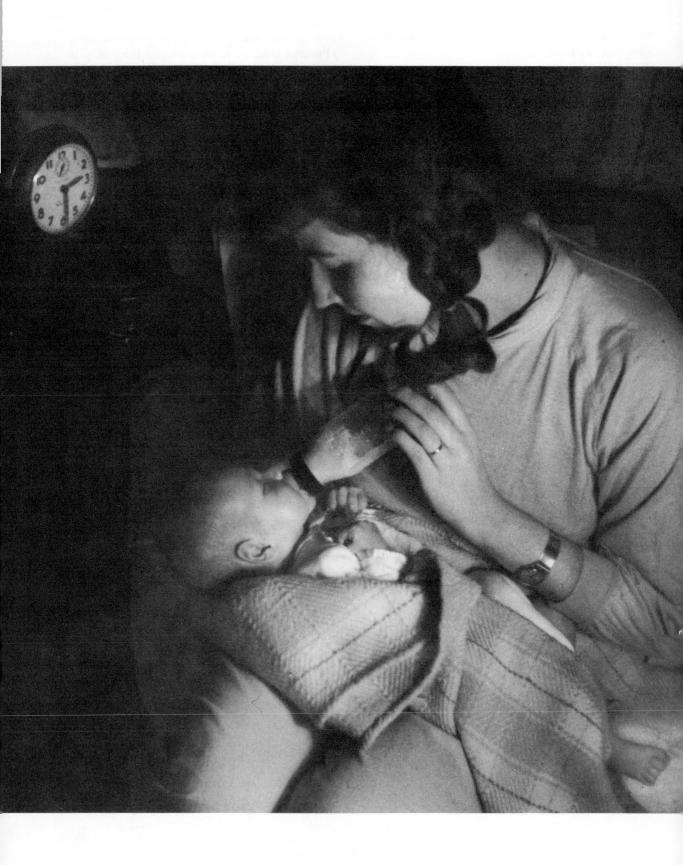

Photographing babies is not very difficult, because they are not usually going anywhere or doing much of anything while you are trying to get them in focus. They just lie there, sleeping, eating, gurgling, or trying to find their toes, and they don't mind you at all, unless you frighten them. And they are not at all critical of your attempts to get your camera to work. All the same, they can be very disagreeable, too, as any mother can tell you.

• The All-Important Schedule

The thing is to catch babies (and their mothers too) at the right times. Otherwise, making photographs may be the emotional equivalent of being run over by a Mack truck. The wrong time, of course, is when a baby has just turned his mother into the creature from the deep lagoon by trying to make his shrieks and howls heard all the way to Oshkosh, Wisconsin. So, when babies are hungry, tired, teething, croupy, or just generally ticked off it is best to be elsewhere.

My elder son Cleve and his mother Mitzi (my first wife). As you can see, the hour was late. The lighting was a single photoflood bulb in a reflector, pointed more in front of the pair than upon them. This was both for a lighting effect and to preserve Cleve's young eyes from glare. Shot with an ancient Ciroflex, hand-held. The young man is now nearly thirty.

Mother knows the best times for Baby—she gives thanks for them in her prayers—so just ask her about them and fit yourself into the happy-time schedule. It may be in the morning after Baby has just had a nap and bottle. Afternoons may be all right too, but many a mother is half-shot by that time. The point is that both Mother and Baby should be in top shape if you want your shooting session to be a happy one.

If you want to photograph your own child you don't have to ask about schedules, though husbands would be wise to consult with wives. You just fit yourself into happy times whenever they occur, make your shots, and retreat whenever the emotional weather begins to close in. Fathers aren't especially good at this, because they usually don't pay that much attention to babies, but mothers are real pros. Some incidental advice for Dad: give Mom a Polaroid camera, lots of film, and an instruction book—then stay the hell out of her way. And please refrain from criticizing her pictures.

• This Chapter Is for Men

It is actually quite unnecessary to tell women how to photograph babies, especially their own. Except for a few technical details, they already know. You see, they truly know what babies *look* like, which most men do not, because they look at them, listen to them, think about them, feel them, and live them much of the time. Above all,

women have a profound emotional contact with babies, which extends their perceptions of them very considerably, whereas men don't usually have good emotional contact with much of anything, least of all themselves. One result of this female emotional contact with things is a heightened visual perception well beyond male visual perception, so you can see why a male author refuses to tell women how to look at their children.

A particular woman may need to be checked out on a camera and shown a couple of basic lightings, but a particular man may need the same things. A camera store clerk can do the checkout, and there are enough basic lightings in this book for any young mother.

So, this chapter is for men and boys, because women and girls simply don't need it.

Every parent without exception should have a picture like this of the baby (in this case, Lissa Ann) in a bathinette. It is par for the course, you might say. Overhead bounce flash, shot with a Kodak Medalist. Note how the two are really digging each other, a wonderful thing to remember through photography.

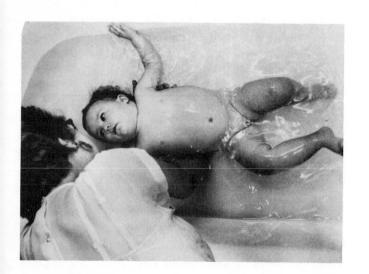

Please the Mother

I have a friend who took many pictures of his infant son that made him look like something from under a very slimy rock. Well and good, he got revenge on Junior for displacing him in his wife's affections, but can't we do a bit better than that? We should have pictorial objectives, no doubt, but they could be a little more noble.

Well, men, pleasing a baby's mother ought to be noble enough, and it is a real challenge, too. Many women think that most men are as blind as bats, and I most sincerely agree with them. So the objective is for a blind man to make pictures of a baby that will convince the mother that he has really seen the child. Takes a bit of doing, wouldn't you say? Enough of a challenge for any man or boy.

Watch the Mother

Another friend of mine makes beautiful pictures of babies and small children, but he is a very tricky rascal. When he is photographing a family or individual child he keeps one eye glued firmly on the mother all the while. What is he looking for? Little cues from her—happy expressions, gestures, and sounds—that tell him when to click the camera shutter. A commercial portraitist, he learned long ago that a mother would buy only the picture that had her imprimatur, her personal O.K. It is not a bad trick if you want to please a mother, and you could hardly do better than that.

On the other hand there are mothers so frantic that the best way to watch them is on their way out of the room, but you should only send a mother away after you have shown her that you can handle her baby as skillfully and gently as she. Otherwise, it would be foolish of her to leave and cruel of you to ask her to.

A wonderfully soft place on which to squirm—Mother's tummy. And seeing things upside down is a lot of fun too. Straight, direct flash. A good trick is to dodge the middle of a direct flash picture and burn in the edges quite a bit. This gives a more dimensional feeling than straight printing would. Direct flash pictures are often flat, but we have gotten around this problem very well here.

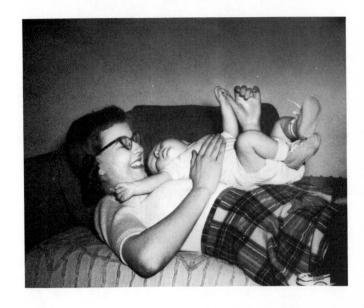

Early Show Points

Tiny babies do certain things that mothers find especially cute or charming: photograph them. Following are a tiny baby's special accomplishments, or show points:

- 1. lifts head while lying on tummy
- 2. smiles (because of gas pain or being tick-led)
 - 3. discovers toes and examines them minutely
 - 4. grasps a parental finger tightly
- 5. sits up more-or-less straight when propped up in an easy chair
 - 6. looks positively cherubic while sleeping
 - 7. handles nursing bottle with great authority
 - 8. yawns vigorously
 - 9. sucks on thumb
 - 10. rolls head around to look at things
- 11. waves feet around in air when diaper is changed
 - 12. makes little bubbles with mouth
 - 13. gets an amazed look on face
 - 14. learns to focus eyes
 - 15. shows interest in a toy

You may think that babies look interesting when they cry, but most mothers won't like that kind of picture. Neither do they care much for scowls, which babies can manage now and then.

• Later Show Points

As a baby gets older he or she grows more accomplished:

- 1. crawls around on the floor
- 2. pulls self to standing position in crib or play pen
- 3. cheered on by adults, takes first tentative steps
- 4. bounces vigorously up and down in little bouncy chair
- 5. makes tremendous mess of self in early attempts to use a spoon
 - 6. becomes wedded to a teething ring
- 7. adopts a security blanket and won't be without it
- 8. pounds toys on floor or high chair until they fall apart
 - 9. dumps food on floor
- 10. makes grotesque faces when offered certain foods
- 11. tries to look between legs to see if the back side is the same as the front
 - 12. sucks on big toe
 - 13. splashes joyfully in the bathinette
- 14. sits with authority on potty seat and resists all pleas to get down to business

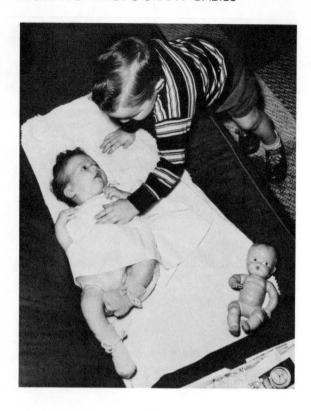

- 15. reacts to kitten or puppy with great suspicion
- 16. laughs at Mother when she nibbles on Baby's finger
- 17. laughs at Mother while poking her in the face
 - 18. sits in play pen, up to waist in toys
- 19. throws toys out of play pen, wants them back again
- 20. burps when held on Mother's shoulder after being fed

These may not seem like special show points to you, but you must remember that babies haven't had time to learn very much. Furthermore, such activities as these bring a sparkle to parental eyes, and this sparkle should tell you when to make your pictures. Photographing them will mainly get you the kinds of pictures that parents like to put in albums, but not necessarily on walls.

My younger son Craig making nice to his sister, Lissa Ann. He didn't start to tease and aggravate her until she was old enough to fight back. Straight flash (flash gun on camera, pointed directly at subjects). Though straight flash is considered pretty awful by photographers, you can see that it works very well indeed.

Wall Pictures

For pictures for display in their homes, parents generally like their babies to look their very best—sparkling clean, all dressed up, smiling or looking amazed at the world, making cute gestures, and being generally angelic. The little rascals may actually be far from angelic, but parents like to see them looking that way now and then, anyway. Furthermore, when a howling baby has nearly destroyed Mother before finally going to sleep, she likes to rest her eyes on a peaceful picture of him and remember that she really does love him after all.

Backgrounds

You can more or less forget about backgrounds for the types of pictures listed under "show points." Don't be choosy; just photograph the babies wherever they happen to be. This will help you fit into the household routine, so that you won't drive Mother up the wall.

However, for display-type pictures you do have to be choosy, because parents want them to have a certain feeling of formality. A plain (no pattern), unwrinkled, fairly dark woolen blanket stretched smoothly across the parental bed makes a fine background for reclining shots of tiny babies, and does well for older ones, too. Use the same blanket draped neatly over an easy chair if Mother wants Baby sitting up.

Mothers and fathers make good posing furni-

ture too—just have them hold their babies and stand in front of uncluttered walls. Professional baby photographers often carry portable backgrounds with them in the form of collapsible screens. A projection screen for viewing color slides will work about as well, if you have one.

An older baby can be posed on a sturdy blanket-draped table, provided Mother stands nearby in case of a tumble. If the baby hasn't beaten them up too much, high chairs and kiddy chairs of almost any kind are just fine. You can shove a table up to a blank wall space and put a small chair on top of it.

If you are really interested in making displaytype pictures of babies you should certainly study pictures made by professional baby photographers, for they have all the answers down cold. They generally use plain backgrounds or ones painted with a certain special texture that many of them like (it helps make photographs look more like paintings). And they use the simplest posing furniture—little chairs, draped boxes and tables, little gadgets for propping babies up, and the like.

Pictorial show point for a Teeny Weenie—fed with a spoon for the first time, manages very well. A must in every mother's picture book. Overhead bounce flash; though the depth of field isn't too great, it doesn't really matter if things get a little fuzzy around the edges, does it?

Three especially good backgrounds for baby photography are beds, overstuffed chairs, and sofas such as this one. They offer simplicity for visuals and good support and protection for babies. In short, they are easy to work with. In this picture: direct flash—center dodged, edges burned in—center also brightened up by bleaching, which makes the highlights even lighter. Farmer's Reducer on highlights is a good standard tool for work on direct flash pictures.

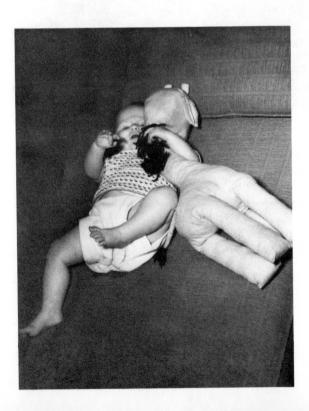

Posing Babies

Don't even try—just take them however they come. Except for laying them down or propping them up there is not much else you can do. When they get old enough to take poses and navigate for themselves they are no longer babies but small children, and we will get to them in the following chapter.

Light Sources

Nearly any light source will work well for making baby pictures—flash, electronic flash, floodlight, and natural light. Tiny babies don't move around very much, so you have little need for intense light and fast shutter speeds. This also makes it easy to work with a tripod. Since older babies can get pretty quick on the draw, you may need electronic flash for good action shots.

Because the eyes of tiny babies haven't as yet learned to adapt to bright lights you should never point floodlights right at them, though bounced floods are okay. It is quite all right to use ordinary and electronic flash. Though they produce very intense light the flashes are of extremely brief duration.

Cleve wasn't exactly a tiny baby, was he?—and he used that big head as a battering ram, jarring loose more than one parental tooth. Direct flash is said to "wash out" (flatten) flesh tones, but if you print your flash pictures carefully this doesn't have to happen. As you can see, Cleve looks as round and solid as can be, which means his skin isn't washed out.

Lightings

Provided that you use ordinary or electronic flash, you can use all the direct lightings described in the last chapter. For best results you need two units—for a key light and a fill light. Direct lightings will permit you to use small apertures, even with color film, and thus get a lot of

depth of field. Unless you really know your lighting, however, they are probably more bother than they are worth. You see, if you don't really know what a light will do you may position it badly and get really godawful results.

Because babies are so soft and delicate it is usually a good thing to go for lightings which communicate these qualities, which brings us to bounce lightings. All of them soft and extremely diffuse, they help us make babies look as we think they should. Use bounce flash or bounce floodlight.

Flash-on-camera works well enough on babies, as many a parent can testify, but it really doesn't flatter them very much. It flattens out their heads and faces and casts harsh black shadows behind them. Even so, many a parent is completely satisfied with this lighting, which indicates that

A bright Sunday morning coming into a pale yellow bedroom gave us this soft and delicate lighting, making flash or floodlight quite unnecessary. Any sane parent can tell you that holding a squirming baby on top of you, wet diaper or not, is one of the world's greatest aesthetic experiences. Lissa Ann and Mitzi, mother of three.

there is nothing greatly wrong with flash-oncamera. But it is not good when a baby's skin is blotchy. A baby's very tender skin does sometimes become patchy, blotchy, or reddened in spots. Unfortunately, direct flash tends to bring this out. What is needed is a very diffuse lighting to blend the blotches together and lighten them as much as possible, so overhead bounce is a good bet.

Another good thing about overhead bounce lighting is that you can put your light stand in one place and leave it there while you make pictures all around the room. And, as you read earlier, there is an eight-foot circle around the stand in which you can work without having to change your aperture and shutter speed settings. This makes it much easier for you and cuts down on the fuss and bother that might disturb the family routine.

Natural, or available, light is also fine—babies' rooms are usually bright and cheery. And if the light happens to be dim you can use a tripod. This is no inconvenience with tiny babies, because they don't move very much. Older babies don't either, though they bounce around and gesticulate more. Since slow shutter speeds are usually used with a tripod, this means that you have to wait for moments of inaction and have to give up many of the good action shots. This is too bad, of course, but you will soon learn in photography that you can't have everything.

Direct flash: note the dark shadow behind Cleve that characterizes flash-on-camera pictures. Such a shadow can be ugly, but it isn't here. Obviously the baby bed isn't going to hold this young mastodon much longer, but for a while it will hold him in one place long enough for pictures. The highlights were both dodged and bleached, one technique implementing the other.

Posing Play

Photographers often play with babies—or have their mothers do it—in order to get pleasing expressions and gestures. With their lively curiosities, babies respond well to unfamiliar toys and quirky sounds, and everyone knows that they like to be tickled under their chins. If you are a stranger in the house, however, you should approach the idea of play with care. Otherwise, your little model may respond to your advances with outright terror, and after that it is all screams and tears.

It would be a lot easier to photograph babies just as they come, but parents place a high premium on those happy smiles and gestures. So someone may have to play with Baby—let Mother do it if you don't know how.

• The Distortion Problem

In adult terms, babies are all out of proportion, because they have very large heads and small bodies. With the wrong camera angle and/or a wide angle lens this "disproportion" can be greatly increased, until we have enormous heads and hardly any bodies at all. You might find this interesting because of its oddness, but don't expect mothers to care for it at all. They prefer shots made from very ordinary angles with normal lenses or ones that are slightly telephoto.

Good Baby Pictures

If you are going to make baby pictures you will probably need some criteria with which to measure yourself. Otherwise, you won't know whether to be pleased or discouraged with the results—people interested in photography get this way. From among the following critical concepts, choose the ones that suit you best:

Cleve did his idiot act at least once a day, usually smearing everything within ten feet of himself with food, of which he was inordinately fond. Since he grew up to be 6'5'' he must have needed a lot.

- 1. Any picture of your own baby is a good one.
 - 2. If it pleases the parents a picture is good.
- 3. Baby pictures that look like paintings are good.
 - 4. If the picture looks like the baby it is good.
- 5. If it looks like a professional picture it is good.
 - 6. It is also good if it looks like a snapshot.
 - 7. If a picture is in sharp focus it is good.
- 8. It may also be good if it is not in sharp focus.
- 9. A picture is good if it shows what babies are like.
 - 10. If it makes the baby look pretty it is good.
- 11. If it makes the baby look bright and alert it is good.
 - 12. If a baby picture has a baby in it it is good.

From this rather abbreviated list you might get the impression that it is hard to make a bad baby picture, for anything you shoot will fit at least one of the criteria. True enough. So why not just bang away and enjoy yourself, perhaps trying to make pictures that will please Mother?

The pictures on the following two pages are of Amanda Goodwin and were made by her Uncle Mike Goodwin, who obviously thinks highly of this tender sprite. He has shot literally thousands of them, but these few are a tasty sample. Mike is a photographer, painter, and graphic designer. He is also Curator of Photography at the Chrysler Museum in Norfolk, Virginia, one of the major museums of the South. His pictures show you a fruitful attitude and an approach for photography of babies. Mike himself shows up later as a ghost in Chapter Eleven.

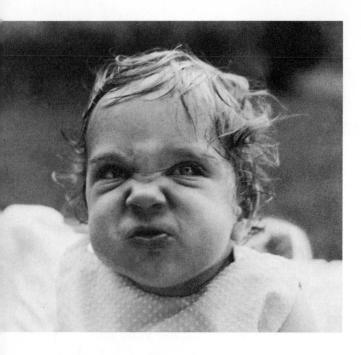

Somebody put frogs in my pants.

Teething is a solemn and serious business.

To what Voice does she listen, and what stars does she see?

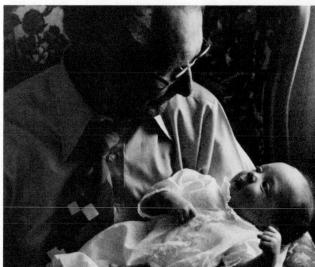

Grandpa and Amanda: reciprocal astonishment.

They say tiny babies don't laugh and chortle—who sez?

Sunday-go-to-meeting hat and guardian clown friend, Tooky.

A love child, shining in the sun.

PHOTOGRAPHING CHILDREN

Having an accepting, unprejudiced, and noncritical attitude toward children is perhaps the major requirement for photographing them well (the technical side is easy). With this outlook you will find nearly everything they do interesting and worthy of your attention, which is as it should be.

Feeling this way about small children is easy enough, because they have little egotism, which is the hardest thing to put up with in people. And it is not impossibly difficult to see their occasional orneriness as cute, especially when it looks good in the camera viewfinder. Not least, they fit into our preconceptions of children by doing pretty much what we think they will, which makes us feel quite omniscient.

Older children are another matter. Though they may seem shy they are all Cossacks at heart, with abundant and as yet untamed egotism, long experience in family infighting, and a profound suspicion of adults, especially their parents. Naturally, getting around such a maverick may take quite a bit of doing, for you may be one of the enemy.

Cherubs Craig (left) and Cleve (right) and their new Christmas hoot-and-holler outfits. Direct flash. You want to know what a snapshot is? *This* is a snapshot. You just raise the camera, close your eyes, and shoot—and get real pictures of your kids instead of projections of your own ego. The noble snapshot: the most believable (and rightly so) kind of photograph that there is.

As part of your tactics you should take great care when you look at older children. Please understand this: they are highly sensitive to visual criticism and know very well when they are being looked at, measured, and found wanting—which in many families is a good part of the time. Naturally, you should use your camera with care also—don't let it become a weapon.

To get close to older children (young ones aren't a problem), you must overcome their suspicion of adults by showing that you accept them for what they actually are, not for what you think they ought to be. When you look at them, directly or through the camera viewfinder, they need to feel that you do it with approval. Whatever you do, don't lie to children about things. If you don't like a kid, say so—he won't mind. But adult lying is very hard for children to take, and they can spot adult phonies from a hundred yards.

• The Snapshot, the Noncriticizing Picture

You may recall that snapshooters never really look at or think about their subjects. Thus when parents make snapshots it provides a very real refuge for beleaguered children. A child feels safe from the critical parent eye, because said eye is being used mainly in a desperate effort to figure out which end of the camera is up. He knows very well that he is not being visually dissected,

PHOTOGRAPHING CHILDREN

analyzed, and judged unworthy; he knows he is being left entirely alone.

For the subject, the snapshot is the safest possible kind of photograph to be involved in. Thus the majority of family pictures—ninety per cent or more—ought to be snapshots. Just raise your camera, close your eyes, and click. Left alone emotionally, your subjects will come on as they really are—and what more could you ask for than that?

The Age of Innocence comes crashing to a close when a snapshooter gets really interested in photography and starts to think that he should stare at everything until it reveals all its secrets. Not so. The art of not looking is even more important, even for a photographer.

He played his new phonograph all day long, day after day, and even took his naps with it. More than once the family was awakened long after midnight by Burl lves sweetly singing "The Little Engine That Could." The lovely lighting on Craig comes from a large skylit window which is just behind the sofa. The darks around him make the light really seem to shine. Hence we have the classic formula in the visual arts: darks make lights, and lights make darks. A thing is either light or dark by comparison with something else. Makes sense?

When grandparents come to visit there is a certain amount of delicate teasing or joshing that goes on with the young sprouts. As we see, Craig takes to it with shy delight. This is another snapshot, though it doesn't look so much like one. I made no effort at all to shoot a meaningful, artistic picture that is definitive of American family life and all such assorted balderdash. I just snapped several pictures, and this is one of them. What it says, if anything, is that there is a lot of love in some families. Bounce flash.

• The Noncritical Eye: A Credo

Though snapshooting is an excellent way for making pictures that do not criticize, it involves a partial mental blackout, which is not always convenient or even possible. Fortunately, there is a way of doing the same thing—developing a noncritical eye—without having to black oneself out. It involves adopting a working credo and conscientiously sticking to it. If you do this long enough you actually may learn to believe it. With respect to making pictures of children, the following credo ought to work pretty well:

- 1. I will shoot the pictures they want as well as those I want.
- 2. I will not look at them analytically unless they are obviously willing for me to do it.
- 3. If my behavior as a photographer threatens to intrude on a child's personal domain I will settle for making snapshots or make no pictures at all.
- 4. I will try to see and photograph children as they are, not as I think they ought to be.

PHOTOGRAPHING CHILDREN

- 5. I will not make pictures that undermine children's sense of dignity—as defined in their terms, not mine.
- 6. I will try to respect the ways in which children offer themselves to my camera, even though I might prefer other behavior.

Well, that is the general idea—ordinary everyday ethical behavior consciously extended to chil-

Still don't know what a genuine snapshot is? Well, try this one on for size. The critical test: are these ego projections of a father or are they projecting themselves in their own right? Raise your camera, close your eyes, and shoot: that's how to get real children on film. Lissa Ann, Cleve Marshall, and Craig Robert. Real bums. A hard crew. Overhead bounce flash.

dren. Are they worth it? You know, Jesus described children as our spiritual superiors. Thus if they aren't worth good treatment, who is?

Poses

The advice on poses in Chapter One is especially good for children of all ages. The gist of it is to wait until they fall into poses you like, then walk up and shoot your pictures. If they think they should pose stiffly (as many do), shoot those poses too, then simply wait for something more relaxed. If it is obvious that they think their relaxed poses are undignified (a commonplace notion), shoot them as they wish, stiff and staring, and hope that they will eventually change their minds. You have to grant children certain rights, you know. One is to have the world see them as they wish to be seen.

I had a special deal with Lissy's Mom: I could let ol' Lissy Pooh make as much of a mess in the bathroom as she liked while I took pictures—provided I supervised getting the mucho spilled gallons cleaned up. This usually meant that I did it, which was much easier on me than having to yell at Young Miss Nightingale here. It also meant that Lissa had a whee of a time whenever her ex-sailor father was around with his trusty mop so that she could really let herself go. The ancient law: if you want kid pictures you have got to let kids be kids.

A year later, Jon again with his feline pal, Arthur, named after Arthur Freed, who didn't appreciate the compliment. We also had a cat named Bumsy, whom I rescued from a wino bar down on the Bowery. When a cat is held this way he ain't going to stay there very long, so you've got to work fast to get your shot. Window light from one side, a little reflected light on the other side of the face from a nearby wall.

My stepson Jonathan while he was still the neighborhood angel and some years before he became the Con Man of the Western world. He has a chocolate thing in his hand, which he is nibbling at in a conservative and fastidious way. A smart, sweet kid, I'll tell you. Bounce floodlight from both sides, with the light from the right being stronger. If you want a kid to get an expression like this on his face, just let your love pour out. Let it pour out.

PHOTOGRAPHING CHILDREN

For two years Craig did this every time he thought I was going to take his picture. An editor at Life magazine told me that kids don't do this. Oh yeaaaaaah? Well, what the hell, you take what you can get in family photography.

If kids want to set up your pictures for you, let them. If you want images of kids looking and acting like kids, that's what you will get. Now, the Easter basket hats and bows are obviously supposed to be hilariously funny; so is giving the strong arm to a loudly complaining little sister. She got even later, you may be sure. Overhead bounce flash.

Mug Shots

Some children automatically make horrible faces whenever they see a camera and may keep it up even into adulthood. That is a very severe situation, and if you can't talk them out of it you can't talk them out of it. So shoot their horrendous mugs and be thankful you could get anything at all. From the age of eight my younger son did nothing but mug shots for two years, laughing at me all the while. So?

• Tying Children Down

Once children learn to run the only ways to keep them in place while you focus your camera are to feed them ice cream or tie them hand and foot. Well, it's not that bad, but almost. Of course, you can always command children to stay put, yet there are better ways of getting them planted.

The best way to tie children down is to give them interesting things to do. Now, they say that the interest span of children is very short, which means that some activities won't keep them planted very long—you have to work fast. On the other hand, they can stay endlessly involved with things that interest them more, for example, television and the bathtub.

TV is the all-time kid demobilizer, of course, but you may be tired of seeing children sprawled in front of it. Though they fall into myriads of interesting poses worthy of circus performers, you eventually get them all on film. The bathtub is a little more interesting (until kids learn to be shy), because children create all of the action instead of just watching it—with the help of numerous floating toys, to be sure. Overhead bounce light (flash or flood) is just great for this scene, but you should tape the wires to the ceiling to keep them far from either children or water.

There are other things that will keep kids corralled for a while, and you should be on the lookout for them—creating juvenile art, baking a cake with Mother's help, building a real or imaginary playhouse, weaving potholders, tearing up magazines, looking at a new puppy, and so on. Until children are ready to move into their teens there is always at least *something* that will help to keep them in focus. After that they either sit around most of the time (usually locked up in their rooms) or take themselves elsewhere.

• The Focus Problem

When a child is sitting down or standing for you your problems are easy—you simply focus and shoot—but children on the go are something else, because they are always moving out of focus. The problem is especially aggravating indoors, because focusing in relatively dim light is difficult, anyway.

The consequence is that you will miss many of your best shots, things that kids do before you can focus again. Well, don't ask kids to repeat their actions—that never seems to work well—but be philosophical about it and wait for something else to happen. If you can get even one tenth of what you see you will be very lucky indeed, so count your blessings.

Zone Focusing

Outdoors, zone focusing provides a partial answer to the focus problem, and you should surely try to master its principles. It involves taking advantage of depth of field, or the zone of image sharpness that extends both behind and in front of something that you have focused on. You might call it depth of sharpness, if you like. Stopping down increases the depth of this zone, which reaches its maximum when the lens aperture is closed all the way. In order to stop down this far, however, you must either have a lot of light or use a very slow shutter speed, or your film will be underexposed.

Fortunately, outdoor light under a hazy sun or full sunlight is so very bright that you can stop down all the way and use a high shutter speed—if you use a fast film like Tri-X and Kodacolor 400. Even with slower films such as Plus-X, Veri-

chrome Pan, and Ektachrome 200 you will be in good shape. The high shutter speed will help you freeze the action when Sally screams past on her skate board. The small aperture will help to keep her in sharp focus.

To use the focusing zone method you mentally stake out the area in which you think the most action is going to take place, then use your cam-

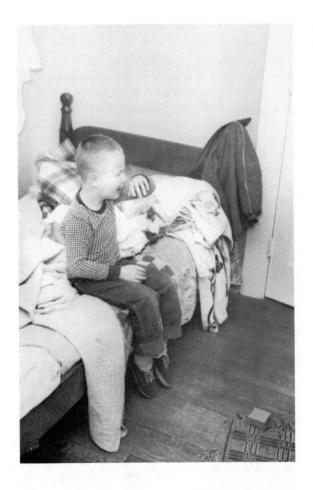

A good way to make yourself acutely unpopular with a kid: photograph him when he is bawling. The fact that the punishment—temporary banishment—is fully justified is entirely beside the point. So shoot your picture swiftly and without comment, then quickly leave his presence and leave him to his angry grief. But do this very seldom, or he will start distrusting you all the time. Overhead bounce flash.

A bit uncomfortable, no doubt, but a better compromise than having to undress and get into bed, for then the day is surely done. I had to work fast here, for her mother soon bundled her off to bed, tearful complaints notwithstanding. Though the bounce flash made it look like daytime, it was actually well after dark. I knew this would happen but naturally took the picture anyway. When you feel the tug on your heartstrings, shoot—then worry about minor matters later.

You just have to photograph them while they are sleeping, they look like such little angels. But don't straighten out the bedclothes. Just let them be the poignant tangle they usually are. They were printed a little dark here so that they wouldn't look visually busy. Dig those hands, Friend, dig those hands. Bounce flash.

PHOTOGRAPHING CHILDREN

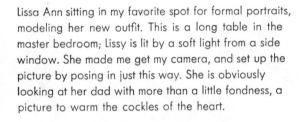

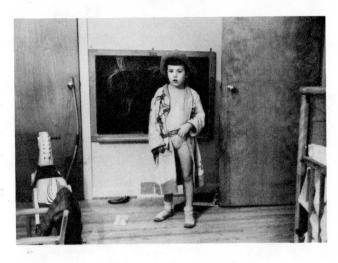

Lissa Pooh Hattersley, the fastest gun in the West. She wanted a picture of herself posed with her latest art (behind her), which I take to be a bearded tomato and a squashed felt hat. She cleaned up her room especially for the occasion. Side bounce light.

era to actually measure the distances to the near and far borders of the area. Do this by focusing on each in turn and noting the distance in feet on the lens barrel across from the focusing mark.

Also on the lens barrel is a depth of field indicator that tells you how much depth of sharpness (in terms of the near and far distances) you will get at each f-stop (for example, f/11 or f/16) at a given focusing distance. The depth of field increases with distance.

Then instead of focusing on something you simply twist the focusing ring until the near and far distances that you have measured for your area of maximum action fall within the near and far distances marked on the lens barrel across from the particular f-stop you have decided to use.

After you have done this you no longer have to focus on anything happening within the preselected area, because it will all be acceptably

sharp due to falling within the depth of field. Not having to focus at all will permit you to pay more attention to what is happening in the arena of action and help you be ready to shoot at the very instant your Cossacks streak by.

Since most of your good shots are lost while you are focusing, the zone focusing system can be a saving grace. But you may be addicted to focusing, a great way to lose pictures, and may be constantly focusing, even when you don't have to. If this is the case, tape down the focusing ring so that it won't move and frequently remind yourself that you are using the zone focusing system.

This arena of action that you have visually staked out and actually measure is portable—you don't have to stay in one place. As you move around, all you have to do is to mentally project it out in front of you, knowing that things included within its near and far limits will come out sharp in your pictures.

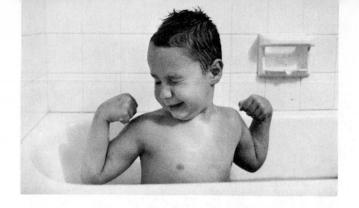

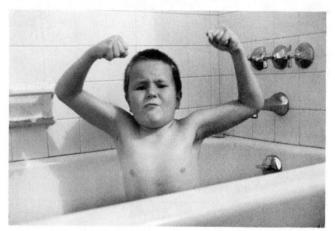

One problem with children is to keep them tied down long enough for you to get your camera in focus. Now, a bathtub serves the tie-down function very well, for it will keep them in one place for hours, will handle from one to six, and has endless possibilities for diversion. It is hard to talk children into a tub, of course, but ten times harder to talk them out of it. Bounce floodlight; the wires were taped up overhead, well out of the way of water and children. Shot with a hand-held Retina II.

• Outdoor Lighting: Great for Kids

You have seen that outdoor light will permit you to use zone focusing, with hazy sun and direct sunlight being best for this, because they allow one to use fast shutter speeds and small f-stops. There is another great advantage, too: under a hazy sun or a cloudless sky you can usually take a single exposure reading and use it for an hour or more without having to take others. This helps simplify matters considerably, especially when you are chasing downhill after wild Indians.

If the sun is moving in and out of clouds the exposure situation deteriorates rapidly, because the correct exposure can vary by two or more f-stops in a matter of seconds. So you take a fresh reading, and by the time you are ready to shoot the clouds have moved again.

Instead of going crazy taking readings, the best bet is to estimate the light intensities. Set your camera for bright or hazy sun (distinct but fuzzy shadows), then reset the aperture according to your estimates. For example, if the sun moves behind a fairly small cloud and is still quite bright but doesn't cast shadows, open up two stops. If the cloud is large and the sun really blocked out, open up three stops.

Following children in and out of sunlight and shade is another severe hazard for photographers. The intensity of sunlight doesn't change, but shade varies all over the place. Only near the edge of a patch of shade, with lots of sky in view, can you depend on an estimate. This is called "open shade," and you open up three stops. Elsewhere in the shade you may have to open up quite a bit more (or use slower shutter speeds), depending on how deep it is. And in this case guesswork won't help much, unless you are already an expert at it.

Many times, the best solution to the shade problem is to work out an exposure plot before starting to shoot. Walk around taking readings in various patches of shade, recording the correct exposures on a little card. Then when you start

shooting you can refer quickly to the card as your subjects move from place to place. This advice is mostly for people who use separate meters, because with many of the built-ins you can work fast enough to make it unnecessary.

• The Bounce Light Stakeout

Shooting action indoors isn't nearly as easy as outdoors, but having an electronic flash unit, especially one with a rather high output, will help things considerably. With a miniature unit the best bet is direct flash, but you must remember to use different f-stops for different subject-to-camera distances (to get correct exposures). With one of the larger units that embodies a sensor and a thyristor circuit you don't have this problem, of course. You can just let the unit itself take care of the exposure problem while you concentrate on keeping your subjects in focus.

With a larger unit, which includes many of the thyristor jobs, the easiest thing may be a lighting stakeout, so to speak. Plant a light stand in the middle of the room, tie it fast to a heavy piece of furniture so the Cossacks won't knock it over, and fasten your unit to the top of it, pointed at the ceiling (overhead bounce lighting).

Then you can just loaf around all day, if you like, shooting anything of interest that happens within the area covered by the sensor unit. You need an electrical connection between your camera and the unit, naturally, but a ten-foot cord will take care of that very nicely. You can use regular flash in the same way, though you have to put in a new bulb after each shot.

Though you can't freeze action with it, a stakeout with a photoflood bulb also works very nicely (if you use it without a reflector you will get quite a bit more light). Fortunately, kids aren't on the move all the time—they sit, stand still, or lie down just like anyone else. Or if you like blurred movement pictures, as some people do, you can get them easily enough with the shutter speeds permitted by overhead bounce with a photoflood.

PHOTOGRAPHING CHILDREN

The lamp will make the room very bright, but children don't mind this at all until they become teenagers, and even then they may not care. Unlike some adults, most children are fully heliotropic. The pictures of children on the following pages are selections from several hundred that I shot during a summer vacation from teaching. I decided to use photography as a means for getting closer to my children and coming to know them better. For both purposes it worked very well indeed.

If You Don't Know What to Do with Children

If you are photographing children and stalled for ideas, let them in on your problem, because after the age of four or five they have all kinds of ideas concerning what photography is good for. They will come up with ideas such as these: acting out the comic books, doing the King Kong bit, poor little Frankenstein, Mother nags Father, Starsky murders Hutch, disciplining bad dolls, nursing good ones back to health, wearing Mother's clothes, training the dog, teachers and students, and so on.

If you ask kids to come up with ideas you are more or less obligated to photograph everything they come up with short of mayhem. It is just the decent thing to do. Since they run through ideas rapidly (a one-minute act is very long for a child), you won't have time to get bored with anything they do. They'll get bored first, unless, perhaps, you can keep them well fed on pictures from a Polaroid camera or its Kodak equivalent.

Feeding people, young and old, on Polaroids has gotten to be a time-honored professional trick, incidentally. Many pros shoot them for their subjects, later doing their own work with Nikons, Canons, or Leicas. These prints help people see what you are up to and make them more willing to be involved in it. And for an amateur photographer (sometimes even a pro) there is no reason why a Polaroid print can't be the end product.

Well, so much for photographing children. As you can see, the subject has hardly been touched on, yet you may have read enough to get you started.

Deadeye Cleve, the rottenest gun in town.

Serving up a home run.

Injured party and not-quite-so-innocent bystander.

Checking out the wild blackberry harvest.

A most serious business: marriage.

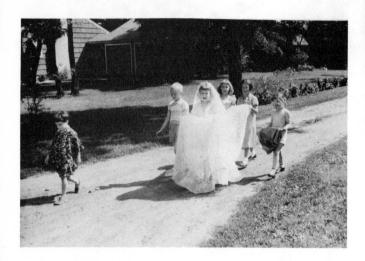

Root beer for the parched and desperate.

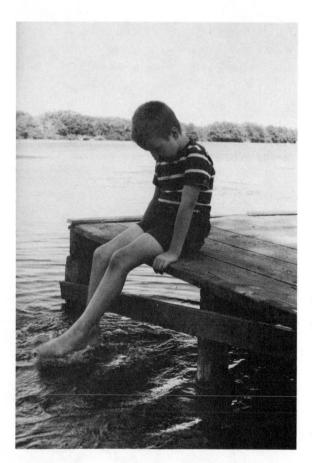

Sick in bed, recovery phase two.

I'm tying a string around your eyes so they won't fall out.

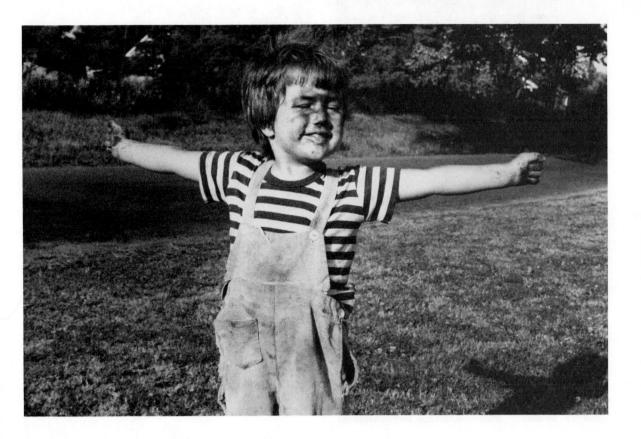

Mud, mud, glorious mud— Keeps off mosquitoes And good for the blood.

Nude babe watching boob tube.

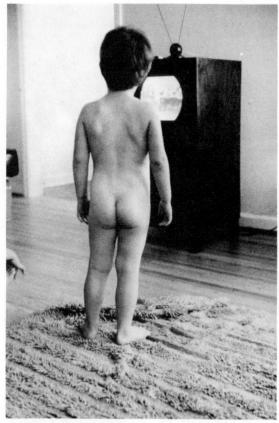

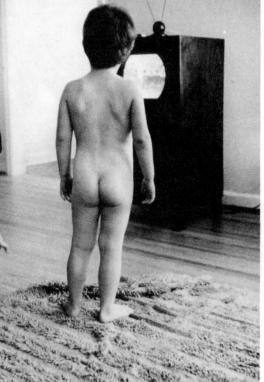

Preparing tents for a circus.

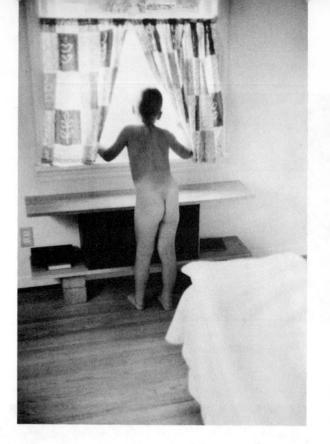

Hello, Morning Sunshine.

If I sat in the mud my mother would spank me.

Abandoned outhouse still works.

Backstage at the rodeo.

Fallen asleep while watching TV.

Efficiency expert.

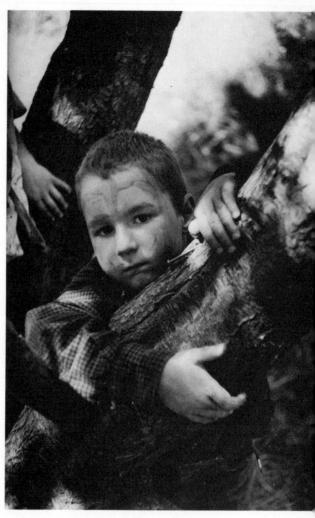

Craig Robert—also known as Keggy Bobbert.

HOW TO PHOTOGRAPH A PARTY

Photographing children's parties is dead easy—you just click away and nobody gives a hoot—except the little child who is crying. At an adult party you should carefully size things up first. If people are feeling friendly and in no pain your camera will be welcome. If the hostess is climbing the wall and the guests look strained beyond endurance, better forget about it.

Parties for adolescents are strictly off-limits for adults, except for those busily at work in the kitchen. You may be able to bang out a few quick snapshots at the beginning of a teenage fray, but then it is time to beat a hasty retreat, for sticking around just isn't cool.

Also off-limits are parties for women who have reached that age and don't wish to be reminded of it by your pictures. Family parties are usually snapshot heaven, so be sure to buy plenty of film.

Children's Parties

Outdoors: remember zone focusing, how to estimate exposures when clouds are crossing the sun, and how to solve the shade problem by making an exposure plot, which should only take ten minutes. Then just snap away at whatever is going on, using up lots of film. Don't try to make great photographic art, for that can turn you into an overselective and grumpy critic. Just get all the kids on film, then go help with the ice cream.

Indoors: with just a few kids, all quite young, the overhead bounce light stakeout is a good idea. With more kids, or older ones, it is a hazard. One of them will manage to knock over the light stand and clobber Deborah Jones with it. So use flash on the camera. If you have a type of unit that can be bounced while it is attached to the camera, all the better. And if you have an automatic thyristor unit you are really in clover.

It is dead easy to photograph children's parties outdoors, because you can use a fast shutter speed, stop the lens way down, and use zone focusing. Just help deliver cake and ice cream, stay out of the way, and bang away like mad with your camera. With Tri-X film, the exposure here was about 1/250 at f/11.

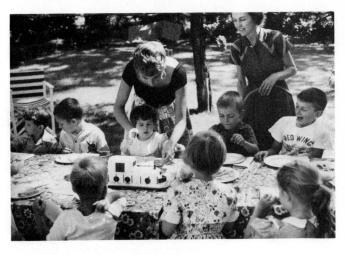

Adolescents' Parties

I repeat: off-limits for adults. Let the teenage photographer in the family photograph them. If you haven't got one, Mother may get away with making a few fast snapshots, then leaving. But Father may be a bit too much to take. "Say, Man, your father just isn't with it." A kid doesn't want to hear that at his own party. Yet there are fathers who know how to get along with adolescents.

Adult Parties: the General Situation

Most parties are tailored by women, who give a lot of thought to who goes with whom, the appropriate food and drink, and such matters. One of their favorite ploys is to have the lights turned down nice and warm and low, which doesn't make a party pig heaven for a natural light pho-

Bounce flash has falsified the lighting of this party, for the room was very softly lit in low key. However, it shows what everyone looked like and that they were having a good time together. Furthermore, the available light was just too dim for making pictures. Thus a compromise (direct or bounce flash) was necessary.

tographer, but does help the guests relax after a harrowing day in home or office. So here we come to an ironbound rule: don't fool around with the lighting set up by the hostess. Don't you dare touch even one light switch.

If you can't hand-hold a camera steady for long exposures, your only out is flash, direct or bounce—but don't overdo that, either. Your hostess is having a party, not putting on a circus. And be sure to ask her if it is all right to make a few snaps before you bring out your camera.

Even when it brings old friends together, a party is always a tricky business and often in danger of failure—because so many adults have forgotten how to have fun. So respect this unhappy fact and use your camera with discretion.

And remember the virtues of the snapshot, the photograph that doesn't criticize. Raise your camera, close your eyes, and click. People don't go to parties to be visually dissected; they just want to enjoy themselves—if they can.

When you are shooting a party, don't neglect to catch the people who are working backstage to keep it going well. Straight flash. The harsh shadows usually associated with straight flash have mostly dropped out of sight behind the figures.

Bashes

When the fruit of the vine flows freely and the cupids on the wallpaper start to blush, the situation for photography loosens up a bit. Even so, stick to flash or natural light pictures and continue to leave the light switches alone. Plenty of people will be making faces or doing hijinks for your camera, so you won't lack for interesting photographs. However, there is a certain etiquette that you ought to follow, or you may get punched in the nose. The point is that people are never as far gone as they seem to be, so they know very well when you are up to something.

Refrain from trying to make people look as sozzled as they actually are; don't try to sneak shots when people aren't looking; leave people who are engaged in forbidden flirtations alone; and don't photograph the guy trying to stick a whirling douche in his ear. This is paparazzi stuff,

The life of many a party, Dick still managed to look as if he were on the way to his own funeral, with no one else bothering to come. Overhead bounce flash. Electronic flash freezes action nicely.

and you just don't have to indulge in it. You should never try to make people look silly or stupid, even when they are behaving that way. However, if they want pictures of themselves playing the fool, that's O.K.

Passing the Polaroids

A fine approach to party photography, one that many people naturally take, is to make a Polaroid snapshot of everyone present, passing all the pictures around as soon as they are made. This is not interpretive photography, to be sure, but as the years go by you will greatly enjoy having a visual head count of all your friends. Truthfully, snapshots look better and better with the passage of time, while interpretive photographs often begin to look empty and sterile.

Passing the Polaroids has gotten to be an American party pastime that everyone enjoys, so it is not likely that you will upset the flow of a

As you can see, my English friends got into a laughing jag, though the laughter looked suspiciously close to despair. It often does, doesn't it? I photographed by the available light, which was very dim, using an exposure of 1/8 second at f/4.

HOW TO PHOTOGRAPH A PARTY

party by making them. If you lacquer them before passing them around, you can always wipe off the drink stains later. Of course, the XL-70 color print doesn't need the lacquer.

Incidentally, the Polaroid company markets a kind of film that produces both snapshots and excellent negatives, which can be enlarged later to any size you want. It comes in two sizes—Type 55 P/N (4×5) and Type 105 P/N (3½×4½). Kodak is now on the market with an "instant" color film and cameras for shooting it. Though they are bulkier than, say, the Polaroid Pronto! they seem to work quite well. The color is roughly comparable to Polaroid XL-70 color. Both Polaroid and Kodak instant color films produce pictures very much like color TV, which doesn't say much for their quality. However, people seem to like them just fine.

The singing was more energetic than harmonious, but no one seemed to mind. Harris reached for notes that would make a lyric soprano quail and missed them by five miles each. He didn't care. Bounce flash.

Though the party went on for hours, Jerry never once strayed from his young lady. Pestered by one and all, they finally moved to the bathroom, hoping to escape attention. However, this picture is proof that they did not. Bounce flash.

The boys had a way of wrenching a song out of shape that put Mr. Shawcross right up the wall. Fortunately, he survived the encounter and chaperoned many more noisy parties as the years went by. Bounce flash.

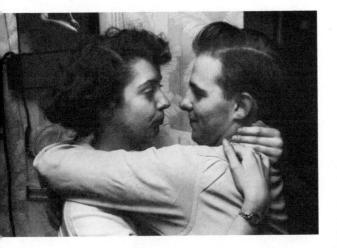

"Hello, I am here." "Hello, so am I." Bounce flash again.

They tried to catch Dave's attention, but it was already thoroughly caught. Bounce flash.

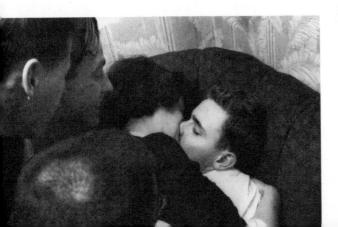

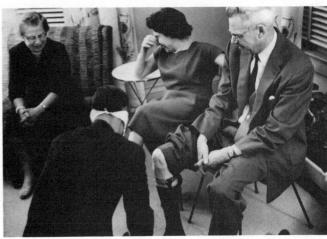

Don Smith was supposed to recognize his wife by the feel of her stockinged leg, but we brought in C. B. Neblette as a ringer. Don wasn't fooled. Available light.

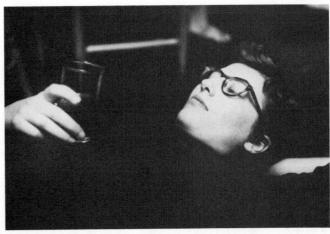

At many a party we just listened to music and had a few quiet drinks. Barbara usually stretched out on the floor, finding it very peaceful down there. Available light.

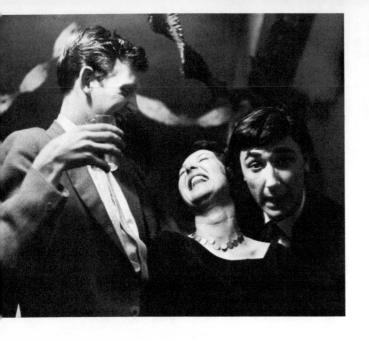

I gave a party for the entire acting company and backstage crew of the Birmingham (England) Repertory Theater. Numerous barrels of good English beer were consumed. Available light.

Pat always took off her shoes and socks and parked herself on the floor. The cracked cup was merely the least cracked cup in the house. Available light.

• Ideal Party Cameras

Since I have no idea what kind of a camera you have, I can't very well tell you how to use it for photographing parties. And you probably have just the one camera and have to stick with it, come what may. Even so, you may be interested in what I consider to be the ideal party cameras. They are the 110 cartridge-load types with built-in electronic flash, such as the Vivitar Point'n Shoot cameras. And that is just about all you do: point 'em and shoot—no focusing, no nothing.

Now, 110 color transparencies and negatives are only about the size of your thumbnail (13×17mm), yet they will produce very good wallet- and album-size prints. When projected the slides show excellent quality. Verichrome Pan, a black-and-white film, will permit rather good enlargements up to about 11×14 inches when it is developed in Microdol-X (diluted 1:3—develop 10 to 12 minutes at 68°F). The grain is surprisingly fine,

Though blow-ups of 20X and larger are mainly of interest to fine-grain buffs and technicians, they do suggest that 110 cameras are not mere toys. However, the fact that they *look* like toys makes them work all the better as party cameras. When you point them at people they pay little attention, undoubtedly thinking that a camera that small couldn't possibly do anything but turn out fuzzy snapshots. In other words, they are very harmless and nonthreatening in appearance.

In the 35mm format the Konica C35-EF looks very good. It, too, has a built-in electronic flash unit, which pops up when you are ready to use it. Focusing the camera changes the aperture setting, thus determining the flash exposure automatically. Since getting the exposure right is one of the primary problems in photography, this automatic system is very useful. When you are shooting without flash a cds electric eye sets your exposures automatically, which also is handy.

I will say no more about cameras, because a

The room was so dark that I could hardly see my own hand, but I shot pictures anyway and was quite surprised at who showed up in them. The exposures were about one-half second at f/2.8—f/2.8 being my favorite f-stop for indoor available light.

book is not the best place for information on photographic equipment, a field that is in a constant state of change. The best sources are the photography magazines, especially *Popular Photography* and *Modern Photography*. They make a strong point of keeping up on developments as they come along.

My only reason for mentioning Vivitar and Konica cameras was to give you an idea of the ideal party camera: a small, inconspicuous device that looks like nothing more than a child's toy, the more toy-like the better.

Poses

Asking people at parties to pose is often an imposition on them—they just want to be left alone to have a good time. However, if they obviously want to pose, just shoot without hesitation any poses they present to you, even if you don't like what they look like. This is the kindly thing to do. Now, if people want you to pose them you can do that, too—just don't make a production out of it. If they want a production, that's something else; go ahead and stir one up.

Perhaps the important thing to remember about parties is that people go to them to have a good time. Therefore, you should make your behavior as a photographer a part of the fun, not an inhibition against it. Don't try to turn people into photographic art: just let them relax and come across as themselves.

Host Hal Bolton surveys his party and finds it a roaring success. Hal is the inventor of the world's wickedest Gibson. Available light.

They were only fighting for fun, yet the fight was very vigorous anyway. One-half second at f/2.8, which is pretty slow for a fight. Available light.

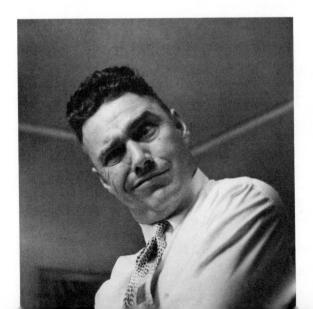

A gadget for tripping a shutter release from a distance, useful in self-portraiture, especially if your camera doesn't have a self-timer (this one does). It can also be used to hold the shutter open when the "B" (bulb setting) is used; this is convenient when you are painting with light. You operate the device by pulling gently on a linen thread, which can be of any length desired. This pulls the slotted wedge out of the assembly, thus permitting the rubber bands to force a firing pin into the shutter release mechanism and fire the shutter. The pressure is gentle, and absolutely no harm is done to the mechanism.

Here we see the three main parts of the shutter tripping device. Parts A and B are pieces cut from a one-inch dowel; part C was whittled from a scrap of wood and the slot put in with a saw. In part A, the two screws on the perimeter are for attaching the rubber bands. The screw in the center, rescued from a wornout cable release, permits the device to be screwed into the camera shutter release. In part B, the two pins on the left are for holding the rubber bands in place. The longer pin on the right, made from a small finishing nail, is the firing pin. The trigger mechanism is made in a wedge shape so that as it is gently withdrawn the force of the rubber bands will come to bear on the firing pin very gradually. This is to prevent camera shake. As a further precaution against camera movement the wedge is rounded on both its top and bottom so that it will slide out of the assembly with a very light pull on the thread.

A corner of my dining room that I often use for portraiture, always using just one light bounced off the wall and ceiling in various ways. This particular lighting is the one I use most for a person sitting on the chair. Notice that the "hot" part of the light pattern on the wall doesn't extend as far as the corner of the room. The lens on the camera has a focal length of 55mm, which I find quite good for portraiture. The strange object in front of the chair is a focus and cropping target useful for self-portraiture (see text).

HOW TO MAKE SELF-PORTRAITS

Shooting a self-portrait is very easy, though you can make it difficult if you try. There are several ways of going about it, one as good as another. I suggest that you start with the easy ways, then work your way up to the harder ones.

Equipment

Tripod: you really need one so that your camera will hold a steady position while you pose in front of it. However, you could prop up the camera on a table, chair, stack of books, or something.

Self-timer: this mechanism on a camera is made especially for self-portraits. When you set it and activate it you have from about eight to ten seconds to get into position before the shutter goes off. A self-timer makes self-protraiture dead easy, though there are ways of getting along without one.

Remote releases: if your camera has no self-timer you may wish to get an air or electronic release. An air release is a long rubber tube with a cable release plunger on one end and a squeeze bulb on the other; you squeeze the bulb to activate the plunger, which depresses the shutter release. An electronic release embodies an electrical device for depressing the shutter. You can use either type of release when you are sitting in front of your camera at some distance from it.

Shaving mirror (about 8×10 inches): if you are sitting in front of your camera and want to

know how you look in the lighting you have set up, hold up the mirror to yourself, making sure it isn't reflecting light into your face and changing the lighting.

Focus and framing target: for making a self-portrait it would be nice to have an identical twin in the form of a mannequin. You could light it, pose it, focus on it, then push it aside and take its place for a self-portrait, knowing in advance exactly what the picture would look like. For a focus and framing target a little less fancy, try taping an egg-shaped piece of cardboard (about ten inches long) to the top of an adjustable-height light stand. Simple as it is you can use it as a stand-in for yourself.

Measured string: for getting yourself in focus if you are not using a focusing target. Fasten a length of it to your camera and tie a knot in it to mark off the distance on which your camera is focused. If it is, say, four feet the knot would be four feet from the back of the camera and the focusing scale would be set at four feet. Just sit squarely in front of the camera, pull the string taut, and move your head forward until your forehead touches the knot. You will then be in focus.

Mirror Self-Portraits

The easiest way to shoot into a mirror is with a hand-held camera. Focus on your image in the mirror, then lower the camera until it is just below

Here I am sitting behind the focus and cropping target, which has been set at the same height as my head. The black-paper egg shape has the same outside dimensions as my head; my nose is touching the back of it. Before actually shooting a picture I would set the height and position of the target, crop with my camera, focus on the target, sit behind it, touch it with my nose, then push it aside and shoot the picture. Thus the picture would be sharp and properly framed.

your chin and shoot the picture. Since you won't know exactly what the camera will be seeing, it's a good idea not to crop your head too tight; so back up and leave plenty of space around it in the viewfinder. Then if your camera isn't aimed quite right you will still be in the picture.

If you don't want a self-portrait with a camera in it you can get rid of it by aiming at the mirror at an angle, either from below or from one side. In this case you will have to work with a focus and framing target, such as the one described in the last section. Pose yourself, standing or seated, When you are shooting a self-portrait you can check the lighting on your face (to see if it looks good) by holding up a mirror. However, you should hold it at such an angle that it doesn't reflect light into your face, for that would give you a false picture of the results that you would get.

A self-portrait I made using the focus and cropping target and a mirror lighting check. I'm not actually as grouchy as I look, but the picture is Ralph Hattersley all right.

and set the target with the back of the egg shape touching your nose and at the same height as your head. Then set the camera angle so that the target is well positioned in the viewfinder. Then focus on the target. To get your posing position, move up behind the target until your nose touches it. Then push it to one side and shoot your picture, in which you will be in sharp focus. (The

string-focus idea won't work very well with mirror pictures, incidentally, because the focusing distance is the mirror-to-camera distance plus the mirror-to-subject distance, which is a little hard to work out with a string.)

To make a mirror picture with a hand-held camera you obviously don't need a self-timer or a remote release. You probably won't need them for head-and-shoulder angle shots, either, though you should use a tripod and cable release. For a shot angled from below the camera will probably be about waist level and easily reached. When

you are angling from one side you should still be able to reach the cable release easily enough, though it might be handy to have an extra-long release.

When you take pictures by pointing your camera in a mirror they naturally come out as reversed, or mirror, images. The chances are that you will like self-portraits better that way, because that is how you are used to seeing yourself. If not, you can give your pictures the correct orientation by putting your negatives or transparencies wrong-side down in the enlarger.

A setup in my dining room for making a mirror self-portrait when the camera is off to one side of the mirror, the focus and cropping target off to the other side. The advantage to this system is that you can see pretty well what you look like just before you take the picture. Later, I sat on the stool behind the target, touched the black egg with my nose, pushed the target aside, and made my own picture.

A picture made with the camera and myself at opposite sides of the mirror. I was looking at the reflection of the lens in the mirror, which makes it seem that I am looking right at you. This is a mirror image showing what I see when I brush my hair—when I bother to look. To get a normal image I would reverse the negative, printing it emulsion up.

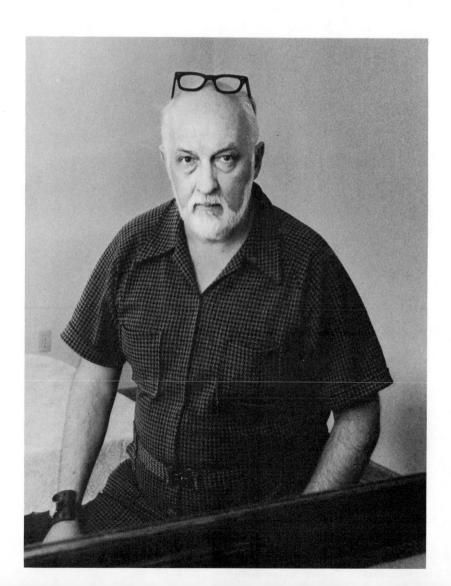

A setup for making a picture with the camera below the mirror and the subject standing well above the camera. The advantages are that you can see what you will look like and can easily reach the cable release to take the picture.

A self-portrait made with the camera below the level of the mirror and angled upward. My head tilted forward somewhat and I was looking directly at the mirrored image of the camera lens, which makes it seem that I am now looking at you. The thing growing from my head is the chain-support for a light fixture. I would rather it weren't there, but what can one do?

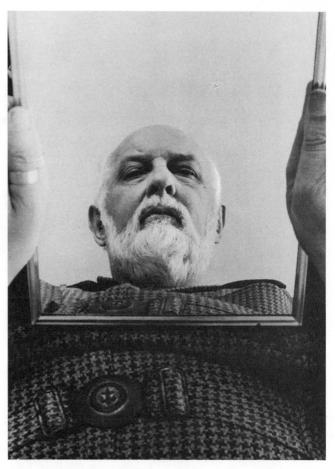

I sat on a chair with a mirror in my lap (you can see my belt buckle). The camera (on a tripod) was right in front of me and angled downward at the mirror. I moved the mirror around until the camera lens was centered in it, then activated the self-timer to take the picture. I don't know any particular advantage to this system, but it does work.

Self-portrait with John Boy in his usual position on the east end of the dining room table. Here I used a 19mm lens (very wide angle) stopped down to f/16, which gave me a tremendous depth of field. Thus I could use zone focusing (see text), getting everything sharp from John Boy's tail to the far end of the living room. I used the natural light that was coming through the dining room window.

• Depth of Field

Even if you are using a focusing target or a measured length of string it is a good idea to stop down quite a bit, in fact as much as you can. This increases the depth of field (depth of sharpness) and will help keep you in focus if you accidentally move a little bit out of position. In order to stop down quite a bit when shooting indoors you may find yourself using shutter speeds as slow as one-half second, but that is quite all right—as long as you are also using a tripod and a cable release, remote release, or self-timer. All you

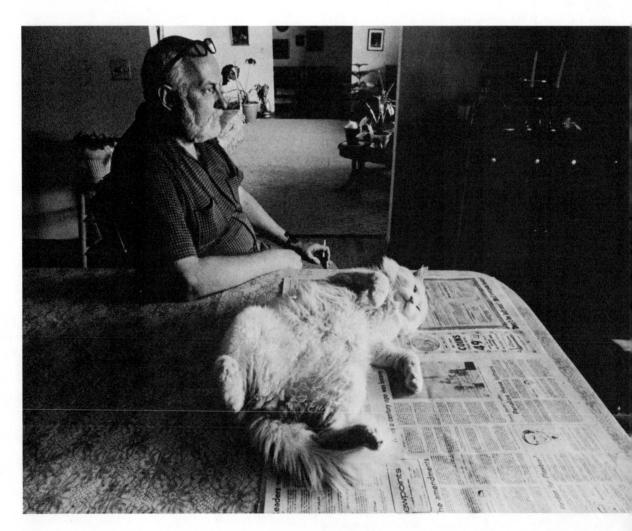

have to do is hold still for that long, which is easy enough.

Outdoors (still using a tripod) it is nearly always possible to stop down your camera all the way (for sunny bright, hazy sun, light overcast, and even heavy overcast lighting conditions). For a 35mm head shot with a normal lens this would give you roughly a foot of depth of field at f/16, which gives you quite a bit of latitude for getting positioned at the right distance from your camera. For a half-figure pose you would have about two and one-half feet, which is even better. In either case, touching your nose to a sharply focused target, or using a measured string, should guarantee a sharp picture.

If you are using a wide-angle lens for portraiture (or a telephoto, for that matter) you will get the same depth of field for head shots and half figures of the same size. Due to the distortion, however, one generally works for smaller figures when using wide-angles, and then the depth of field can be very considerable. For example, using a 19mm lens at f/16 would give us a depth of field extending from about one foot to infinity.

With depths of field this great you might just as well use zone focusing, realizing that if you position yourself anywhere within the zone you will come out sharp. You can figure out how *large* you will be at different distances by checking them out with your focusing and framing target.

Mainly because of the depth of field that you can use (with wide-angle, normal, or telephoto lenses) it is considerably easier to shoot self-portraits outdoors than in. However, if you have a modest command of the photographic medium it is easy to do indoors, too.

This was shot in the master bedroom with me sitting on a step stool. The light was coming from windows on two sides of the room. Notice the back of my head and the camera in the mirror. I shot this with the aid of the little focus and framing target, a very handy little gadget for self-portraiture. The face looks pretty dissipated to me, but I guess this is how I look.

Old Grouch-Puss rides again, this time in an outdoor self-portrait lit only by skylight, which is extremely diffuse. Its very diffuseness fills in a lot of lines and wrinkles on the face, making it look somewhat younger than its actual ninety-seven years.

The Lord of the Manor standing behind his garage and straining hard to see his camera, which is buzzing its self-timer on a tripod in front of him. Used a 28mm lens, which permitted zone focusing and produced a very considerable depth of field or sharpness. The idea was to make use of the groovy shadow patterns that were happening in the back yard.

The Troll of the Tree gazing out at the world with more than a little suspicion. I used a 19mm lens stopped down to f/16 and zone focusing and thus got everything sharp from A to Izzard. Now hear this: until you have taken your own picture as a tree frog you really haven't lived.

For Total Picture Control

One problem with most self-portraits (if it is a problem) is that you don't know exactly what you look like when the shutter goes off. This shouldn't matter very much, but some people just don't like to be surprised. One way to solve the difficulty is to stand a large mirror right next to the camera, angling it slightly so that you can see yourself in it when you are posed. The mirror won't see quite what the camera does, but it should come close enough for your desires.

I once knew a man who was greatly disliked for his contemptuous attitude and extreme egotism, which were written all over his face. He needed some portraits of himself one time, but he knew what he would get if he asked one of his colleagues (all of them photographers) to make them: pictures of a self-adoring young fool. So he used the mirror trick and made them himself. And what did they look like? St. Francis couldn't have looked so sweet, Clark Gable so handsome, or Einstein so intelligent. Considering the model, I was flabbergasted by the effectiveness of his self-canonization. But it does show how far you

Getting in shape for the races—I'm actually a rather speedy guy, though a bit on the fat side. I used a 19mm lens and zone focusing and was actually only ten feet from the camera, though the distance seems greater.

can go toward total picture control by using this method.

There are other possibilities for mirrors, if you have a mind for such things. For example, you might cut a circular hole in the center of a mirror and poke the camera lens through it. Or you might center the lens behind a two-way mirror—the kind that is transparent like a window from the back. Both systems would give you a reflection almost identical with the image in the camera viewfinder. With a two-way glass there is a certain amount of light loss, but you can compensate for it with longer exposures or brighter lightings. The important thing with either system is that you can see almost exactly what you look like.

For total control it would be best not to use a self-timer, which gives you only eight or ten seconds to bring your facial expression under control. Use either an air or electronic shutter release, and trip the shutter whenever you feel ready.

As you have probably surmised, making a self-portrait is very easy, though you can make it hard for yourself if you wish. You may wonder why you should photograph yourself. Well, a lot of people do it and claim that it is a very meaningful experience. There is just one way to find out if this is true: try it.

Hard shadows caused by direct sunlight make this friendly lumberjack look as tough as he really is. Made with a 19mm lens at f/16 and zone focusing. The focus and framing target was used to get the head framed in the center of the picture.

While you are at it you might as well take a picture of yourself as a corpse. At this very minute you are as good a cadaver as you'll ever be. Or maybe we are talking about too many mint juleps in this picture.

I took a picture of myself in front of a large piece of black paper, then photographed a print on the same frame of film. My camera has a bypass system (many cameras have), so that I can cock the shutter without advancing the film to the next frame. For each exposure I used half of the total exposure.

A face and a print photographed on the same frame of film. I find it rather amusing in a gross sort of way.

HOW TO MAKE STAGED CANDID PICTURES

If you are tired of people lining up like bowling pins in your pictures you might like to try shooting staged candids. The idea is to pose people—more or less—in such a way that your pictures look entirely unposed, or natural. In this way you can get a slice of life effect, not a bunch of wooden dummies. Once you get the idea, setting up a staged candid is easy enough to do. Of course, wooden dummies in pictures are all right, too—it is just that you might like a change of pace.

Non-Pose Poses

There is only a limited number of things that people do that look like poses for a camera. If you ask them to do other things instead they tend to look unposed, or natural. For example, when setting up a group candid you might give instructions such as these: "When I say, 'Go'-and not until then-I want you to look away from the camera and to start doing the following things. Bill-lean back, put both arms on top of your head, and chew on your lips. Claire-lean toward the coffee table and push the candy dish slowly back and forth. Dan-prop up your chin on your left hand and leaf through this magazine, looking at the pictures. Mary-slide way down in your chair, cross your legs in front of the coffee table, and twiddle your thumbs."

You can make your shots at several points: (1) as soon as they start moving into position but

before they actually get there, (2) when they have settled into position and are waiting expectantly for you to shoot, and (3) after they have become bored with you, the charade, and the camera and are chatting with one another. The chances are that shots (1) and (3) would be best and that the one in which they are actually following your instructions (2) wouldn't amount to much. But you don't have to tell them that you plan things this way as a diversionary tactic. If your models get their instructions all confused, so much the better. At least they won't be looking like wooden Indians.

I asked Brent to prop up his feet on Sam's chair and got this very informal posed candid picture, which doesn't look in the least posed.

Diversionary Tactics

- 1. Put your camera on a tripod (it looks very harmless there, especially if you walk away from it). Tell your models to make themselves comfortable while you run a couple of tests on your shutter (or electronic flash, self-timer, remote shutter release, etc.). Move slowly. Be a complete bore, if possible. Don't look at your subjects at all, except out of the corner of your eye, even though you are actually making pictures with your "tests." Shoot some of your pictures with your back to your subjects. After you have gotten the pictures you wanted with your "tests" and "fumbling around," make the picture that your models have been expecting—for them, not yourself.
- 2. Put your camera on a tripod, line up your picture the way you want it, then turn the camera over to an assistant, who will trip the shutter whenever you give an unobtrusive signal. Then distract your subjects by talking to them, pushing equipment or furniture around, bringing in drinks, turning on the hi-fi, and so on, all the while giving your assistant signals at appropriate times.

If you have a long enough remote release cable, you can do more or less the same thing without an assistant. Or you might use the selftimer on your camera, though it makes a distracting sound. Cover it up with loud music or conversation, and it won't be so bad. In shooting, activate the timer, walk away from the camera, and engage in distracting your subjects until the shutter goes off, doing this as many times as necessary to get the pictures you want. Since neither you nor your models will know exactly when the shutter will click, there is a good chance that the pictures will look truly candid. There is also the possibility that some of them won't come out very well, but you can cover yourself by shooting lots of frames.

3. Use someone (or several people) as a spe-

The children were all lined up stiff as starch, so I waited around until they relaxed a little bit. The posed candid trick is to pose people more-or-less, then wait around until they break the pose.

Charley Arnold likes to do things with his hands, which gives pictures of him an impromptu, candid feeling. We see the unexpected.

This picture looks candid because it is rather improbable—not the kind of thing people ordinarily do when posing for the camera. However, it was very carefully set up this way.

My son Cleve also likes to do things with his hands. I had intended to make just an ordinary candid snapshot, but see what happened—nothing ordinary at all about the picture.

cial distractor. For example, if you wish to photograph a young woman you could ask her to have several good friends with her. Then, having posed her in a non-pose pose, you could ask them to stand or sit just out of camera range and chat with her. While they are getting used to the idea, disappear for a minute or two or bury your head in your equipment, taking pains not to listen to what they are talking about. Well, good friends like to talk, so they will easily enough forget you as you unobtrusively make your pictures, even if you are using flash. The click of your camera shutter will tell them that everything is all right and that they don't have to worry. So reassuring is this sound that some photographers start out with empty cameras, clicking merrily away until everyone has relaxed. Then they load up and start shooting pictures, though they don't let their models know what they have been up to.

Staged Emotion

One of the surest signs that a photograph is truly candid, or real, is a display of genuine emotion on the model's face. You may think that emotion can't be faked—but don't be too sure. It is true that if you ask someone to express a certain emotion it will probably look as unrealistic as wheels on a bat. So don't ask people to do this. Instead, ask them to do certain specific things with their faces, hands, and bodies. If you pick the right things the emotions will be there—fake but real. That is, no one could look at your pictures and tell them from the real thing.

In all fairness to your models, you should tell them roughly what you are up to but not the specific emotions that you are going for. They will usually be able to tell, anyway, so don't worry about it. The important thing is that they understand that they merely have to push their bodies and faces around at your direction, nothing more.

Following are some tried and true instructions that you might try giving to a model to see what "emotions" you will get:

HOW TO MAKE STAGED CANDID PICTURES

- 1. Open your eyes as wide as you possibly can and see how long you can hold them that way.
- 2. Tense your neck muscles until they stand out like strings.
- 3. Put your hand on your forehead about an inch above your eyebrows and try to push the skin down over your eyes.
- 4. Put your hand to your face, with your thumb on one cheek and your fingers on the other, and push the skin up into your eyes.
- 5. Put your hands to your temples and press until it hurts.
- 6. Put a bit of this snuff on the back of one hand and sniff it up your nose.
 - 7. Try eating this dill pickle.
- 8. Put an index finger in each corner of your mouth and push it up into a great big smile.
- 9. Put these two wads of paper between your back teeth and clamp down on them as hard as you can.
- 10. With your eyes closed, face right into this very bright light (such as a 500 watt photoflood), screwing your face up as much as necessary to make the light intensity tolerable.
- 11. Close your mouth tight and puff out your cheeks as far as you possibly can.
- 12. With your thumb on one cheek and your fingers on the other, twist your face as much as you can.
- 13. Press your chin against your chest as hard as you can.
 - 14. Open your mouth as wide as you can.

If you remember your childhood and the things you used to do with your face it should be obvious that having a model do these things could lead to some ridiculous pictures. On the other hand, the very gestures that are the most ridiculous will also produce all the "genuine" emotions you want—the idea is to click the shutter at just the right time. For example, from a sneeze we can get sorrow, dismay, and terror in addition to the expression normally expected, depending on how soon we shoot after the sneeze has started.

Some of the above gestures are already as-

The candid emotion in this picture was carefully fabricated from a special lighting and from having Anne Lawrence open her eyes as wide as she could. There was bounce light coming from each side of her. The pattern in the background helps make the setting look real, though the picture was shot in a studio.

sociated with various emotions, being the things we often do when we have certain feelings. Oddly, merely doing them mechanically tends to arouse the emotions, real ones recovered from memory. It is often said that sneezing is almost exactly like dying, which might explain why genuine emotion is briefly but violently aroused by a sneeze. The point I am getting at here is that your "faked" emotions may not be as phony as you think.

Peg and Dick just horsing around. The candid feeling comes from the fact that neither of them cared a hoot what they looked like in front of the camera. They could just relax and be themselves.

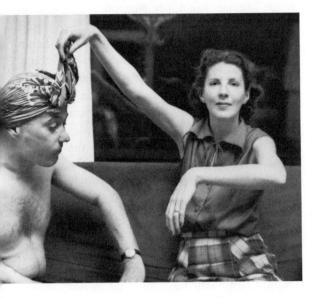

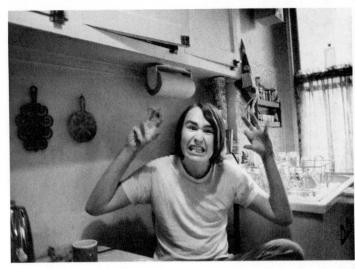

My son Cleve explaining why he is tougher than King Kong and all the lesser apes put together. Since it doesn't look like a posed studio portrait or a fashion picture, we might as well call the picture candid. What else to call it?

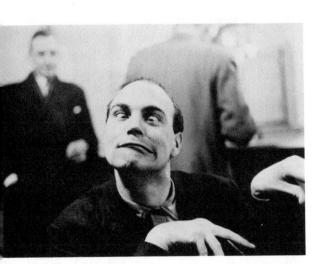

More often than not, Eddy Mole would make a terrible face for my camera. I guess you call this picture candid.

I asked this Spanish musician to look Satanical, and this is what happened. Reality can be faked, for he is a very gentle person. We might call this a faked-emotion posed candid picture.

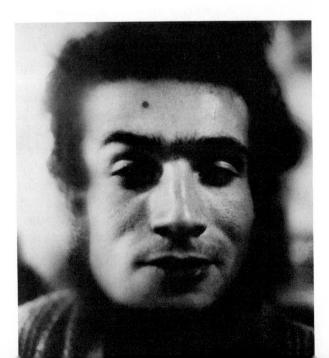

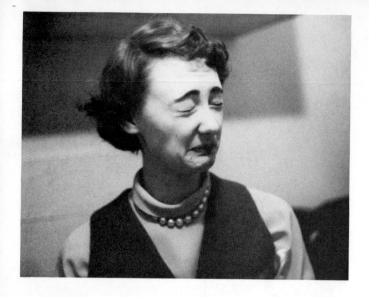

Deep and candid emotion caused by the first taste of a dill pickle.

Psycho-Drama

With the techniques discussed so far it is easy enough to make staged candid pictures making people look as they ordinarily do when they are not in front of cameras. However, you may wish to construct your pictures around a theme, or concept, and not have people come on in an ordinary way at all. Even so, pictures built around themes can look very realistic.

One way to do it is to get your models involved in a psycho-drama, which many people see as a very interesting thing to do. You create such a drama by describing a hypothetical situation, usually traumatic, that everyone is presumably involved in, tell each person how he or she fits into it, then ask them all to act out the situation (while you shoot pictures).

For example, the drama might revolve around the hypothetical necessity of telling Ellen (one of your subjects) the bitter truth about herself. You might assign the roles as follows: "Ellen, you're a beautiful bitch in angel's clothing, but you are the only one fooled by the clothes. Tom, you're her third husband and have just learned that she is having an affair with her boss, who is very handsome and extremely rich. You are the long-suffer-

ing type. Alma, you are Ellen's homely younger sister, whom she has never really paid any attention to, which you deeply resent. You think you could help her by telling her what kind of person she really is, but you are afraid that your temper will get away from you." Et cetera.

Another way to do it is to simply suggest the theme—telling Ellen (or someone) the truth—and let people choose and define roles they would like to play. As the roles are acted out the theme may be changed considerably, or even turned upside down. But who cares? And there may be some who would rather be bystanders than participants (psycho-drama can get *very* emotional), but that is all right too.

As in any theatrical enterprise, the casting ought to have a reasonable amount of believability. For example, fiftyish-Fred might work out well as Ellen's father but not as her lover or younger brother. However, people have a natural eye for the incongruous, so they are not likely to risk ridicule by badly miscasting themselves.

As the photographer, you can also produce a psycho-drama with just one other person, taking a role yourself. I myself used to do such things when I was young. For example, I once photographed a young actress who wanted some pictures with real emotion in them for a change, so I laid out the drama for her as follows: "I am going to play your counselor, but everything I tell you will be a lie—as far as I know. Even so, I will say it in the most positive and believable manner, so stand warned. (pause) You know, your parents have been terribly disappointed in you for years. Do you even remember that they exist? Do you care for them at all? Yeah, that presumably 'warm' look in your eyes is just as phony as anything else about you. As an actress you have the emotive talents of a dead mackerel." Et cetera. My barbs got through to herwhich we both wanted-simply because I accused her of things that would probably be true of almost anyone.

Well, this is heavy-duty stuff, as you have probably seen for yourself. However, actors and

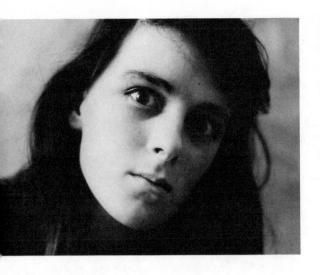

Actress Sue Jamieson and I were involved in a little psycho-drama in which I was telling her deliberately convincing lies concerning her relationship to her parents. Actors and actresses like psycho-drama, because it helps them understand emotion better.

A bit of impromptu psycho-drama in which Phillip, who is a little naïve, is telling Kim that he sees her as an angel and wants to photograph her with the wings he'll make for her.

"Father" Dale has decided to save Mrs. Pritchard's soul, with Eddy Mole and a masked stranger in attendance. The salvation efforts were tightly structured, but the picture came out loose and candid. This happened at a costume party, of course.

actresses intentionally go through this kind of thing many times when they are trying to learn what emotion is all about. And the pictures? Oh, they were a great success—our young lady far transcended herself and gave an Academy Award performance. One of her photos is printed in this chapter.

Now, psycho-dramas are just not for everyone, because the tension does get awfully thick. If this is not your cup of tea, simply forget about it and use less emotional methods for staging candids, such as the one that follows.

• The Walkaway Technique

Perhaps the easiest way to stage a candid is to simply group people roughly the way you want them, then simply walk away from them for a while—ostensibly to check out equipment, bring in another light, or something of that ilk. If they are all friends, anyway, they won't really care where the photographer has gone off to. Watch them from the corner of your eye until you see that they have tired of acting like wooden dummies and have disposed themselves more comfortably. Then walk up and start making your pictures.

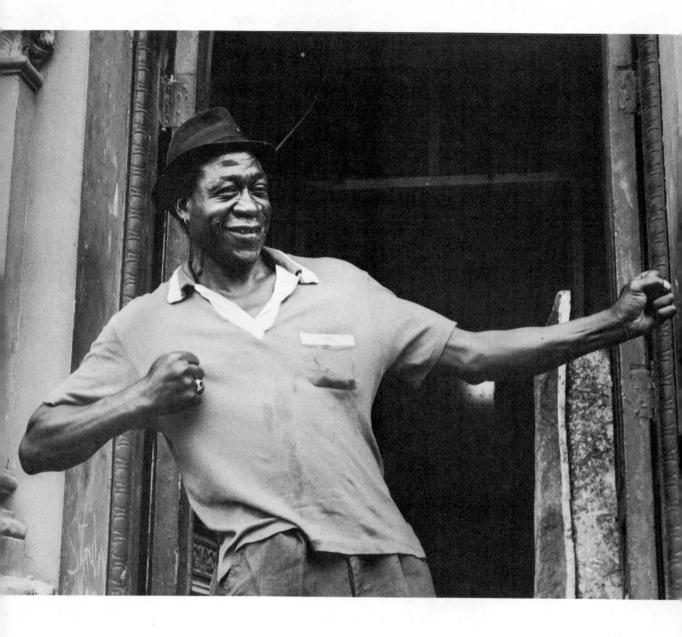

Though men frequently take this fighting pose, this man apparently knows how to use it. From the scar tissue on his face and his oft-broken right fist I would say he is no stranger to the prize ring.

HOW TO PHOTOGRAPH STRANGERS ON THE STREET

We tend to think of the people in our pictures as friends, even if we don't know them at all. Thus street photography is a way of making friends and cherishing them without having to struggle through the formidable barriers that separate people from one another. It is also many other things, of course, including the hunter's way of collecting trophy heads, a means for recording one's contempt of other people, and a method for using other people without having to ask their permission or thank them. Let us just say that you can do street photography for both good and bad reasons.

Shooting the pictures is easy enough—just focus, frame, and click—but that is not really what bothers inexperienced photographers. They want to know how to do it without getting hassled or harmed by the strangers they photograph. Well, there are some excellent techniques for avoiding such problems, and this is what the chapter will be mainly about.

• Shoot for the Right Reasons

Remember that people are telepathic on the unconscious level and always know when you are photographing them; and if they don't like your reasons for doing it they can often shift this awareness to the conscious level and may then act on it. When they then hassle or threaten you they are, unbeknown to themselves, trying to

teach you a lesson: don't think about people in the wrong way or photograph them for the wrong reasons.

Unfortunately, your reasons (good or bad) for doing things are mainly buried in the unconscious, where you can't examine them in detail. Even so, you know whether they are positive or negative, and that should be enough to guide your behavior. For example, a feeling of guilt, whatever be its source, is enough to tell you that you have negative reasons for wanting to photograph a certain person or negative feelings concerning the way you intend to do it. The easiest thing at this point is to simply refrain from making the picture, because shooting it would violate your own inner ethics and possibly bring on a hassle.

However, a better idea would be to dig up your motives, replace negative motives with positive ones, and go ahead and shoot your picture. Simply start thinking good thoughts about your subject. It is easy enough to tell when the replacement has been successful: the guilt feeling goes away. This brings us to the ethics of taking pictures of strangers without their knowledge—should one do it at all? For the right reasons, yes. For the wrong ones, no. And your conscience is an excellent guide in this matter, so be sure to listen to it.

Furthermore, on the level of soul or higher self, people are delighted to have you think about them, look at them, and photograph them—provided that you try hard to do it in a way worthy of your own higher self (the *trying* is what counts). Much of the important spiritual work of the world gets done in this manner, with people permitting themselves to be used by others. And so it is with street photography: if you try to use people well in your mind and heart you honor them, whether they are *consciously* aware of you or not.

On the ego level it is often another story, unfortunately, because many egos are like spoiled and selfish children, always afraid that someone will try to diminish their inflated, yet fragile, self-esteem. So you might find yourself in the following situation: a stranger's higher self applauds your reasons for wanting to photograph him, while his ego, suspecting the worst, wants to take you apart.

One solution to the problem is to outwit egos, using some of the basic shooting techniques of street photography. There is no chance whatever of outwitting a higher self, because you are telepathically linked with it—so just forget about trying. Remember that if a person's higher self doesn't like your reasons for photographing him it may awaken his ego to what is going on. And egos throw rocks, Brother or Sister, and egos throw rocks.

• The See-Through Technique

If you are convinced that it is ethically permissible to fool egos in a harmless way for commendable reasons, you should enjoy the rest of this chapter, including this first technique. Our first good street photography ploy depends on the fact that you can make people think that they are transparent—really. For example, I wish to photograph a woman standing about four feet from me, so I look over her head and, never looking at her at all, bring up my camera and shoot. Lowering the camera (the follow-through is important), I look over her head again (still not looking at her), then make another shot and turn slightly away, still paying no attention.

In trying to make himself heard above the roar of traffic on Forty-second Street the preacher lost his voice, yet he managed to save at least one soul, anyway. No one was aware I was taking pictures, though I made no attempt to hide my actions. If a distraction is strong enough the photographer is virtually invisible.

He calls himself the King of St. Marks Place, and the girl has just moved into the neighborhood. I simply pointed my camera at them and raised my eyebrows in questioning. As you see, they gladly posed.

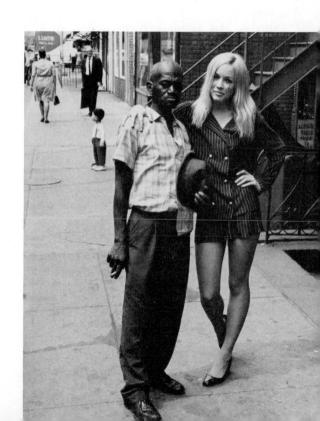

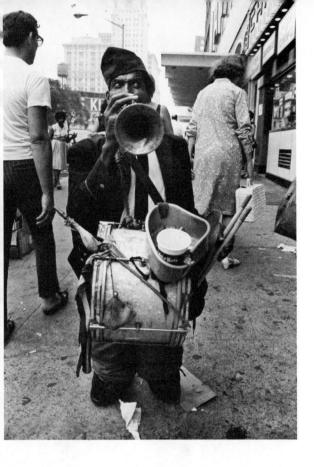

Both a street musician and an ordained minister, this man gladly posed for me. I had but to ask him courteously.

A couple of New York's finest return the smile of a pretty young mother. I just stood there, shot the picture, then went on my way.

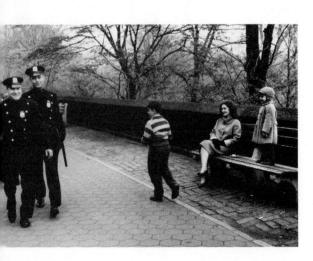

Now, the odd thing is that she seems to think she is transparent, for two compelling reasons: (1) the photographer is so little concerned about her being in the way that he doesn't even see her and (2) he goes right ahead and shoots his pictures. If she were not transparent, why would he behave this way and be so entirely casual about it? Of course, she isn't aware of her assumption, for it is only half-conscious, yet it controls her behavior, anyway.

Though not a dedicated street photographer I have used this technique numerous times, and it has always worked. Incidentally, you can usually tell when a given ploy will work: it is when you think that it will, simple as that.

Don't Look at People

Eyes emit some form of energy to which people -and apparently many animals—are highly sensitive. Whatever it is, this energy doesn't pass through glass very well. Whether you believe in this energy or not, something very definitely happens when people make eye contact, and everyone knows it, so you shouldn't make such contact when doing street photography. First of all, it is a violation of an unwritten covenant among strangers that there will be no eye contact. Secondly, it is like hitting someone in the stomach. Finally, once you have made eye contact with strangers they know that you have singled them out for some reason and your objective of photographing them without being noticed goes right down the drain.

Eye contact through a camera viewfinding system is usually not the same at all, because the radiated energy is mainly absorbed by the glass which makes up the system. So if you have to look at a stranger, do it through your lens, not directly. There are a few people who give off so much of this visual energy that a large amount of it will get through a viewfinding system in either direction—from a photographer to a subject, or from a subject to a photographer—but I wouldn't worry about it. Such a heavy charge is not commonplace.

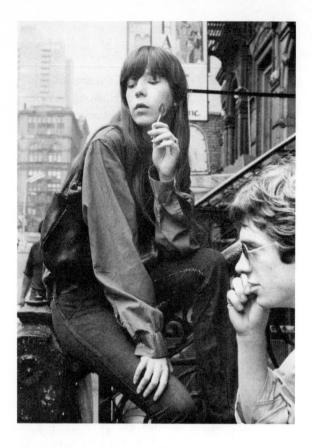

Young people used to like to go down to St. Marks Place in New York just to hang around and to see and be seen. Strangers would sit or stand together for hours, never saying a word. In that particular neighborhood people generally liked to be photographed and were very used to it. There are such pig heavens for photographers in most cities.

Once they learned I wasn't trying to put them down the young men were pleased to be photographed. The older man and his grandson (?) just happened to fall into the range of my wide angle lens, so I gladly incorporated them in the picture. We fell into a brief conversation, and one of the young men offered to show me his bunny rabbit, which he produced from a handsome brief case. I would take his pose to be provocative, but that is apparently just his way.

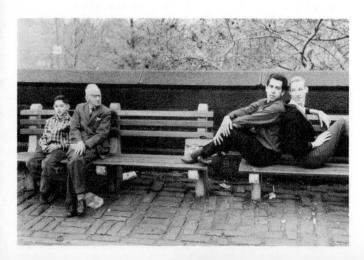

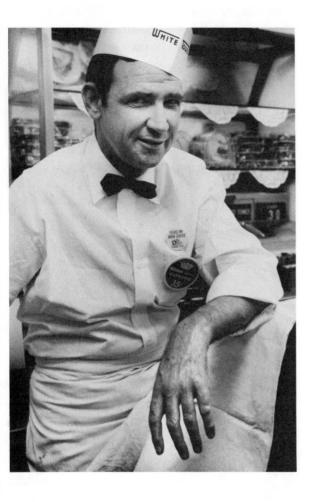

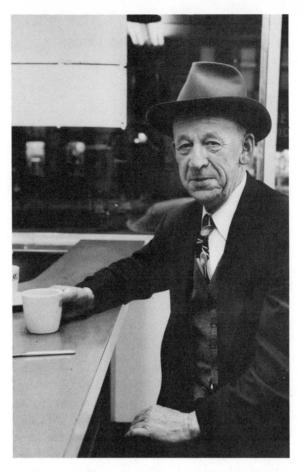

Also in the White Tower was this gentle and engaging man, who found it amusing to be photographed by an eager stranger. I liked what the years had done to his face, what he had done to it, in fact.

The chef from the White Tower Restaurant posed for me when I asked him for a picture. Strictly speaking, this is not a street picture, though the street is only six feet away. On Broadway and Forty-second Street people are likely to be suspicious when they see you photograph them. It is just that way: one part of a city isn't the same as another. Though I was playing at playing with my camera I still got this suspicious look and didn't fool anyone. Some New Yorkers are hard to fool.

• The Catcher's Mitt Trick

Perhaps you have noticed how baseball catchers grab bad pitches and instantly center them right behind the plate in order to convince umpires that they were actually strikes. You can do this with a camera, too, and it works a lot better than trying to fool an umpire. Just shoot someone, then point your camera a little to one side and hold it there for a couple of seconds. Then lower it and look elsewhere. It is hard to understand why people can get taken in by a dodge as old and obvious as this, but they certainly do.

The Swing Shot

The idea here is to look through the viewfinder, pointing the camera here, there, and everywhere, as if you were checking out the lens or merely killing time. However, using a fast shutter speed you may shoot your picture right in the middle of a swing—without interrupting it, to be sure.

Don't advance your film right after shooting, for that tips off what you are up to. Wait for a

few seconds. With most of the tricks, waiting is a good idea, because advancing the film tells people you have just taken a picture. You don't want them to know when you do it or even that you did it.

Shoot from the Waist

A favorite ploy in street photography is to shoot from the waist with a wide-angle lens (a 28mm is possibly the most popular, followed by a 35mm). Such a lens will give you so much depth of field that you can use zone focusing and not have to focus for each shot, which makes it much easier

He lived right around the corner from me and I often saw him with his dog, but I didn't want to disturb him with my presence as a photographer and possibly a threat. So I made a swing shot. As if just goofing around, I swung my camera in a 180° arc, clicking the shutter when he was in range but never looking at him directly. Then I made off down the street, still not looking at him.

to work fast. Once you have set the zone on the focusing scale, just leave the camera hanging at your waist. A wide angle will generally give you enough extra picture space around your subjects so that you can easily crop your pictures to compensate for camera aiming errors.

A part of the trick is to not look at your camera at all when you are shooting pictures or advancing the film. And, as always, don't look directly at your subjects. With a fast enough shutter speed (e.g., 1/500 second with Tri-X) you can shoot from the waist while walking down the street toward your subjects.

• Fake Camera Tests

It seems to be a well-known fact that many people are more interested in tinkering with their cameras than in taking pictures with them. And many of those who want to take pictures have to fiddle a lot with their cameras in order to figure out how they work. Thus a person playing with a

Street photography is easy when a person asks you to take his picture, as this young man did. He is a delivery boy from one of the grocery stores in the New York neighborhood in which I formerly lived.

camera is a very familiar figure and not likely to attract much attention.

So, while you are "fiddling" you can be taking pictures without anyone being the wiser. With your apparent fumbling and bumbling you can also use the see-through technique, the catcher's mitt trick, make swing shots, and shoot from the waist. And another trick that always works is to "listen to the shutter." That is, hold the camera up to your ear, look down at the ground, and shoot your picture. Since people will assume that no one but a complete idiot would try to make a picture this way, you will be beyond suspicion.

Mirror Attachments

A very ancient trick for street photography is to cover your lens with a special mirror attachment that will permit you to take pictures of people who are at a right angle to the lens axis. I suppose that some people would recognize such a device if they saw you using it. On the other hand, people have a strongly conditioned tendency to believe that a photographer always faces the thing he is taking a picture of, so even if they recognize your gadget they won't believe what they are seeing. Indeed, a mirror attachment is one of the safest tricks for street photography.

Telephoto Lens

With most of the tricks presented so far there is some risk of detection—if you don't use them properly. But with a telephoto lens there is considerably less chance of being found out, though I have seen photographers being threatened by people fifty yards from them. Even so, a telephoto—the longer the better—is almost always a very safe bet.

Substitute Exposure Readings and Focus Target

Unfortunately, you cannot walk up to a stranger, stick your camera in his or her face, and take an exposure reading. 'Tain't done. Instead, hold the palm of your hand vertical to the ground and take a reading from it, making sure that your hand is facing in the same direction as your subject so that they both get the same light. Since one piece of skin reflects about the same amount of light as another, your hand reading should also be accurate for your subject's face. For a person with a very dark skin, tilt down your hand until the palm is equally dark before taking your reading. As long as you and your subjects are in the same light you don't even have to be close to them when you take your palm reading.

Taking time to focus on people may tip them off to what you are up to, especially if you can never remember in which direction you are supposed to twist the focusing ring. So find a suitable target (a lamppost, for example) that is at the same distance from you as your subjects, focus on it, then swing around and shoot your picture. It will be sharp. Though zone focusing is an even better idea, there may not be enough light to permit you to stop down far enough, for example, at dusk.

• The Problem with Fear

Perhaps you are a paranoid, a person afraid of nearly everything that exists and especially of people. Well, most of us are this way now and then. Despite their fears, some paranoids try street photography, often being rewarded with gratuitous insults and threats from the people they try to photograph. Since this can happen to any of us we ought to look into it.

The thing is that people are like broadcasting stations, and fear is a very disruptive high energy emission. Thus the human receivers who pick it up react to it in a very negative, angry way. Unfortunately, the best receivers for fear are those who are themselves filled with it. They react in such a negative way because they confuse fear with anger and feel that the anger is being directed against themselves. The confusion shouldn't be surprising, because fear and anger are essentially the same thing.

Fear can be broadcast in all directions or focused mainly on a single point by means of the mind or the eyes. For example, if you are fearfully looking at or thinking about someone whom you intend to photograph it will focus your fear on this person, who may unconsciously interpret it as an assault. Especially if he or she also happens to be paranoid at the moment. So, you have a person who is angry at you, perhaps even before seeing you at all, and strongly predisposed to give you a hard time on any pretext whatever. You should understand that being afraid is an in-

vitation to assault and battery by others who are also afraid.

Therefore, it should be obvious that you shouldn't try street photography (especially in large cities) when you are frightened, for there is a good chance that you will get hassled. On the other hand, some chronic paranoids deliberately turn to street photography as a way of confronting and overcoming their fears with the help of strangers. No harm is done, and on the level of the soul the strangers are glad to help. On the ego level, however, they can be quite a problem, especially if they too are paranoids.

It is too bad that people's fear of your fear comes out as anger, but that is just the way things are. And the fact that fear is broadcast and can be focused doesn't help much, either. There is just no escaping the consequences of being afraid.

I just stood on the corner of Fourteenth Street and Fifth Avenue and photographed everyone who came along with a camera equipped with a 28mm lens, which is very good for street photography. I was so obviously standing there and shooting "dumb pictures" that no one paid any attention to me. And I took care to look at none of them directly, which further directed attention away from myself.

This was a grab shot made quite openly, but the young man, who obviously has things on his mind, didn't seem to care.

• You Ask Them or They Ask You

Though the tricks in this chapter are some of the favorites of experienced street photographers, you may feel guilty about using them—simply because they *are* tricks. And guilt goes hand in hand with fear, which sets up the strong negative vibration. So don't use tricks. Simply ask people if you can photograph them.

But it is not quite that simple, is it? Especially if you are shy. The best you can do in this case is to hope that some people will ask you to take their pictures. Young people often do this, and even some older ones now and then. If they ask you, just photograph them in whatever way they present themselves—posing stiffly, teasing you, hamming it up, and so on. Because such behavior is catching, you may find other people also wanting to pose for you a minute or two later.

(Photo by Jim Jennings)

A proper hassle at a hockey game, but about par for the course. This was one of Jim's first pictures as a full-time press photographer. Shot with a 200mm f/3.5 lens with Tri-X rated at ASA 2400—exposure 1/500 at f/8. Processed normally in Diafine for that film speed.

HOW TO PHOTOGRAPH SPORTS

Since there are a great many sports I obviously can't tell you how to photograph them all in a single chapter. The subject is simply too large. However, there are certain basic problems that occur in many kinds of sports photography, and they can be discussed in the space available. Perhaps the main problems are getting yourself within range of the action and freezing the action.

• Picking Your Spot and Laying Claim to It

It should be obvious that some photographic vantage points are better than others. For example, at a boxing or wrestling match it is handier to be at ringside than fifty yards out in the audience. At a horse race a spot near the finish line is considered best. Ski jumpers are photographed from below, so that they look like great black birds. And so on.

Perhaps the easiest way to select vantage points is to analyze sports pictures in newspapers and figure out where the photographers must have been standing when they were shot. By now the vantage points are traditional, and most sports photographers use the same ones, often in the form of press boxes. Another approach is to try to locate the pros before the start of an event to see how they have spotted themselves. They are usually the people with the very long telephoto lenses, heavy-duty tripods, and three or four cameras hanging from their necks.

Finding a good spot and getting permission to

use it are two different matters. The people who conduct most sporting events just don't want you getting in the way—unless you represent the press, on whose continued favor their welfare often depends. Thus a standard ploy among sports photography nuts is to persuade newspaper editors to issue them official press photography passes, usually with the understanding that the photographers will bring in their really good shots.

So many of my students have gotten such passes for themselves that I assume that any good con artist who is also a good photographer can talk himself into one. Some have had their own passes printed, with dubious results, and others have gotten police department passes—just to copper their bets, so to speak. Even with a pass, bona fide or fake, you may still have to be a very clever con in order to gain occupancy of your vantage point. Genuine press photographers are old hands at this sort of thing.

• Telephoto and Tele-Zoom Lenses

Even with the best of vantage points you will still be very far from the action during many kinds of sporting events. For example, you might con your way right up to the sidelines for a college or high school football game, but what can you do about action across the field from you? The obvious answer is a telephoto lens, which will bring distant things up close. I suspect that most pros are now using the zoom telephoto, which is an even better answer, though a very expensive one.

A zoom lens has many focal lengths built into one, as it were—for example, 50mm all the way to 200mm. Such a zoom lens can be used as a 50mm lens, as a 200mm lens, or as a lens of any focal length in between. For sports photography it would be desirable to have a 50mm-5000mm zoom, but there is as yet no such beast. If there were it would probably cost \$10,000 or more.

However, there are certain compromises possible, also expensive. For example, you could use the Nikon 50–300mm zoom (about \$1,000) with a teleconverter which will convert it to 100–600mm. This would give you a range of from 50mm to 600mm, which is a lot of zoom in the present state of the art. However, the lens is very heavy, and the teleconverter cuts off the corners of the image. If that is the lens you need —and you can afford it—that's okay.

One way to get the cost closer to the \$100-\$200 range is to buy a fixed focus 200mm lens with a teleconverter, which would stretch it out to 400mm. If you want to buy a lens without a converter, 300mm looks like the best compromise for sports photography. It won't work for all sports, but it will work for many. Fortunately, many of the cheaper telephoto lenses on the market nowadays are quite good, mainly because lens design and manufacture on all cost levels is heavily computerized.

• Tripods, Bipods, Unipods, Rifle Stocks, and Bean Bags

Unfortunately, many a person finds it impossible to hold steady any lens that throws his camera off balance, which includes most tele-zoom lenses and fixed focus lenses beyond 90mm—the heavier the lens, the greater the problem. This makes for fuzzy pictures. If there is enough light for you to shoot at 1/500 or 1/1000 second this may solve the problem by counteracting lens and camera movement, but being able to use only these shutter speeds is a severe restriction.

The natural answer is to use as heavy a tripod as you can carry—light ones aren't much good with a heavy lens. Many professional sports photographers prefer the very heaviest Mitchell, Linhoof, or Gitzo tripods made for use with professional 35mm movie cameras, which weigh a lot. You can get them with very smooth oil-friction pan heads, which are very good for following sports action. However, tripods of this sort are very expensive, so you might consider a lighter one such as the Soligor Quick-Set Husky (\$55-\$95), which is quite a sturdy model.

Since it is very unhandy to work with tripods in many situations—in crowds, for example—you might consider supporting your camera and lens with a bipod, unipod, "rifle stock," or bean bag. A bipod is a two-legged "tripod," a unipod a one-

(Photo by Jim Jennings)
A high school wrestler seems to be a bit confused as to what belongs to whom. Shot with a 135mm f/2.8 lens with Tri-X rated at ASA 1600—exposure 1/250 at f/2.8. Developed for 10 minutes in Acufine.

legged one. Both will give a long lens a surprising amount of support. With a special rifle stock bolted to your camera you can aim it much as you would a rifle, which is immensely better than hand-holding without the stock. A bean bag is simply a small sack three quarters filled with dried beans; you put it on a railing and rest your lens on it. You can make one with a man's sock, two pounds of beans, and a length of string for tying up the open end of the sock.

• Stopping Action: Shutter Speeds, Electronic Flash, Panning

Most photographers prefer to stop or freeze the sports action that they photograph, though we do see blurred-action pictures now and then. The first step when working either indoors or out is to use the fastest film available, and for indoor work to possibly push its ASA speed from one to three stops (see later section). The next step is to use the fastest available lens (for indoor work), which happens to be very expensive when it comes to telephotos and tele-zooms. Indoors, with the speed advantages provided by a fast film, film speed pushing, and a fast lens, you then use the fastest shutter speed that you can, usually trying to stay within the 1/250–1/1000 second range. Outdoors in strong natural light, the main

things are a fast film and a camera with high shutter speeds; you can use a *much* slower lens and simply don't need film speed pushing.

One of the best ways for freezing indoor sports action is to use electronic flash, the heavy-duty professional thyristor unit being the best bet. Depending on your distance from the action you are photographing, such a unit will produce a flash duration varying from, say, 1/500–1/50,000 second—the closer the action the shorter the duration. With electronic units the flash itself freezes the action; 1/500 will freeze most action, 1/50,000 will freeze almost anything. However, for the very fastest flashes you have to be almost within touching distance of your subjects.

With most modern cameras (single lens reflexes and other cameras with focal plane shutters) the shutters synchronize with electronic flash at relatively slow speeds, which means that the shutter speed must be set on a low number, usually 1/125 or 1/60 or less. If the flash goes off at a higher shutter speed setting with such a camera it will expose only a portion for the film frame, the rest of it being covered by part of the shutter curtain.

With cameras that synch at speeds that are too slow, electronic flash for sports photography is mainly restricted to working indoors or shooting outdoors at night. In sunlight the slow shutter speeds would simply overexpose fast films. For example, with Tri-X and a camera synched for

(Photo by Jim Jennings)

An experiment to see how long a lens could be used successfully for basketball—300mm seeming to be the practical limit. Shot with a 300mm f/4.5 lens with Tri-X rated at ASA 3200—exposure 1/250 at f/4.5. Developed in a mixture of LPS and Ethol 90 at 75° F for 4 minutes.

1/30 second you would overexpose (from the sunlight alone) by 4 stops (16 times) by setting the aperture at f/16, the smallest opening that most cameras have. Add to this the light from the flash itself and you can see that the overexposure would be very severe.

Cameras having between-the-lens or compurtype shutters will often synch at high enough shutter speeds to work well with electronic flash and fast films outdoors in daytime, especially if they have the apertures f/22 and f/32. However, the main function of a flash unit is for flash fill (for lightening the shadows somewhat). If your camera has fast enough shutter speeds you simply don't need flash to freeze action in sunlight, or even on overcast days.

A classical action-stopping technique called "panning" dates back to the days before fast films and high-speed shutters, and it works as well now as ever. It is used most for such things as race cars, horses, and sprinters speeding across your line of vision. The idea is to pick a target, say a running horse, and follow it with your camera just as you would follow a clay pigeon with a shotgun. When it reaches the right position you shoot your picture-while still moving the camera to keep the horse framed in the viewfinder. This follow-through is an important part of the technique, yet you can master it in one or two tries. Even better, make a bunch of dry runs without film in the camera, just to get used to the idea. With panning you can stop action at shutter speeds below 1/100 second, though your horse's legs will be blurred in the picture.

Film Speed Pushing

The main reason for film speed pushing is to make it possible to shoot by available light indoors at faster shutter speeds than you could normally use with a given film. The idea is to use the fastest film available and to increase the effective ASA speed of the film as much as possible by overdeveloping it. This can be done with both black-and-white and color films. The best bets for

pushing are probably Tri-X, Kodacolor 400, and Fujicolor F-II (a color negative or print film), all three rated at ASA 400 and capable of having their speed pushed by several f-stops.

The ASA speed of a film is actually a constant, determined by the manufacturer, that can be neither increased nor decreased. However, it can be used as if it had a higher speed, which is what we really mean by saying we "increase" the ASA speed. That is, you can set a higher number on your exposure meter, shoot your pictures, overdevelop the film to the appropriate degree, and get printable negatives (black-and-white or color) or acceptable color transparencies. For example, before shooting Tri-X you can set the number 1600 on your meter and say that you are shooting it at ASA 1600. Yes, this is precisely what you are doing-a kind of as-if proposition-though the actual ASA speed itself remains a constant 400.

However, it is not quite this simple, because pushing the speed of a film nearly always results in a loss of image quality, the higher the push the greater the image deterioration. With more and more pushing you get a progressive loss of detail in shadow (or even midtone) areas, increase of graininess, increase of contrast, and blocking up (blurring together) of highlight details. These things happen with both color and black-and-white films, but with color film there is an additional problem—a color shift or change that can make an image look like badly tuned color TV. Despite all these difficulties, film pushing is used a lot for indoor sports photography.

You can readily see why you should consider speed pushing as strictly an emergency measure and therefore continue to expose films at their rated ASA speeds whenever possible. Unfortunately you sometimes *have* to push the speeds. Say you decide to shoot a basketball game with an f/2.8 135mm lens and either Tri-X or Kodacolor 400, both rated at ASA 400. You may find that the best you can do in the available light is to shoot at 1/60 second at f/2.8, which won't permit you to freeze much action.

(Photo by Jim Jennings)
The East Coast Surfing Championships at Virginia
Beach, Virginia. Shot with a 500mm f/8 mirror optics
lens with Tri-X rated at ASA 400—exposure 1/1000 at f/8. Processed normally in straight D-76.

So consider the faster shutter speeds that pushing will enable you to use: with a one-stop push (to ASA 800)—1/125. With a two-stop push (to ASA 1600)—1/250. With a three-stop push (to ASA 3200)—1/500. And with a four-stop push (to ASA 6400)—1/1000. Unfortunately, by the time you reach ASA 1600, or a two-stop gain, your images will probably be falling apart rather badly, though not always. Even so, a shutter speed of 1/250 is a great improvement over 1/60 second.

One of the decisive factors determining how far you can safely push a film is the contrast of your subject matter. Contrast means difference between tones (or values), high contrast meaning a great difference, low contrast very little difference. With a high contrast subject all the details will vanish from the dark areas of the image with even a one-stop push. Indeed, you may even lose these details when using a film at its rated speed. Naturally, the loss is even greater with pushes of two, three, and four stops. With rare exceptions, the pictures aren't even printable.

On the other hand, with very low-contrast or flat subject matter (such as you would find at an indoor swimming meet, where the preponderant tones are all about the same) you may be able to safely push to ASA 1600, 3200, or even 6400, though the 6400 negatives (black-and-white or color) might be barely printable. However, a part of this pushing game is to learn to make acceptable prints from very bad negatives. Though it takes a while you can learn to do it if you try hard enough.

In this country, very little is known at this time about Fujicolor F-II, though the Japanese tell us that it can be pushed quite a bit. At any rate, I can't give you the details right now. At this writing I have no data on pushing Kodacolor 400. The chances are that you would want to have your pushing done by a professional color lab anyway. The situation with respect to black-and-white film is different, and I can tell you what to do. For film pushing, Tri-X is the overwhelming favorite of all films, simply because it gives the best results and, of course, it has a high ASA rating to begin

with. Two of the most popular film developers for this purpose are D-76 diluted 1:1 and Acufine. For a speed up to 800 use D-76 with Tri-X. For 1200 and above use Acufine (1200 would be a 1½-stop push). The people at Acufine Incorporated insist that 1200 is the *normal* (or real or actual) ASA speed for Tri-X developed in Acufine, so you can see that you run little risk in exposing it at that speed.

Before moving to the how-to-do-it of film pushing we should consider Kodak 2475 Recording Film, which is rated at ASA 1000 by Kodak. Because of its speed it is of considerable interest to sports photographers, and you can determine its "push speeds" with the techniques that follow. Though it is a little grainy, the grains are very small and very sharp. When you decide to start pushing films you will just have to learn to live with grain, anyhow. It is better to get a grainy image under adverse lighting conditions than no image at all.

The overdevelopment required for film pushing is done by increasing the developing time while at the same time using the recommended temperature and agitation schedule. Unfortunately, if you were given a developing time chart for various degrees of pushing in either D-76 or Acufine it would be of no use whatever to you. This also applies to the chart furnished with their developer by Acufine Incorporated. You (or any other photographer, amateur or professional) simply have to figure out times for yourself. The reason for this is that photographers have different kinds of exposure meters, built-in or separate, and they vary considerably in the way they use them. Meters vary a lot with respect to their accuracy. And the degree of shutter speed accuracy is not at all the same from camera to camera. Thus if five experienced photographers were asked to photograph the very same subject at ASA 1600 we would find them getting quite different results, even if all the rolls were to be developed simultaneously in the same film tank at a custom lab. Though all the photographers would think they were shooting at 1600 we might later discover that the speed ratings actually used ranged all the

way from 800 to 3200. The managers of Modernage, the world's largest custom lab, tell me that such wide deviations are not at all unusual for the professional photographers who use the lab.

A chart that gives you the developing time for a push up to ASA 1600 will be of little use to you if you actually expose at 800 or 3200 instead. At 800 you would get overdeveloped negatives, at 3200 underdeveloped ones. In either case they might be quite unprintable. To get around this problem you don't have to have your shutter speeds and meter sensitivity checked (though it wouldn't be a bad idea), nor do you have to change the way you do your metering. Indeed, if your method of using a meter has been giving you good results all along it would be unwise to change it, even if you are doing things backward or upside down.

The thing to do is to experimentally establish personal "push speeds" and developing times, working in your usual way with the equipment that you ordinarily use. If you stick to the method that follows the results will compensate for faulty equipment and errors in metering technique.

You must run some simple exposure and development tests. Make your exposures (test pictures) at the location you are most interested in, say an indoor skating rink, basketball court, or swimming pool. Since these particular places are rather flatly lighted, you will find rather low subject contrast. So let us say you want to go for broke on pushing Tri-X and decide to find out what it will do at both 1600 and 3200 (with 2475 Recording Film you might try 3200 and 6400).

Go to your chosen location during a practice session and set up your tripod at the vantage point you will use during a regular game or meet. Center your camera on the area in which the most interesting action ordinarily occurs, take an exposure reading with the meter set at 1600, and shoot a whole 36 exposure roll without moving the camera. Alternate back and forth from shot to shot between 1600 and 3200. For example, shoot a picture with an aperture and shutter

(Photo by Jim Jennings) Crisis on the mound: a Little League baseball coach pulls his pitcher after five walks in a row in the first inning. Shot with a 300mm f/4.5 lens with Tri-X rated at ASA 800—exposure 1/500 at f/4.5. Given $1\frac{1}{2}$ times normal developing time in straight D-76.

speed indicated by your meter—you will be shooting at ASA 1600. Then stop down one more stop and shoot another—you will be shooting at ASA 3200. Or instead of stopping down you can switch to the next fastest shutter speed—again, you will be shooting at ASA 3200. Thus you switch back and forth between two f-numbers or between two shutter speeds.

This is a very simple business, but beginners find it terribly confusing, so I will go over it again in a slightly different way. Say your exposure reading (with your meter set at 1600) indicates that 1/125 second at f/2.8 is the correct exposure. Leave the shutter speed set at 1/125 and make exposures in which the f-number alternates between f/2.8 and f/4. Or leave the aperture set at f/2.8 and make exposures in which the shutter speed alternates between 1/125 and 1/250 second. Either way you will end up with the same final results.

The idea of immobilizing your camera on a

tripod is to get a series of images as much alike as possible, so that pictorial differences won't throw off your judgment later when you are examining your test negatives. For this same reason you should try to get approximately the same kind of sports action in each shot. Since games, meets, and practice sessions tend to be quite repetitive, this shouldn't be too hard. If you rehearse your actions before shooting you may be able to expose the whole roll within 10 minutes. On the other hand it may take you an hour to get a series of shots that will look approximately the same.

Since we have taken Tri-X as an example and you are pushing it to 1600 and 3200, you should develop it in Acufine. Refer to the Acufine time and temperature chart (it comes with the developer) to get the correct developing time for the temperature at which you intend to process your film. For example, if you wish to develop at 68° F you would find that the recommended time for Tri-X (rated at ASA 1200) is 5½ minutes. This is a good starting place. Give 5 seconds agitation every 30 seconds.

Develop the whole roll for 3 minutes, then remove the film reel from the developing tank, cut off a 5-inch length of film, and drop this short piece into a fixing bath. Return the reel to the developing tank. Every minute thereafter, cut off and fix another length, until the whole roll has been used up.

Then wash and dry the 5-inch lengths and examine the frames. Each length will contain at least one whole 1600 frame and at least one 3200 frame. The range of developing times that the strips represent should cover the entire usable developing time range for Acufine. With longer times we would expect altogether too much grain and fog.

The next step is to choose the most printable 1600 and 3200 frames, which you can only do by making test enlargements. Remember not to expect really good negatives—there just won't be any. The problem is to get the best possible prints from bad ones, which many a sports photographer has learned to do. From the frames that

print best you can check back to get the developing times, which you can then use after shooting Tri-X at 1600 or 3200 at your test location. Though your figures will be totally reliable for that place alone, you may be safe in using them for other locations that have similar lighting contrast.

These tests won't tell you anything about the accuracy of your shutter or meter, or whether you use your meter correctly. And they won't tell you at what actual ASA speeds you expose your film when you think you are shooting at 1600 or 3200. However, if you go to a game at your test location and use the very same exposures that you used for your tests, you can safely predict what kind of negatives you will get when you use the developing times that worked best in your tests. And that is all you really *need* to know.

However, if you are going to have a professional color lab push color film for you, you will have to find out whether you actually expose at the ASA speeds you think you are using. If a lab tells you they can push Fujicolor F-II to ASA 1600 you have to know whether the lab's 1600 is the same as yours. If their 1600 turns out to be your 3200, then you should expose this film at your 3200 when you expect to send it to this particular lab. When they see the developed film they will assume that you exposed it at 1600.

The way to find out how your ASA speeds compare with the lab's is to set your meter at 1600 and make test shots at several locations that interest you, bracketing the exposures in each place. To bracket means to make a series of exposures ranging from underexposure to normal exposure to overexposure, the normal exposure being the one that your chosen ASA speed, meter, and metering technique identify as the best one. For such a test you should bracket with a sufficient range of exposures, for example, with underexposures of 1, 2, 3, and 4 stops, a normal exposure, and overexposures of 1, 2, and 3 stops.

When the film comes back from the lab you may find that their 1600 is the same as yours, that their processing made the frames that you

presumably exposed at 1600 come out best. Since you may not know how to judge color negatives (in the case of Fujicolor F-II), you should ask the lab people to select the best exposures (with color transparencies you can judge well enough for yourself). If the best exposures happen to be at your ASA 800 or 3200, simply set your meter with the number that worked best and continue using the same metering methods as before. Indeed, in your test locations use the very same exposures, which is even better. It doesn't really matter what push-speed numbers you use as long as you get usable exposures.

Though many sports photographers use film speed pushing as an everyday technique, it is only because they have to in order to get the kind of shots they want. Never use it except as an emergency measure. Remember, the further you push film the greater the image degradation. (There is more information on film pushing in the chapter on available light photography, p. 155).

Motorized Cameras and Special Film Backs

Because sports action often breaks very fast and is hard to capture at its peak, many sports photographers have taken to using motorized cameras with which they can shoot pictures in rapid sequence, say at 4 or 5 frames per second. The idea is that one of the frames in a 5 or 10 frame series will probably catch the action at its height. As you might surmise, it doesn't take many sequences to use up a 36 exposure roll.

Thus there are special backs for handlinglonger rolls of film. A good example is the motorized Nikon MF-2 back, which will take a 100-foot roll of 35mm film, permit you to make single exposures, or give you sequence exposures at rates ranging from 1 to 4 frames per second.

Aside from their initial cost, which is usually considerable, the problem with motorized cameras and backs is that you can use an enormous amount of film without even thinking about it. And with a back like the MF-2 you also need special processing equipment in order to process

the extra-long rolls. Since I don't envision readers who are prepared to cope with such problems, I'll say no more about this highly specialized equipment.

More About Electronic Flash

Earlier, I said that using electronic flash is a very good way for freezing indoor sports action, but many of the smaller units aren't powerful enough to be generally useful. Unfortunately, broad utility is usually a function of price—if you can lay out enough money you can get a unit that will do the job.

The best bets are the automated professional units with thyristor circuits and independent sensors, provided that they have enough range when operated on automatic. The automatic range for the better units may be anywhere from 40 to 50 feet, depending on the make, which is all right for many sports. Most of them can be manually operated for greater distances.

One of the most interesting models available is the Vivitar 283 Auto Thyristor, which costs less than \$100 without accessories. The automatic range is 43 feet, which means that at that distance you can shoot Tri-X at f/5.6. This also means that you can shoot at the same distance with an f/5.6 telephoto instead of a fast (and very expensive) f/2.8 or f/3.5.

One of the problems in using flash with a telephoto lens is that the angle of the beam distributes most of the light over an area outside the area covered by the lens. Thus much of the light is wasted and the maximum distance from which you can photograph a subject is unduly limited. Vivitar solves this problem with special lenses to slip over the flash head to make the angle of the light beam match up with the angles of lenses of various focal lengths. For example, one of them is for use with camera lenses that are 135mm or longer. If you operate the flash manually it will permit a maximum range with Tri-X of 60 feet with an f/5.6 lens or 85 feet with an f/4 lens.

(Photo by Jim Jennings)

You are never too young to develop a two-handed forearm smash—if you can keep your eyes closed long enough. Shot with a 100mm f/2.5 lens with Tri-X rated at ASA 400—exposure 1/1000 at f/8. Processed normally in straight D-76.

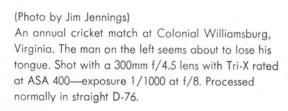

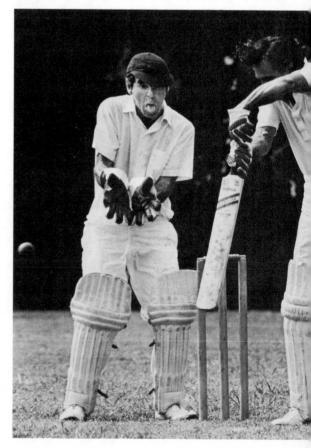

(Photo by Jim Jennings)

In the last thirty seconds of a city championship game the boy in the center missed a two-foot jump shot with no one near him. His team lost by one point. Shot with an 85mm f/1.8 lens with Tri-X rated at ASA 2400—exposure 1/500 at f/3.5. Processed in a mixture of LPD and Ethol 90 for 4 minutes at 75° F.

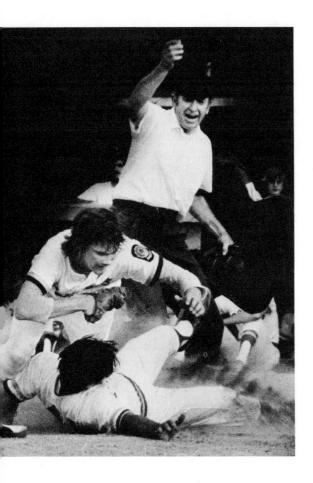

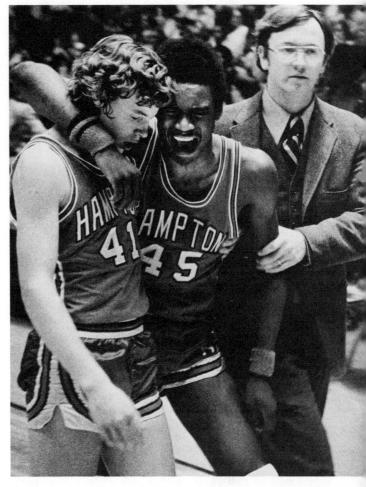

(Photo by Jim Jennings) Some home plate action in American Legion Baseball. Shot with a 300mm f/4.5 lens with Tri-X rated at ASA 800—exposure 1/1000 at f/11. Given $1\frac{1}{2}$ times the normal developing time in straight D-76.

That is, by concentrating the light beam the light lens makes possible more light at a given distance than you would get with a wider angle beam. This in turn extends the range of the flash unit.

To operate a unit manually you ought to know the so-called guide number for the film you are using so that you can use the number to determine the f-number setting for any given distance. The computer dial or chart on your flash unit may not include the ASA speed of this particular film. Now, when a unit can be used either with or without a lens slipped over the flash head there will be *two* guide numbers for a given film, each film having different guide numbers according to its ASA speed. For example, with the Vivitar 283 and Tri-X film the guide numbers are 240 (without the lens over the light) and 340 (with the lens).

You make use of a guide number by dividing it by the focus distance (in feet), which will give you the f-number you should use for that distance. As an example we will try the 340 Vivitar guide number for Tri-X and a focus distance of 100 feet. Thus we divide 340 by 100, which gives us 3.4 or f/3.4. There is no f/3.4 but we are close enough if we call it f/3.5 (this is a half-stop setting between f/2.8 and f/4). In short, you should set the lens aperture at f/3.5 when focused at 100 feet.

In advertisements and technical writeups in

(Photo by Jim Jennings)

The boy on the left is still in the race, though it doesn't seem so. He is the last runner in the first heat of a high school cross-country meet, heading to finish as the second heat starts. Shot with an 80–200mm f/4.5 zoom lens with Tri-X rated at ASA 400. Processed normally in straight D-76.

photography magazines the guide numbers for flash units are given only for 25 ASA films, which erroneously assumes that readers will know how to interpret this information. You should understand, first of all, that the number is a way of describing the light output of a unit in terms of the f-stops you can use with an ASA 25 film at various distances. It is convenient to check out a guide number at a distance of 10 feet, because 10 is an easy figure to work with. For example, we will see what we could do with a guide number of 60 at this distance, i.e., what f-stop could we use? So we divide 60 by 10 and see that we could use f/6 (or f/6.3, which is a half stop between f/5.6and f/8). The larger the guide number the smaller the aperture that you can use-and the more powerful the flash unit.

Technical writers also assume that readers will be able to start with the guide numbers for 25 ASA films and figure out the guide numbers for

(Photo by Jim Jennings)
A hang glider at Jockey Ridge, a sand dune near
Nags Head, North Carolina. A long lens makes the
glider seem much higher up than it actually was, which
was just a few feet. Shot with a 300mm f/4.5 lens with
Tri-X rated at ASA 400—exposure 1/1000 at f/8.
Processed normally in straight D-76.

faster films, though this isn't necessarily so. However, there is an easy way to do it: divide the ASA 25 guide number in half and multiply the result by each of the f-numbers, starting with f/2.8.

Let us again use a guide number of 60 for an ASA 25 film and see what guide numbers we would get for faster films. Halving the 60 gives us 30, which we multiply by each of the f-numbers, starting with f/2.8—2.8, 4, 5.6, 8, 11, and 16. We come up with the following new guide numbers: 84 (for an ASA 50 film), 120 (for ASA 100), 168 (ASA 200), 240 (ASA 400), 330 (ASA 800), and 480 (ASA 1600). If the rated ASA speed of the film you are using falls between two of these speeds it is quite safe to simply estimate what the guide number would be.

Unfortunately, manufacturers often publish guide numbers that are higher than they should be, because this makes their units appear to be more powerful than they actually are. If you use these inflated guide numbers you will underexpose your film. Thus if you buy a unit you would be wise to personally establish the basic ASA 25 guide number for yourself, then use the preceding system to get any other guide numbers that you need.

Use color film and laboratory processing for making your determination, because both are so standardized nowadays that the results will be highly dependable. Using an ASA 25 color film (e.g., Kodachrome 25), set up an average subject (including at least one person) at a distance of exactly 10 feet from your flash unit and camera, which should be on a tripod. Next shoot a series of pictures that are identical except for exposure, shooting each one at a different f-number, and starting with the largest aperture that your camera has. For example, you might shoot at f/2, f/2.8, f/4, f/5.6, f/8, f/11, and f/16. Then take the film to the drug store or a color lab.

When you get your film back, pick the best exposure in the series and figure out the f-number at which it was exposed. Then determine the ASA 25 guide number with this formula: f-number \times distance (10 feet) = guide number. For example, f/4 may give you your best image, which would give you a guide number of 40, just as f/2.8 would give you a guide number of 28.

If you are testing a miniature flash unit, or

your camera doesn't have the larger apertures, 10 feet may be too great a distance for making your tests. Therefore, use a distance of 5 feet and substitute 5 for the 10 in the formula just given.

Before leaving electronic flash we will deal with one more problem. Many black-and-white films produce negatives with too little contrast when they are exposed by electronic flash, the shorter the flash duration the lower the contrast. You can put the contrast back in by simply extending the film developing time by 20 to 50 per cent. This will increase the grain somewhat, but with a film such as Tri-X the increased graininess is hardly noticeable.

• Flash or Push?

Since we have covered two of the main methods for freezing sports action indoors—film pushing or using electronic flash—you may wonder which you should use. Should you freeze action with a high shutter speed made possible by pushing, or should you freeze it with flashes of extremely short duration? Well, there is no way for me to know what *you* should do, but I can tell you the method that most professionals seem to prefer.

Whenever they can the pros try to get along without electronic flash, getting their high shutter speeds with very fast lenses, fast films like Tri-X and 2475 Recording Film, and film speed pushing. However, they back themselves up with flash equipment, using it if absolutely necessary—which it sometimes is.

Their objection to electronic flash is that they usually have to point it right at their subjects, which flattens out all the shadows on figures and makes backgrounds black. Though bounce flash would solve the problem, the high ceilings of indoor sports arenas make it impossible to use it. So we are stuck with direct flash, which gives us lightings entirely unlike the ambient light in arenas. This makes the professional unhappy, because he wants to as nearly as possible capture the entire flavor of events, including what they actually look like to the spectators attending them.

One way around the synthetic nonrealism of direct flash is a multiple-flash setup in which you use two or more off-camera flash units fired by remote control. Such arrangements can be very effective, and they have been used many times. But setting one up and testing it can be quite a production. The average newspaper pro just doesn't have time; he has to dash in, get his shots, and return to his paper in time to process them for the morning edition, which is already well under way by the time he returns. So he uses available light and push speeds when he can, or turns to direct electronic flash when he has to.

The chances are that you just don't have the equipment for multiple-flash. If you do have there is still the problem of getting permission to set it up for an event.

So what should *you* do? Whatever your experience, equipment, and ability as a con artist will permit you to do. As for electronic flash and film pushing, why not try them both if you can?

• What Should You Shoot?

You may have noticed that you haven't been told what you should shoot—what sports, what specific action within each sport, and so on. For very simple reasons you don't have to be told. For example, if you are enough of a football nut to want to shoot some games you already know what football is all about and wherein the visual excitement lies. And with many sports the key moments are self-evident—when a high diver looks most like a swan, when a pole vaulter clears the bar, when a racing driver spins out or goes over the wall, when a horse wins a race, etc.

Such things you already know without being told due to a lifetime spent in a sports-oriented country. Sports are mainly about winning and losing, and both winners and losers make interesting pictures.

As you have seen, the emphasis in this chapter has been on how to use some of the primary tools of sports photography. However, this knowledge has a great many additional uses in photography.

HOW TO PHOTOGRAPH THE NUDE

A nude is generally a picture of a totally unclothed person, male or female, that has rather obviously been made for artistic rather than grossly sexual purposes. That is, nudes are made with the intention that they shall be art. This is the traditional way of thinking about photographic nudes, and it is wise to keep it in mind. The term "nude" is also a euphemism for "naked body."

Art and Pornography

Though pictorial nudity is now commonplace, many people are still very touchy about pictures of bare skin and strongly inclined to condemn the photographers who make them. For this reason it may be best to attempt to produce only traditional nudes and to avoid trying anything that might be labeled pornography.

We have seen that a photographic nude is supposed to be art, meaning that to some people it should *look* like art, which isn't the same thing at all. Looking like art usually means to look like a handsome painting of a nude person, the idea being that people who paint pretty pictures are somehow proper custodians of public virtue and aesthetics. But this definition is very restrictive. Furthermore, when something looks like art it usually isn't. For a better viewpoint we should ask ourselves, What is art? Well, it is hard to say,

but it is surely an abundant embodiment of such things as beauty, hope, meaning, and truth.

If a photograph of one or more unclothed people has all these things it is surely art, whether it looks like a painting or not. Photographers generally settle for beauty alone and strive very hard to create or record it. When they are successful it is quite good enough—their pictures should certainly be called art. You see, each of these terms—beauty, hope, meaning, and truth—basically includes all the others.

Essentially, pornography is simply failed art, an attempt at art that doesn't come off. The question isn't whether a picture is sensual, for real art can be very sensual indeed. Art can be about people tenderly and beautifully making love, for example, or about sensually glorious human bodies. No, the question is whether a picture, sensual or not, embodies beauty, hope, meaning, and truth.

In other words, was the photographer able to see and understand such things and project them into a picture? In short, is he or she a sensitive, perceptive, healthy, and sane human being? The law is that you can only see what you are; thus to *create* art you have to *be* art. You have to be sane, for example.

Most definitions of pornography are very sick, yet people will hold them over you like a club—so you should know what some of them are. A photograph of human nudity may be called pornographic if it shows:

- 1. the sex act in any of its many forms
- 2. people of opposite sexes
- 3. two or more people of the same sex
- 4. pubic hair
- 5. genitals
- 6. a nude man
- 7. a pose even vaguely reminiscent of one used for sex
- 8. any mixture of clothed and unclothed people
- 9. an ordinary everyday environment (living room, kitchen, bathroom, back yard, etc.)

The list could be extended indefinitely, because nudity as such—in pictures or out—is pornographic to some people. Oddly, the nude male figure is seen as very pornographic, especially to men. Through the years the female figure has been depersonalized to a great degree, but the male figure has not.

Though it is possible to consider figure photography without thinking of pornography, it is better to keep it in mind. You see, every time you do figure studies you must skirt the pornography problem, and if your pictures don't come out well you are right in the middle of it. Remember that pornography is simply failed art. You must also deal with the fact that art and pornography are often confused, one being taken for the other. Since you yourself may make this mistake you should at least consider both sides of the coin. But more: pornography mainly arises from the inability to see the world as wonderful; you should remember this, too.

• The Figure as Sculpture

One of the long-accepted ways to deal with the pornography question is to treat the figure, male or female, as an art object—as sculpture, for example. Since many sculptors have managed to see the human body as beautiful, emulating them is a way to learn to see beauty. You could start by using sculptors' poses and could also use the same kinds of models. However, many sculptors

Prints from the same negative shot with a white no-seam paper background, which creates certain interesting problems for the photographer (see text). One of them comes from the insistence that white always stays white and should be printed that way, which led to the print above that is pretty well falling apart, the body almost disappearing into the whiteness. The better print below accepts the fact that a particular lighting and model have turned a white background into gray (by comparison with everything else), so it has been printed as gray. The girl's body now has a feeling of volume and space.

have used chunky women who would look simply fat in photographs, though their male models are usually trim and well muscled.

In treating figures as sculpture it is important to use the right backgrounds and lightings. Those mentioned later in the chapter will work very well, for I am taking you through an essentially sculptural approach to photography of the nude.

Finding Models

If you are not too shy, the easiest way to get a model is to ask a friend to pose. Nowadays, a man and a woman will often make a trade, each posing for the other. Taking figure drawing courses in an art school is a way to contact models, though the men and women who pose there are often pretty beat up. The bedraggled ones usually refuse to pose for photographers, anyway, but the handsome ones sometimes will. Photography courses that deal with the nude are an even better bet, and there is the advantage of working under experienced instructors.

Some newspapers will accept advertising for models if it is clear that your purposes are legitimate. Though the models that one contacts in this manner often have very miscellaneous faces and figures and are out for kicks, there is always a chance of getting one or two good ones. Furthermore, it is excellent experience to work with faces and figures that are far from perfect. There is always a considerable amount of beauty in them, and you should learn to see it.

Advertising on an art school bulletin board is a good idea, because the men and women students are long-accustomed to nudity and often in need of extra money. Make it very clear in your ads that you are not a sexual pervert in search of sexual kicks, for art students are extremely leary of such people. Offer a modeling fee of around ten dollars an hour, plus a promise of modeling sessions at least two hours long. Nowadays, it is hardly worth crossing the street for less than twenty bucks, and modeling can be very hard work.

Joining a camera club may bring you in contact with photographers who know figure models willing to work for a reasonable fee, but you should investigate this possibility before joining.

Joining a little theater group is also a good idea, because many young actors and actresses think that the experience of being nude in front of others will fit into their training very well. Some of them also like to be daring. And some will pose to satisfy their vanity, theater people being well endowed with it.

The main problem in getting models is suspicion: the people you approach may think you are an uptight voyeur or that you are stupid enough to have sexual seduction in mind. There are many such people, you know. If you ask a model to bring a friend to a modeling session or to pose for a small group of photographers (instead of just yourself) the suspicion will generally lessen. Since they are not voyeurs and generally prefer to have real love as a prerequisite of sex, women photographers are not often suspected. However, the men whom they ask to model are often surprisingly shy—terrified, in fact. Though he may not know it, the average man is scared to death of women.

Emotion and Ritual

Confronting nude persons of either sex with the intention of really looking at them is usually quite a traumatic event, though most of the emotion will drain out of a modeling session in a few minutes. Since emotion can make you as blind as a bat you should control it by establishing a matter-of-fact, businesslike ritual and sticking to it:

- 1. When your model arrives, review the terms for posing—the posing fee, the length of the coming session, the amount of time between rest breaks, the kinds of pictures you wish to make, whether you will want model releases, and what you intend to use your pictures for.
- 2. Take your model to a place where he or she can undress in privacy and return to during rest breaks.

- 3. Have a clearly established place where the posing will be done, for example, on a no-seam paper background. Suggest that the model wear a dressing gown during rest breaks and at other times when not in the posing area.
- 4. When you are ready to go and your model is in the posing place, just say, "All right, we'll start now—just hand your robe to me."
- 5. Give posing instructions in a clear and matter-of-fact way, taking some of the poses yourself so that your model can see what you want. Don't touch the model unless it is very clear to both of you that he or she just doesn't understand your instructions; then it is all right to push an arm, leg, or hand into place.

As you see, this ritual is very artificial, almost like a heavily stylized dance. You can add to it or shorten it, depending on how at ease you and your model are. Consider yourself the main problem, however; when you relax your model will too. Bear in mind that the main purpose of the ritual is to lessen emotion, which it does by making the situation totally unlike a seduction scene and by constantly reminding both you and your model that your only purpose in being together is to produce fine photographs. Though the sexual tension very quickly drains out of a modeling session, it is wise to continue the ritual, anyway. So it is a bit phony? So it works, that's what.

Backgrounds and Posing Environments

In deciding on a background it is usually a good idea to follow photographic tradition, which insists that the posing place should be simple, handsome, and very unlike an everyday environment. In addition, it should "look like art," i.e., like something in a picture that is generally assumed to be art. Following this rather restrictive covenant may introduce an air of self-conscious artiness to your work, but this can be overcome. You should permit yourself to be guided by it mainly for self-protection, because following the tradition will make it obvious to nearly everyone

that your intentions are to produce art, not pornography. If your work isn't very good it is especially important to make your intentions clear.

Earlier, I listed an everyday environment as one reason for calling a nude study pornographic, an idea that approaches the ridiculous. Well, some people think this way, so you ought to take it into account. The thing is that everyday environments may imply certain things about your models and yourself that people find unacceptable. For example, if a man photographs a nude woman in her living room (an ordinary one) the implications may be that she is a nudist, that the photograph recorded only part of a seduction scene on the couch, that a sexually promiscuous woman removed her clothes in order to beguile the photographer, that the photographer deliberately invaded her privacy, and so on.

Though it is possible to produce nude "art" in an ordinary living room, the odds are against it. If the room itself is "art," that is good for a start. That is, you can do anything you like in Buckingham Palace. This is pretty weird stuff, but one has to go along with public morality—or at least be aware of it.

Fortunately, there is a very easy way around the background problem and it has other important advantages, too. Use no-seam paper, which comes in rolls nine feet wide and is available in many tones and colors. You staple or tape the free end of the paper to the wall, up near the ceiling, then roll it down the wall and out across the floor. Then you have your models pose on the paper.

No-Seam Paper

Since no-seam paper is by far the most popular background for nude studies, it deserves a section of its own in this chapter. It will also be discussed in the section on lighting.

An important factor in its usefulness and popularity is that it completely isolates the things that are photographed on it from everyday reality. In the resulting pictures they seem to exist in no par-

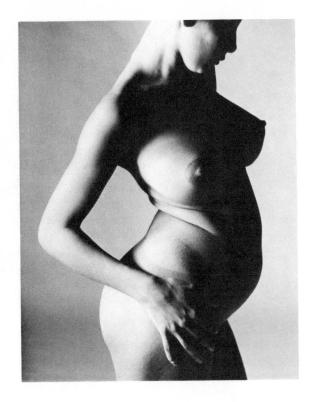

This girl has a splendid body (though her breasts are a bit large), yet it was possible to make her look gross and ugly. Though this might seem like a cruel and stupid thing to try, intentionally creating ugliness is actually a way of learning to see beauty better, for beauty and ugliness are two sides of the same coin. In the print below you can see that the girl's body is actually as healthy and handsome as I say.

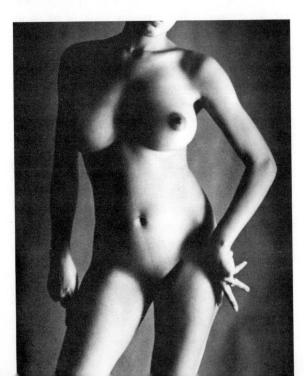

ticular place, and the paper itself doesn't even look like paper.

Since the paper background effectively represents no-place, it implies very few things about the people or objects that are photographed on it. However, one implication is fortunately quite clear: that the photographer's intention is to produce "art." Not journalism, sexual exposes, sociology, psychology, history, and so on—just "art."

Furthermore, using a no-seam will even help you in this effort, because it removes all environmental distractions so that you can concentrate on really seeing your models. And a well-seen human being always comes out as art—a well-seen anything does, for that matter. Since the human body is a very complex and aesthetically confusing structure, you need all the help in this direction that you can get. The body can be both beautiful and ugly; learning to see the difference is difficult; and a nondistracting background is a great help.

Though no-seams come in many colors it is best to stick to gray and white, even if you are using color film. The problem with color?—distraction. For example, with a red background—which you might wish to buy because it is very pretty—your eyes and emotions would be so overwhelmed by the sheer redness that you would have great difficulty in seeing the difference between Helen of Troy and a kangaroo. Because there was nothing else available, I once used a red background for some nude studies and thought I would go totally crazy before the session was over. However, color is pretty and you may insist on it. If so, you might try a pastel blue, which is the least distracting of colors.

The main problems with no-seam paper are finding a place that sells it, getting it hung without creases or tears, and keeping it clean while you are using it. It is usually sold in stores that supply artists, photographers, or window decorators. Experienced photographers can usually tell you where to get it.

With experience you will be able to hang a noseam by yourself, but at first you should have an assistant—your model, perhaps. One trick is to lift up the whole roll when you are attaching the loose end to the wall. After it is *very* securely attached (the paper is heavy) you can start carefully unrolling it. To unroll it *before* attaching it is an invitation to disaster, for it tears easily and is extremely unwieldy.

The cleanliness problem is due mainly to dirty feet-yours and your model's. Put a chair, a bucket of warm water, soap, and a towel right next to the background and have your model very carefully wash his or her feet before stepping onto the paper. Make it very clear that one should step directly into shoes, slippers, or socks upon leaving the background, so as not to dirty the feet again. The cleanest of floors isn't clean enough, so bare feet shouldn't touch it. As for yourself, step directly out of your shoes onto the paper and work in your stocking feet. And when you leave the paper, step directly into your shoes again. With such precautions you can keep a noseam clean for several modeling sessions. Without them you can ruin it in five minutes.

Abstracts of Nudes

Most people are extremely critical concerning beauty in the human figure, so most figures, including many very healthy ones, simply will not measure up to their standards. When you start shooting nudes you will probably feel the same way, but this is no cause for celebration. It means that in your ignorance and inexperience you are depriving people of their God-given right to be seen as beautiful. It also means that you will be deeply disappointed with all your full-figure shots, for you will undoubtedly work with bodies that are less than perfection or see really fine bodies poorly.

The thing is that our basic ideas of beauty and ugliness stem mainly from ourselves; we derive our concepts from human faces and bodies without really looking at them. We see nearly everyone as composed of both beauty and ugliness—physically, mentally, and emotionally. Though we

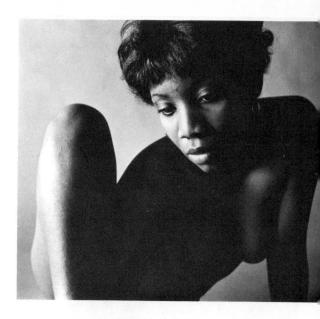

The leg is just one example of the phallic symbols that male photographers are always finding in female bodies. So be it. It seems to be one of the normal things for men to do.

see ourselves hardly at all, we think of mankind as flawed.

Now, ugliness can be defined as "that which is not well seen." Thus ugliness in humankind is largely a fiction based on the inability to see, yet it has a powerful influence on most of us. And the fact that we persist in seeing the average figure as both beautiful and ugly at the same time makes figure photography difficult, because ugliness easily wins out in our minds. The solution is to learn to see all figures, from the gross to the gaunt, as beautiful, but this is far easier said than done.

We must work toward this solution in easy steps, one of which is to make abstracts of nudes rather than full figures. In this way it is fairly easy to see abundant beauty in even the most ill-proportioned bodies, whereas in full-figure studies we might see only ugliness.

Photographing the figure in sections helps us

see beauty and ugliness in the abstract in terms of tones, lines, contours, textures, and colors, which simplifies the perceptual problem considerably. When one is working with segments of the body, the beauty and presumed ugliness residing in these areas are relatively easy to see. In a full figure, even a splendid one, beauty and so-called ugliness are often so intertwined and complex that it is next to impossible for a beginner to sort them out; and he or she often ends up seeing only the ugly.

Working with sections of a figure does more than help you differentiate between beauty and presumed ugliness in abstract visual terms such as tone, light, texture, etc. It also helps you expand your mental-emotional concepts of beauty—which control your ability to see it—until you eventually see little in a human figure but beauty. Frankly, this is one of the main justifications for doing figure photography: to learn to see all people as beautiful.

When you are working with abstracts of nudes it is sometimes interesting (and quite easy) to work with two or more bodies; and people—both men and women—don't mind posing together. However, if you show whole figures people are likely to think you are purveying pornography, so stick to abstracts.

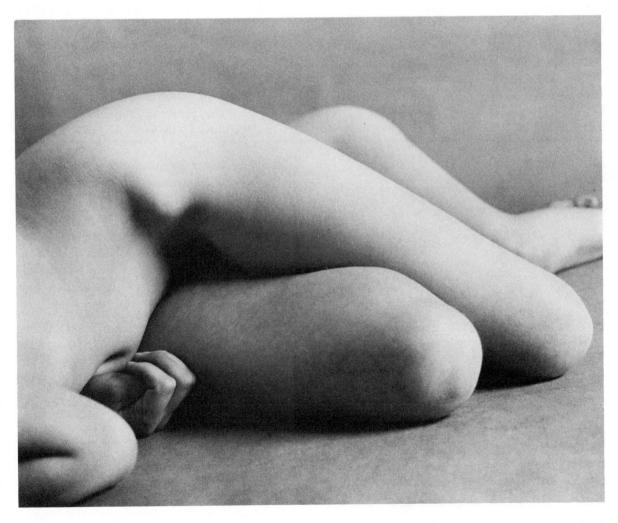

HOW TO PHOTOGRAPH THE NUDE

Learning to see the beautiful drains away the fear of ugliness, and when the fear goes away the ugliness goes with it, for fear and the concept of ugliness are very closely related. In essence, that which we fear is called ugly, though fear itself is the real culprit.

Now, with an expanded sense of the beautiful you will still be able to identify so-called ugliness (with much greater skill than before), yet you will tend to see it mainly for what it really is: a concept based largely on fear and ignorance.

The emotional charge (fear) will drain out of your perception of ugliness, enabling you to use it with dispassion in your photography. In truth, ugliness is only a tool for the artist; it is merely an aspect of the beautiful; and art without it isn't really art. These things are very hard to see and understand, but approaching the nude mainly through abstractions will help you a great deal. You think you already know all about beauty and ugliness—but wait and see.

Once you have a better idea of the endless dimensions of beauty you will be able to handle

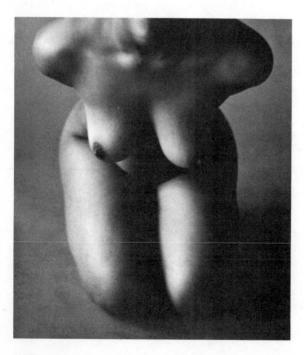

full-figure nudes with little difficulty. Until then you will tend to see human bodies only through your stereotypes, which means you will hardly see them at all.

Posing the Nude

The best way to pose nudes is to not pose them at all, though one can pose them up to a point. The thing is that the beauty in human beings comes out best when they are behaving naturally by making themselves comfortable. However, giving people detailed instructions limb by limb on how to dispose themselves for your camera almost invariably makes them quite *uncomfortable*, which introduces too much of the ugliness factor.

The thing is that people will cheerfully move a limb at a time if you ask them to, but this is not the normal way to shift position. With every movement, no matter how small, the body as a whole wants to adjust position, for that is the way it was made to function. Thus having models move their parts piecemeal makes them look like badly built robots. However, if that is what you want, go right ahead.

The best way to get handsome poses is to give very generalized instructions to your models and encourage them to do as you wish in the most comfortable ways possible. For example, you might say, "Lie down here, curl up a little bit, and make yourself as comfortable as you can" or "Stand facing me, carry your weight mainly on one leg (like this), and brace your right hand on your hip (like this). Now, make yourself com-

The objective here was to see the figure as an abstract sculpture, perhaps by Henry Moore or Jean Arp. Working with abstracts is the best way to refine your perception of beauty. With whole figures, personality problems tend to interfere with vision.

fortable, because you may have to stand there for a while."

Though the instructions for the standing pose are rather specific, they only ask a person to do what people normally do when they have to stand for a while. Such things as the position of the head, the tilt of the pelvis, the position of the left hand, and the placement of the leg that is not carrying weight are left strictly up to the model. Indeed, the less you have to tell a model the better off you are.

Unfortunately, some people don't quite believe it when you say you want them to be comfortable, so you have to continually reinforce the idea until they do. One way is to frequently tell them to break their poses as soon as they begin to get uncomfortable, even if this makes you miss a few pictures. Just tell them that there will be plenty more good poses to come and that you will get all the pictures you need. Even with such instructions, some models will hold poses until they turn to stone. So be on the lookout for signs of strain and ask them to break their poses as soon as you see it. And bear in mind that holding a pose can be very hard work.

Some models deeply enjoy following the instructions: "Make different shapes with your body just to see what they feel like. Hold each shape for a few seconds, then try another—or hold the shape longer if it feels good. I will take care of the photography end of it, so don't bother waiting for me to shoot." Doing this kind of thing is much easier than holding set poses for five or ten minutes at a time, so models don't tire so rap-

The objective here was to see the figure as akin to a sugar bowl with two handles, or perhaps to some winged creature. Seeing a human body as related to lots and lots of things is a way of comprehending how wonderful it is. And the related things are wonderful too.

idly. It also gives you the opportunity to see many more poses than you normally would in a modeling session. If a particular pose is good, you can ask your model to hold it a while, or until it begins to get uncomfortable. For your model's morale you should photograph every pose (film is cheap), even if you don't like some of them very much. Later, you can study your contact sheets and figure out why you didn't like them, which is a good way to learn.

The morale factor is extremely important, incidentally. In order to let their natural beauty flow out, people must feel cared for and appreciated while they are being photographed. In order to be beautiful they must dare to think that they are, so you must help them. One way to do it is to welcome each pose with words such as good, fine, swell, wonderful, excellent, lovely, and so on—but it works best if you really mean what you say. If you don't like a pose think of something you do like (say your model's efforts to please you) and say, "Wonderful," anyway. Your affirmation will then be genuine.

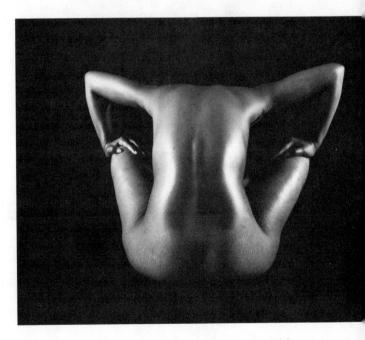

You don't always have to be dead serious in figure photography. Here Dorothy Grazes reveals that she has a heavy vein of natural ham in her. A welcome change from pious or preachy nudes.

Lightings

Beginners should use only bounce lightings, for they are easiest to use and very flattering to the human body. In contrast, direct lightings bring in far too much of the ugliness factor, unless one is expert at using them. This is because they create sharp-edged shadows, which can make bodies look hacked-up, ill-proportioned, and stuck together with joints in the wrong places. This is all illusional, of course, but the magic is so strong that it can lead to very ugly pictures. Well, just to see for yourself you should try some direct light-

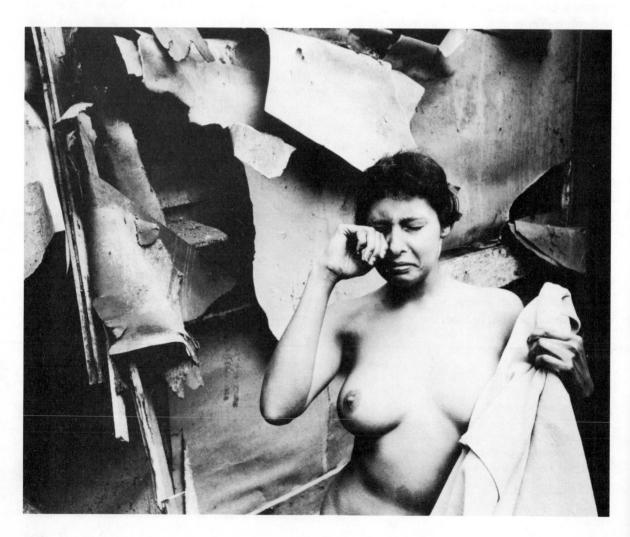

ings, anyway. But if your models come out looking like dead meat, don't be surprised.

Fairly contrasty side bounce lighting gives bodies a very sculptural feeling, that is, roundness, solidity, and realness. And it may actually make them look like sculptures. At the same time it creates very soft-edged form shadows on figures, gently bringing out all the beauty of the human form. The darker shadows (in prints) obscure certain areas, so that an element of mystery is added. Surely, one should approach human beings as mysteries, for that is the only intelligent thing to do.

For figure studies, side bounce light works best with a medium-gray no-seam paper background. Using bounce light from both sides of a model also works well, especially if the light from one side is slightly stronger. With this double bounce lighting you get highlights on both sides of a figure and very interesting and handsome shadows in the middle. You will surely see curves that you have been unaware of before and increase your awareness on what figure photography can teach you.

Side bounce can also be good with white noseams, though gray is much easier to work with. However, you may have trouble in making your prints if the highlights on your model match the background in tone. Then parts of the figure will simply disappear into the background tones of the prints. The way around this is to position the model far in front of the vertical part of the white no-seam; about seven or eight feet is far enough.

With this distance to work with you can use your lighting to control the brightness relationship of model and white background and make them sufficiently different in tone so that they will not blend together in prints. This is called "getting enough separation." If you use overhead bounce light you will usually not have as great a separation problem with a white noseam, but you will probably have printing problems, anyway. Your preconceptions will undoubtedly get in your way.

You see, many people think that white back-

grounds should "logically" come out white in prints, because white is always white. So they print them white, but the pictures just don't look right. They simply "fall apart," the tones looking disconnected and shattered. Even so, white *is* always white—but only as an abstract concept.

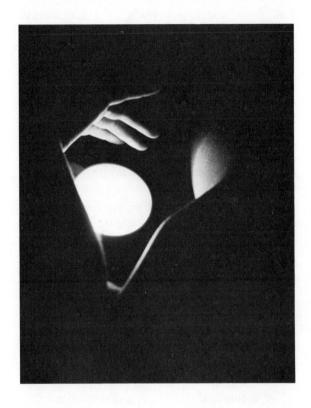

Here we see how very abstract a figure study can be—just three curves, four fingers, and the light source. Working this simply will help you refine your taste, whereas in working with full figures you might be greatly distressed at your inability to see the beauty in them. So stick to simplicity and save yourself suffering.

However, in the world as we see it the whiteness of something is mainly relative to the lightness or darkness of other things seen at the same time. Grayness and blackness are also relative. Another way of describing this tonal relativity is to say that lights make darks, darks make lights, and both can make grays. In other words, a thing is seen as light, dark, or gray only in comparison with other things, for vision is a comparative process. In a universe exclusively black, white, or gray there could be no human visual perception at all, at least not with our present perceptual equipment.

Now, we are not off on a digression, or detour, but are creeping up on the question of what figure photography is actually good for beyond producing pretty pictures of naked people, which is not really very important. So bear with me a while longer.

We will return to white paper, because it is a good teacher. When we exclude its surroundings, a white no-seam will also *look* white only if it reflects considerably more light than the model positioned on it (this is difficult to see in the studio, easier to see in prints). Whether this will happen depends on the reflectivity of the model's skin and the paper (the percentage of incident light that they reflect) and the relative intensity of light falling upon each one (there are other factors, but they are best ignored at this point).

For example, if the model and the white background receive the same amount of light the background will tend to *look* white because of its higher natural reflectivity. However, if we slowly change the lighting geometry so that the model receives progressively more light than the background paper, the paper will be seen to gradually change from light, to medium, to dark gray—or even to black. Though such a change should be obvious to anyone who sees it happening, it unfortunately is not.

To understand why it isn't obvious we must consider certain differences between seeing and perception. In the simplest terms, seeing means using the eyes to permit visual data (in the form of differential light energies) to enter oneself. In this sense, all people with normal eyes see extremely well. But perception is quite another matter. Perception refers to what the ego and the portion of the mind that it dominates do with the visual data received through the eyes. Since the ego is a highly fallible instrument it frequently garbles, or misinterprets, the data.

Among other things, the ego creates highly inaccurate mental images of the visual world from the splendid data transmitted by the eyes. That is, the ego's perception of this world is very poor. For example, it radically alters nearly everything, confuses memory with vision, ignores things it can't explain, automates perception with bad programming, and refuses to see changes in the constantly changing visual world around it. This is perception. Unfortunately, our awareness of the visual world is strictly limited to our perception of it. We see immensely more of it, but we are not aware of this. Another way of describing the situation is that our only contact with the visual world (our perception of it) is through egocolored glasses, which is a very uncomfortable thought.

So, we return to the white background that people persist in perceiving as white, even when it happens to be gray. Why is this? Well, it is an ego problem, first of all. The ego insists on seeing whiteness (or grayness or blackness) as an unchanging (absolute) characteristic of certain things, not as a relativistic quality that they may sometimes display. White as an absolute is a comfortably simplistic concept, while the notion of whiteness as relative is not. The ego clings to the absolute simply because it always wants to move in the direction of its greatest comfort. Therefore, it persists in perceiving whiteness that isn't there, even though this contradicts the visual data coming to it through the eyes.

Considering the problems, you might suppose I am trying to tell you to never use a white no-seam for figure photography. Indeed, I consider it manditory that you use one now and then to help you really understand the things you have just

read. There is more to come, so bear with me still longer.

Though this is a section on lighting, backgrounds are a very important part of learning how to light things. The reason for this is that certain backgrounds will give you a greatly improved opportunity to perceive what light does to things and what things do to light. The great visual simplicity of neutral-colored no-seams eliminates all visual distractions (rugs, chairs, wallpaper, architectural details, etc.) and makes such perception much easier. And nude human models contribute greatly to the motivation.

The overall objective is to overcome the bad perceptual habits of a lifetime (ego habits, or self-conditioning) and make your perception as accurate as your seeing. In the arts this is called "learning to really see" or sometimes just "learning to see." Whatever it is called, it means developing acute awareness of what is happening in the visual world. And it happens that the human body has been studied for this purpose for millennia: to teach people to see.

Overcoming the habit of perceiving the tone of a background as an unchanging absolute is just a step along the way, yet it is an important breakthrough. The lightness or darkness of a thing is a relative quality. A larger step is to see that this also applies to human bodies. By careful choice of background and lighting, one can make a black person white, a white person black, or make either of them gray, but these are gross changes. Becoming aware of the subtleties of what light can do is what really matters, and doing figure studies can be a great help in this direction. More of this in a moment.

A Primary Justification for Figure Photography

You may think that the best reason for photographing nudes is to simply make beautiful pictures. Not so. It is the process of making them and what experiencing the process does to you that count. The pictures as such are of relatively

little importance. These truths have been known in the arts for hundreds of years. The main objective of figure studies has always been learning to see better.

Now, learning to see is a very heavy experience involving a good deal of suffering in the form of nausea, headaches, and despair. Any real artist can tell you this. Indeed, so great is the suffering that most people won't even try to learn unless they are powerfully motivated. So here is where the human body comes in: most of us are strongly motivated to see it well. As we are learning how we soon discover that seeing the body helps us see everything else, too, and this encouraging insight adds greatly to our motivation. Understand this: the urge to be truly aware of the visual world can be very strong.

Essentially, to develop motivation means to tap the forces within oneself, the sexual force being the strongest. People being what they are, it is not hard to understand that this force might provide photographers with abundant energy for figure photography. Psychologists like to call this "sexual sublimation," or the use of a lower force for a worthy purpose, such as the creation of art. More accurately, it is the use of the *highest* force for self-evolution, part of which involves learning to see. In learning to see we create ourselves, you might say.

In this so-called age of sexual enlightenment, one might wonder if interest in sex is still strong enough for it to perform its motivational function in the arts. Or has it gotten so commonplace that nobody gives a damn any more? Well, this sexual revolution of ours is mainly journalistic hot air, and people haven't really changed a bit in any fundamental way. Whether we like it or not we are programmed to be interested in sex and will be able to draw on its energies for artistic purposes as long as people are left on earth.

Usually, when we try to learn something we start out on the simplest possible level and try to build up to it step by step. In studying the figure, however, we do it the other way around and start out on the highest level of all. Following is a list

HOW TO PHOTOGRAPH THE NUDE

of some of the difficulties encountered: figures are visually complex; we are greatly confused by seeing them as beautiful and ugly at the same time and unable to decide which is which; positive and negative sexual feelings badly impair our vision; our perception is badly warped by extremely ignorant notions concerning what healthy bodies should look like; and we are willing to look at them from just a few highly selective viewpoints, all others being considered as distortions. And this is not the half of it.

Considering the difficulties of learning to see a figure well, one might think that only an idiot would even try. Sure enough. If it weren't for the benevolent energy of the sexual force, figure photography would be much too hard for any of us. However, a little bit of this energy goes a long, long way.

Since there is a lot of heavy reading in this chapter, a simple summary of some of the main points may be helpful to you:

- 1. Learning to see is difficult.
- 2. Part of the process is to discover the things considered worth seeing, many of which are embodied or reflected in the human figure. This is because our aesthetic value systems are based on ourselves.
- 3. Learning to see the body will help us see things worth seeing elsewhere, for the body is visually related to the rest of the world. For example, its curves and textures are found in many places.
- 4. But learning to really see the body is extremely hard work, and this work involves a considerable amount of suffering.
- 5. However, the sexual force gives us direction, provides us with energy, helps us have staying power, makes our suffering bearable, and gives us hope, so that we can confront this otherwise overwhelming task.
- 6. In short, we can use the sexual force and the human body in a method for teaching ourselves to see. Though there are other methods, this one is fastest.

Scenes from my figure photography classes at New York's School of Visual Arts. The atmosphere was always casual, with people running in and out of the studios, and students didn't have to make pictures unless they wanted to. In one picture we see the boys persuading student Jan Cobb that he should be a nude model too.

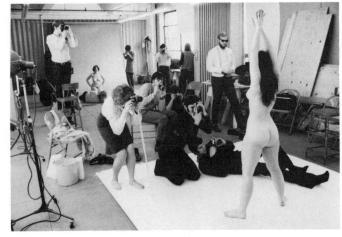

Miscellany

Hand-held miniature cameras, especially 35mm single lens reflexes, are best for learning to see through doing figure photography. In comparison with larger cameras they encourage one to shoot more pictures, view models from more angles and distances, and make more prints.

Normal lenses are best for figure work. Though wide-angle distortions are very interesting at first, one soon tires of them. Telephotos won't let you get close enough and may limit the angles from which you can shoot—unless you have a very tall stepladder.

Model releases can be obtained from camera stores.

A roll of no-seam paper is long enough to provide you with either two or three backgrounds, depending on how far you stretch it out on the floor. To inhibit wrinkling in the paper, store the roll by standing it up in the corner of the room. If you like, you can buy special aluminum poles for hanging no-seams.

Don't use black no-seams, for they are psychologically very depressing to both photographers and models. Also, they make human skin look very dead and dreary.

To maintain your morale you should try to work only with handsome, well-built models while you are still a beginner. Even then you will find it quite a challenge to solve the beauty-ugliness problem. When you are quite advanced you may be ready to search for beauty in the gross and the gaunt, or you may never reach that level. Though beauty abounds in such people, it may be very hard for you to find, for that beauty must also be in the eye of the beholder.

Use either one or two 500 watt bulbs for your bounce lightings. They will give you enough light for both black-and-white and color films. However, 1000 watt bulbs are even better—if you can find them. A household electrical circuit will usually handle two of them at once.

As you have seen, studying the figure can be a way of learning to see. I used the method for five years at New York's School of Visual Arts, where I taught second year photography students. The required semester of figure photography worked very well for most students. The students in my last two years were so exceptional that I permitted them to work only with homely models. They were ready to see that these rather bedraggled men and women were also very beautiful. To their everlasting credit, a few of the students managed to see this. Their pictures were beautiful, of course.

HOW TO PHOTOGRAPH A GHOST

ESP and the occult have become such popular subjects nowadays that every supersensitive soul ought to know how to conjure up ghosts. Since live (or dead?) ghosts are hard to find and not dependable, you may have to stir up some fresh ghosts on your own. Let your friends furnish the bodies and photography provide you with the modus operandi. And as you work think, "Dracula will love me for this."

How to Deaden Your Friends

Turning live flesh into ectoplasm is not a hard job—you do it by double-exposing film. Put your camera on a tripod and take a picture of your candidate for smoky oblivion. Then without moving the camera take another picture on the same film frame without him or her on it. In the resulting color slide or black-and-white print you will find a properly constituted ghost—it's as easy as that. However, ghosts can vary in quality from the truly horrendous to the merely banal, so we will look into some of the tricks of the ghost-making trade.

• Preparing Your Ghost

The average ghost is apparently like anyone else except for being a lot less dense—it doesn't have enough smoke or ectoplasm to fill a shot glass. Thus a very translucent picture of somebody ought to look ghostish enough, but some photog-

raphers won't settle for that. They think that ghosts ought to be hoked up like everything else. If you agree with them there is a lot of mischief that you can cook up.

There is catsup, of course, if a bloody ghost is your ideal. A sheet to make a ghost of your wife or husband, and a pillow case for the cat—wraparound ghosts, you see. Some people think that ghosts should dress like nuns or monks, though genuine nun or monk ghosts are no more common than any other kind. Real ghosts wear ectoplasmic clothes, they say, but you may wish to fabricate a nude ghost. And you could get some good mileage out of Halloween masks and fright wigs. I personally prefer very ordinary ghosts, but that is what I am used to. If there is to be a brimstone ghost with three heads, snakes for hair, a forked tail, and teeth like a snark, I'm afraid that you yourself will have to create it.

How to Make Double Exposures

Depending on the kind of camera you have you may or may not be able to make double exposures. Many cameras have built-in provisions for this, but you can get along if all you have is a shutter with a "B" (bulb) setting. A typical built-in arrangement is a little button you depress before rewinding your film. On some cameras, if you hold it down while using the film advance lever you will cock the shutter without advancing the film. That is, the film frame that you have just

HOW TO PHOTOGRAPH A GHOST

exposed will stay in place so that you can expose it again.

To use the bulb setting for double exposure you need a 5-inch sheet of black paper or cardboard. A cable release is extremely useful, though not absolutely necessary. When you have set your camera on "B" the shutter opens when you depress the shutter release and stavs open as long as you hold down the release with a finger or a cable release. When you are ready to make a picture. hold the black card in front of the lens so that no light can get into it, then open the shutter and hold it open. As long as the card is there no light will reach the film. To expose the film, jerk the card away for a moment, then put it back in front of the lens and ask your ghost to get out of the way. Finally, jerk the card away again to make the second exposure, then put it back in front of the lens and let the shutter close itself.

This black card exposure method is classical in photography, incidentally. It was used with ancient cameras and lenses that didn't have shutters. With modern cameras it is a way of making sharp pictures by getting around camera movement caused by shutter vibration or by reflex mir-

Ghostly Bob and the mirror again—from another angle and distance.

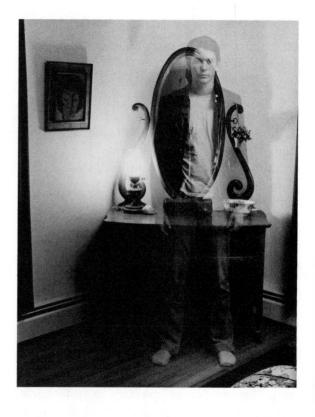

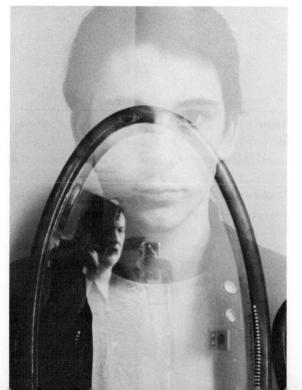

My younger stepson Bob Turner as a ghost. This was a simple double-exposure shot, with the mirror (and my reflection in it) getting two exposures, Bob getting one.

HOW TO PHOTOGRAPH A GHOST

rors slamming into the "up" position. If the shutter is held open with a cable release, the method can also be used to get away from movement caused by a flimsy tripod or makeshift prop for a camera.

Ghost Bob Turner with ancestors, mainly mine. The little girl on the right is his mother as a child. She and Bob look very much alike.

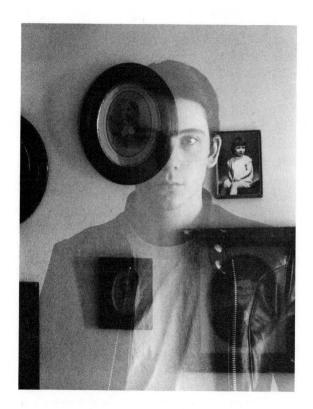

The ghost of the chair—again simple double exposure. Notice that Bob's head and hands look real enough, while his legs look quite transparent. How substantial a ghost looks depends primarily on how much exposure it gets in comparison with the total exposure.

Exposures

Since the background gets photographed twice, you should avoid overexposing it by giving only half of the correct exposure with each of your two shots. You can halve the correct exposure by stopping down an extra stop or by selecting the next fastest shutter speed. Thus the background will end up correctly exposed, while your ghost will be 50 per cent underexposed, which is mainly what will make him or her look like a ghost.

For the black card exposure system you need exposures that are long enough to be timed with reasonable accuracy by counting under your breath, with 1 second probably being the shortest usable time. Thus before being cut in half the correct exposure time would have to be at least 2 seconds. There are several things that you can do to get such slow exposure times—stop down your

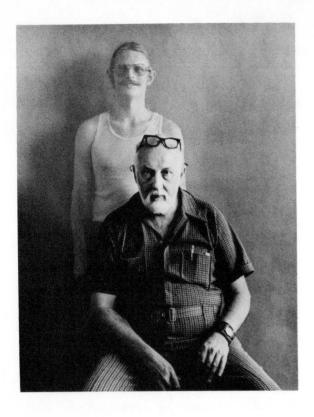

The author with ghost Mike Goodwin. Mike has the most erect posture of any man I know.

Mike and Claire Goodwin, a simple double exposure. Claire sat still for two exposures, while Mike only stayed around for one.

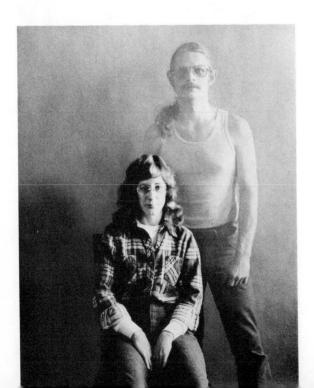

lens all the way, work in rather dim available light, or use a medium-to-slow film (ASA 125 or under).

You might think that exposures timed by counting wouldn't be accurate enough, but they usually are. Furthermore, inaccuracy as high as 50 per cent usually doesn't matter very much, especially with black-and-white films. With color films you will barely be able to see what difference it makes.

Backgrounds

In order for your ghost to show up well in a color slide or a print, the area behind him or her in the picture should be from medium gray to black in tone. With light gray backgrounds ghosts show up poorly, with white ones not at all.

If there are objects (chairs, pictures, doorways, etc.) in the backgrounds behind your ghosts they will be visible through the ghostly bodies in your pictures, making said bodies look quite transparent, as proper ectoplasm should.

If your background is *really* black the ball game changes somewhat, because you can make as many shots as you like on the same frame without the film getting any exposure at all from the background. Thus you can make from 3 to 12 or more shots of the same ghost located in different parts of the picture.

By using a black background (black no-seam paper or the black sky at night, for example) you can use the same model as both a real person and a ghost in the same picture. For the real image, give the full correct exposure. For the ghost, cut the exposure in half. Your model should change position after the first exposure, of course. If you like you can make the ghost image even more wispy and ethereal by using only one fourth of the correct exposure when you shoot it.

Unfortunately, black no-seams aren't really black (just dark gray) unless you take pains to shade them from light. It may take a while to figure out how to do this, but you will come up with an answer if you try. In comparison, a black

sky will stay that way, no matter what you do with your lights.

If your background is really black you can take several real images and several ghost images of the same person on a single frame of film.

Ghosts and Non-Ghosts

You can make a ghost picture with just a ghost image, but it is often better to have two images—one to look ghostly, the other to look real. By having someone real to compare your ghost with it will look even more ghostly.

The technique is simple enough, though your real person will have to hold a long pose. The ghost has to be in position for just one of the exposures, but the real person must hold stock-still until both exposures have been made. However, if you are using a really black background you can photograph your models one at a time, exposing normally for one and underexposing the other. You won't get quite the same effects with the two methods, but your ghosts will look sufficiently ghostly.

Other Tricks for Making Ghosts

You can turn a person into a ghost simply by photographing him out of focus. Or you can use selective focus and have the person out of focus and everything else sharp. Blurred movement also works very well. You get it by using a slow shutter speed and having your subject move during the exposure. Moving your camera instead of your subject will also give you blurred movement.

Some Potentials of Photography

Though this chapter is mostly about ghosts it is also designed to help you see some of the many potentials of photography. You can do a great many things with double exposure, which you now know how to do. It is one of the standard creative techniques of the medium.

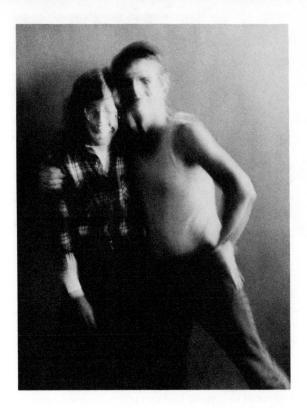

Ghosts made in another way, by blurred subject movement. Mike and Claire were jumping around quite a bit, and I photographed them with a slow shutter speed, their movement and the slow speed causing the blur.

Charles, holding a candle, spins to his left and becomes a ghost. A very slow shutter speed helped create the effect.

The ghostly bartender, your author himself. Notice that the central part of my figure—which was a dark jump suit—disappears almost entirely.

A statue of an ancient Egyptian princess turned into a ghost by selective focus. I shot at a wide aperture (probably f/2), which would give only a very limited depth of field. Then I focused on her headdress, letting her face go way out of focus. This makes it appear that my model was a live person.

Christine turned into a rather ghastly ghost by blurred movement. Here she looks like a cross between a troll and a grasshopper.

I exposed a whole roll of film with tree trunks, stumps, and knotholes, then re-exposed the roll with images of Anna, this being one of them. She's the nymph of the tree more than a ghost.

I changed a little statue into a ghost by racking it way out of focus and shooting it that way.

A typically foggy winter night in Birmingham, England. I guessed a hand-held exposure, but it would have been better to have a tripod and use extensive exposure bracketing.

Making pictures by available light after dark is a lot of fun, though you do have to concentrate on getting your exposures right. Fortunately, there are a number of ways around this problem. In this chapter we will take up the methods that are easiest to use.

More Information for Sports Photography

Though this chapter is primarily designed to provide a general picture of the available light situation and the exposures involved, it is also an extension of the material on sports photography. For example, you will find estimated exposures (for a variety of ASA ratings) for many night sports events, including football, baseball, horse racing, boxing, wrestling, ice shows, swimming, basketball, hockey, and bowling. There is also additional information on speed pushing for both black-and-white and color films, including a list of film and developer combinations recommended for this purpose.

• If You Don't Have a Supersensitive Exposure Meter

For working at night it is desirable to have a supersensitive light meter such as the Gossen Luna-Pro. There are also supersensitive light boosters to use with meters built into certain cameras. Unfortunately, most meters—including built-ins and separate meters—won't give you good readings in dim light. Indeed, many of them

won't register at all when used in the ordinary way. To compound the problem, you may not even have an exposure meter. Don't despair: we will cover two very good ways for getting better readings with insensitive meters. And in the following section there is material that will help you solve the exposure problem without even having to use a meter.

Available Light Categories and Exposure Chart

The things that people generally wish to photograph at night can be put into convenient exposure categories. This is because certain professional photographers and photographic technicians have spent a great deal of time photographing these things all over the country and have learned an immense amount concerning the exposures required. The thoroughly explored categories and exposures are usually printed on convenient exposure dials, charts, or information sheets included in film packages. Since the information has been tested again and again over a period of many years, you can get very good exposures by using it properly.

However, you must understand that some exposure information can only be approximated. For example, in the list of categories that follows you will find "bright downtown streets" (category E). Surely you realize that the brightness of streets will vary from city to city or from one part of town to another. For this reason you may not

The tone of the street just below the car on the left seemed to be about the average tone of the scene, so I took an exposure reading from it, figuring that the other tones would take care of themselves. The exposure on Tri-X at ASA 400 came out right on the button (about 1/30 at f/2.8).

get a good exposure for a given street by following a recommended exposure too literally.

The thing to do in such a situation is to bracket the exposure, using the recommended exposure as the presumed normal exposure. For all the categories listed in this section it should be sufficient to bracket with only 3 shots—one normal exposure, one that is 2 stops overexposed, and one that is 2 stops underexposed. There is a very high probability that one of your 3 shots will be exposed just right.

For the overexposure, open up the lens 2 stops, or use a shutter speed 2 positions slower, or open up 1 stop and use a shutter setting 1 position slower.

For the underexposure, stop down 2 stops, or use a shutter speed 2 positions faster, or stop down 1 stop and use a shutter setting 1 position faster.

While you are doing the bracketing record all of your exposures in a little notebook. Then when your film has been processed mark the exposures that look best. Thereafter when you photograph again in the same places you can get the correct exposures from your notes; your recorded exposures will be more accurate than a dial, chart, or even a sensitive exposure meter.

Even if you have a supersensitive exposure meter the available light exposure chart should prove useful. It gives you a preview of the kinds of exposures you will probably use in various lighting situations and can be used to check your metering technique. If the exposures you get by using your meter differ considerably from the charted exposures you should begin to suspect your methods and carefully check them for errors.

Categories of available light at night

- A Early dusk shortly after sunset
- B Skyline 10 minutes after sundown
 Neon and other lighted signs
 Spotlighted subjects at ice shows, circuses,
 and stage events
- C Brightly lit theater and nightclub districts—
 Las Vegas or Times Square
 Burning buildings and campfires
 Night football, baseball, racetracks
 Floodlit circus and ice show subjects
- D Interiors with bright fluorescent lights
 Boxing and wrestling events in sports arenas
 Ground displays of fireworks
- E Bright downtown streets
 Basketball, hockey, and bowling
 Stage events with average lighting (not spotlighted)
 Hospital nurseries
 Color TV with black-and-white film
 Store windows

- F Bright home interiors
 Fairs and amusement parks
 Interior swimming pools, above water
 Museum dioramas
- G Amusement park and carnival rides
- H School stage and auditorium events
 Church interiors
- I Car-traffic light patterns (give long exposures to bring out the patterns)
 Average home interiors at night
- J Indoor and outdoor Christmas tree lights
- K Aerial displays of fireworks
- L Illuminated fountains Lightning
- M Subjects lit by streetlights Subject 6 inches from a candle
- N Floodlit buildings and monuments
- O White lights on Niagara Falls
- P Light-colored lights on Niagara Falls Subjects lit by bonfires
- Q Subject 1 foot from a candle Dark-colored lights on Niagara Falls
- R Floodlit dark factory buildings
- U Subject 2 feet from candle
- W Full-moonlit snowscapes
- X Full-moonlit marines and distant landscapes
- Y Full-moonlit landscapes at medium distances

In order to condense the information as much as possible the exposures in the following chart were calculated for only two aperture settings—f/2.8 and f/3.5—f/2.8 being a regular f-stop and

f/3.5 a half stop located on the aperture scale of a camera between f/2.8 and f/4. Thus f/2.8 and f/3.5 are a half stop apart. You can make both settings with most lenses fast enough for night photography, and they are very frequently used. If you wish to convert exposure times for use with other f-numbers there are two simple charts that will help you do this. Though experienced photographers usually make such conversions in their heads, you may need a little help at this point in your career.

The ASA numbers on the preceding chart may be considered as either rated film speeds or as push speeds, depending on how you use them. For example, if you use the ASA 400 shutter speeds for Tri-X you would be shooting it at its rated speed (the one given it by the manufacturer). However, ASA 400 would be a push speed for a film rated at ASA 100. Similarly, ASA 800 would be a push speed for Tri-X.

Though a rated speed and a push speed aren't the same thing, we preface both speeds with the letters ASA. You set both types of speeds on your exposure meter as ASA speeds. Furthermore, you use a push speed as if it actually were a rated speed. For example, you can expose Tri-X at ASA 1600 even though it is actually rated at ASA 400.

This is quite confusing, to be sure, but you can figure it out if you stick to it. The jargon of photography is often incomprehensible at first, but you will gradually get used to it.

An old hotel in my home town of Conrad, Montana (population 2,000, more or less). I took an exposure reading from the wall under the sign, expecting the windows, street lamp, and sky to take care of themselves, which they did. I forget what the exposure was—photographers usually do forget.

Available Light Exposure Chart

	ASA 100	ASA 200	ASA 400	ASA 800	ASA 1600	ASA 3200	f-number
Α	1/125	1/250	1/500	1/1000	1/2000	1/2000 1/4000	
В	1/60	1/125	1/250	1/500	1/1000 1/2000		f/3.5
С	1/60	1/125	1/250	1/500	1/1000 1/2000		f/2.8
D	1/30	1/60	1/125	1/250	1/500	1/1000	f/3.5
Е	1/30	1/60	1/125	1/250	1/500	1/1000	f/2.8
F	1/15	1/30	1/60	1/125	1/250 1/500		f/3.5
G	1/15	1/30	1/60	1/125	1/250 1/500		f/2.8
Н	1/8	1/15	1/30	1/60	1/125 1/250		f/3.5
ı	1/8	1/15	1/30	1/60	1/125 1/250		f/2.8
J	1/4	1/8	1/15	1/30	1/60 1/125		f/3.5
K	1/4	1/8	1/15	1/30	1/60	1/125	f/2.8
L	1/2	1/4	1/8	1/15	1/30	1/60	f/3.5
М	1/2	1/4	1/8	1/15	1/30	1/60	f/2.8
N	1 sec	1/2	1/4	1/8	1/15	1/30	f/3.5
0	1 sec	1/2	1/4	1/8	1/15	1/15 1/30	
Р	2	1 sec	1/2	1/4	1/8	1/8 1/15	
Q	2	1 sec	1/2	1/4	1/8	1/15	f/2.8
R	4	2	1 sec	1/2	1/4	1/8	f/3.5
S	4	2	1 sec	1/2	1/4	1/8	f/2.8
Т	8	4	2	1 sec	1/2	1/4	f/3.5
U	8	4	2	1 sec	1/2	1/4	f/2.8
٧	16	8	4	2	1 sec	1/2	f/3.5
W	16	8	4	2	1 sec	1/2	f/2.8
X	32	16	8	4	2	1 sec	f/3.5
Y	32	16	8	4	2	1 sec	f/2.8

Chart for Finding Shutter Speeds (or Exposure Times) for Whole f-Stops Starting with the Charted Shutter Speeds for f/2.8

	Starting with the shutter speed (or exposure time) for f/2.8
f/1.4	2 shutter speeds (or exposure times) faster
f/2	1 shutter speed (or exposure time) faster
f/4	1 shutter speed (or exposure time) slower
f/5.6	2 shutter speeds (or exposure times) slower
f/8	3 shutter speeds (or exposure times) slower
f/11	4 shutter speeds (or exposure times) slower
f/16	5 shutter speeds (or exposure times) slower
f/22	6 shutter speeds (or exposure times) slower
f/32	7 shutter speeds (or exposure times) slower

Chart for Finding Shutter Speeds (or Exposure Times) for Half-Stops Starting with the Charted Shutter Speeds for the Half-Stop f/3.5

Set aperture at:	Starting with the shutter speed (or exposure time) for the half-stop f/3.5			
f/1.4 y f/2	2 shutter speeds (or exposure times) faster			
f/2 f/2.8	1 shutter speed (or exposure time) faster			
f/4 f/5.6	1 shutter speed (or exposure time) slower			
f/5.6 T f/8	2 shutter speeds (or exposure times) slower			
f/8 y f/11	3 shutter speeds (or exposure times) slower			
f/11 y f/16	4 shutter speeds (or exposure times) slower			
f/16 y f/22	5 shutter speeds (or exposure times) slower			
f/22 f/32	6 shutter speeds (or exposure times) slower			

Relationship of Film Speeds in Terms of f-Number Settings

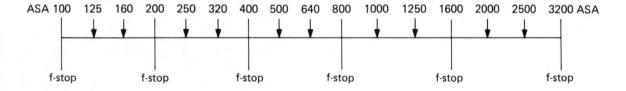

The vertical lines in the diagram above represent f-numbers spaced one stop apart. Immediately above them are the ASA speeds listed on the Available Light Exposure Chart. In between are other ASA speeds that are commonly given to films. If you are using a film with one of the in-between speeds you can safely use the shutter and aperture settings for the charted ASA speed that it is closest to. For example, if your film is

rated at either ASA 160 or ASA 250 you can use the settings given for ASA 200. Since the listed exposures are only approximate anyway, the amount of error that will be introduced this way (about ½ stop) won't really matter. Furthermore, exposure bracketing will compensate for much larger errors and for the approximations in the Available Light Exposure Chart itself.

Because the information on the Available Light Exposure Chart has been highly condensed you will have to extrapolate (perform conversions) in order to get certain other information that hasn't been listed. This new information is implied by the list, but you have to know how to find it. To make your search easier, three supplementary charts have been provided. You might call them charts for interpreting a chart.

The chart above is to help you extrapolate for shutter speeds (or exposure times) for f-numbers other than f/2.8, which is one of the two f-numbers on the Available Light Chart. For example, you may have looked up a shutter speed for a certain available light category and ASA speed and found a shutter setting of 1/500 second for f/2.8. However, you wish to take your picture at f/5.6 instead. This means that you will have to use a *slower* shutter speed, because this smaller aperture won't let enough light through it in 1/500 second. The supplementary chart says to use a setting that is 2 speeds *slower*, which would be 1/125 second.

Perhaps it would be wise at this point to take a second look at the shutter speeds (or exposure times) for f/2.8 listed on the Available Light Exposure Chart. They range from 1/4000 second to 32 seconds. Starting with 1/4000 second the times for f/2.8 get progressively *slower* (or longer) by one-stop jumps (1/2000, 1/1000, 1/500, etc.). Working backward from 32 seconds we find the times getting progressively *faster* (or shorter) by one-stop jumps (16, 8, 4, 2, 1, 1/2, etc.).

When you are working with both fractions and whole numbers it is hard to keep track of which number is faster (or slower) than which. It will help if you use the shutter speeds marked on your camera or exposure meter as a guide.

The chart above has the same purpose as the chart preceding it, except that it is designed to help you make extrapolations from exposure times listed for f/3.5. For example, you may have looked up a shutter speed for a certain available light category and ASA speed and found 1/250

second for f/3.5. However, you wish to shoot at 1/500 second (one shutter speed *faster*). The above chart indicates that you should then open up the lens a little bit, setting it between f/2 and f/2.8. Getting the marker approximately in the middle is quite close enough.

Though it is unhandy to have to extrapolate from both f/2.8 (a whole stop) and f/3.5 (a half stop), there is a reason for this. The classical exposure categories are spaced exactly one-half stop apart. If this difference were to be expressed in terms of shutter speeds we would have numbers

Actor Bernard Kilby was sitting in a dark stairwell in the wings, waiting to go onstage. I already knew the exposure for this spot (about 1/8 at f/2.8 with Tri-X rated at ASA 400), having taken a white card reading earlier.

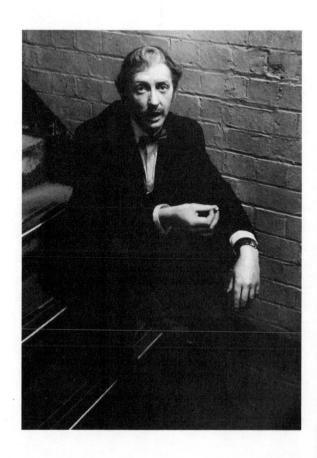

The performance area for these folk singers was so dark that I couldn't get a good reading with my meter (a Weston Master II), so I guessed 1/2 second at f/2 and lucked into a well-exposed negative. Guesswork can be an important part of available light photography after dark. Also luck.

such as 1/185, 1/375, and 1/750. They would represent "half-speed" shutter settings that cameras just don't have, though they could have if we really wanted them to.

The alternative adopted long ago in photography is to express a one-half stop difference by means of unmarked aperture settings located between whole f-numbers. Though we can attach numbers to these intermediate settings, it is easier

not to. However, it is wise to remember 3 half stops that are often marked on lens barrels—f/3.5 (about halfway between f/2.8 and f/4), f/4.5 (about halfway between f/4 and f/5.6), and f/6.3 (about halfway between f/5.6 and f/8). It would be less confusing if manufacturers didn't print half stops on cameras (to indicate the speed of a lens, or its maximum aperture), but we are stuck with what they sell us.

• Figure Things Out in Advance

Though the arithmetic involved in the preceding section is very simple (mainly multiplying and dividing whole numbers and fractions by 2), it gets people all mixed up anyway. Therefore, it is wise to work out all your exposures before you go out to photograph—assuming that you already know where you wish to make your pictures. Then write your data in a little notebook, all ready to use. If you try to figure everything out while you are actually shooting there is a good chance you will never know which way is up.

• The Kodak Exposure Dial

It would help you understand photography better if you were to thoroughly sort yourself out with respect to the Available Light Exposure Chart and the three supplementary charts which can help you use it properly. But such an understanding can come only in due time. In the meantime you may prefer to get your data from an exposure dial such as the one in the Kodak Professional Photoguide, which is available in most camera stores. Since a tremendous amount of information can be condensed into a dial (a very simple type of computer), you will find a lot of things you need to know in a very accessible form. In short, the dial is easy to use and informative.

If you can stand to use charts and dials, you will find all kinds esoteric and interesting information in this splendid little book—things you will need to know tomorrow and others that you

will never use in a million years. But they are all nice to know about. When it comes to accumulating and compressing information about photography the Kodak writers are the very best.

Using an Exposure Meter

For accurate metering you usually need to know just one general rule: read the thing you wish to photograph—not something else too. Not the background behind it or the foreground in front. And most certainly not a light source. In many cases you will have to walk right up to a subject—with your built-in or separate meter—in order to read only what you intend to photograph and not everything else in town. But you can then back up again and shoot your picture.

Substitute Readings

You can't always walk right up to a subject, for it may be across the river, on a theater stage, or on the other side of a fence. Then you should use a substitute reading, which is simple enough to do. This is easiest when the same amount of light is falling upon your subject as upon yourself. Then

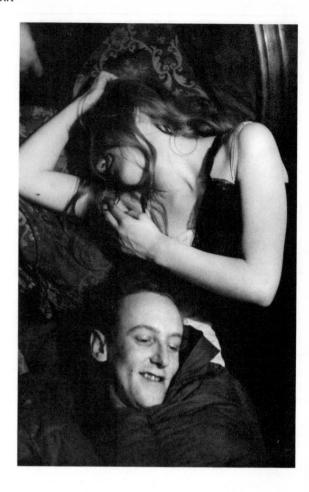

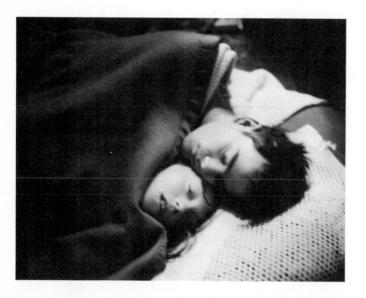

Anita sound asleep and Bartle bright and perky in his sleeping bag—another dim light exposure situation (about 1/8 at f/2.8). With practice you can learn to hold a camera steady with such slow shutter speeds. It mainly involves careful breath control.

Anita and Chris illuminated by a little light gently filtering in from the adjoining room—a very dark exposure situation. Lucky guesswork gave me 1/2 second at f/2, which turned out to be a good exposure. Don't be afraid to guess—you'll be right more often than not.

Actor Ian Richardson working on one of his musical compositions. Though it looks rather dark there was actually quite a bit of light here. I took a reading from Ian's face and exposed at 1/15 at f/4.

Loving partners at a dance—I had never seen them before, but they wanted me to take their picture. I took a substitute reading of my hand (so as not to poke a meter in their faces) and photographed them at 1/8 at f/2.8. The negative was very thin, but I printed for the darks and used ferricyanide bleach to get the highlights light enough—a standard trick for use with thin negatives.

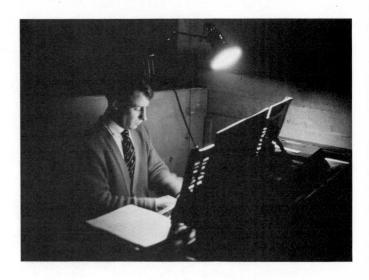

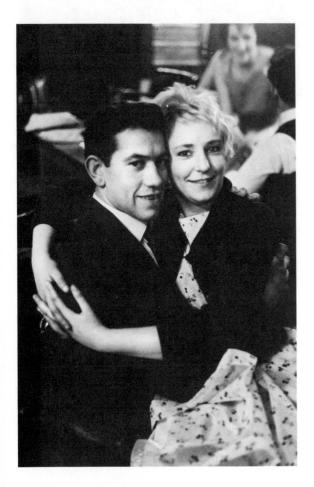

you find a convenient substitute for this subject (something that reflects the same amount of light), read the substitute, and make your picture.

For example, you may wish to shoot a telephoto picture of a person standing under a street-light across the road from you, using a lens that is not coupled with your built-in meter. Walk to a streetlight on your own side and take a reading from the palm of your hand as a substitute for your subject's face. This will give you the correct exposure for both your hand and your subject, for they have the same degree of reflectivity and are positioned equidistant from nearly identical lights. Then set your camera, walk back to where you were, and shoot your picture. As long as they are of the same type it doesn't matter how far apart the lights are; they could even be in opposite sides of town.

If you and a subject aren't getting the same amount of light you can still take a substitute reading, but you should do it by sighting. Hold your palm in front of you as if it were a rifle sight aimed at your subject—your hand should overlap part of it. If you then close one eye you should easily be able to see which is darker, your subject or your own skin. Tilt your palm backward or

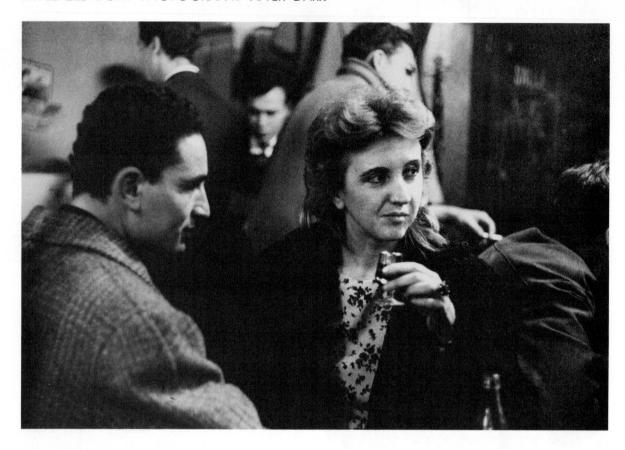

forward (which will change its tone) until your hand and your subject are matched in tone. Then take a reading from your hand, set your camera, and shoot your picture. The principle is that things reflecting the same amount of light generally require the same amount of exposure; when they are matched in tone this condition prevails.

If there is quite a bit more light falling upon a subject than upon yourself, there may be no way of tilting your palm far enough to make it light enough for a match. In this case do your sighting over (and take your reading from) an 8×10 -inch sheet of white cardboard. Like your hand, the cardboard will also change tone when you tilt it. When you get the tonal match, take your reading, set your camera, and shoot. If the white cardboard is still not light enough to match your subject you may have to brighten it up a little with a penlight, which you should carry with you anyway when working at night. Don't worry about

People in an after-hours bistro in Paris. Sitting at my own table, I took white card readings (by sighting: see text), so that I knew the exposure for most of the people in the room without having to walk up to them. About 1/8 second at f/2.8. Now, f/2.8 is my favorite aperture setting for dim light photography. When you can stop down that far (which isn't very far) you are usually safe as far as depth of field (sharpness) is concerned.

Even with as much exposure as 1/4 second at f/4 I got a very thin negative, so I exposed the print to make the darks look good and used ferricyanide bleach to get the light areas light enough. In effect this technique adds the contrast that is missing in a thin negative.

introducing an extra light source. The only thing that matters is that the cardboard (or your palm) be a tonal match for your subject. How you make the match doesn't really matter at all.

• The Commonest Nighttime Metering Errors

Because light may be very dim at night, people tend to point their meters or cameras (with builtins) at whatever will give them the highest readings, for example white things (walls, tablecloths, shiny floors, rugs, etc.) or even light sources. Though it may give you comfort and pleasure to see your meter needle move in a positive way, this approach nearly always leads to serious underexposure. So read your subject as a whole. If you have to choose a part of a subject to read, pick one that is average in tone—not brighter than everything else.

Another serious error is in reading a subject that is surrounded by very dark tones at too great a distance. Since your meter will then read both the subject and the background it will be strongly influenced by the dark tones and tell you that there is very little light available for your picture. Thus you will compensate by overexposing heavily. So walk right up to subjects or use substitute readings.

An error of a similar type is to be at too great a distance when reading a subject surrounded by very light tones. This leads to underexposure, sometimes very serious. Though you can safely make direct readings at a distance with so-called spot meters, you probably don't have one. In such a meter the acceptance angle may be as small as two degrees, so you could reasonably call it a telephoto exposure meter.

At an indoor antique show, an exposure problem easily solved with an incident light reading with a Gossen Luna-Pro (1/30 at f/3.5).

Having made substitute readings for the entire bistro, I knew the exposure for this friendly fellow without having to walk up to him. By pointing at my camera I signaled my request to photograph him. He responded with a toast and a smile.

This lady is friendly and seems determined to flirt with me. The ballroom was so dark that I could hardly see, so I was using exposure times from 1/2 to 1/8 second (at f/2). A couple of pints of goodly English beer helped steady my hand for such slow speeds.

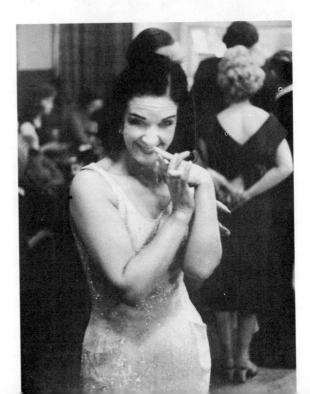

A back street in Paris well after midnight. Since the streetlights were very dim and the street itself darkened by rain I couldn't get a good reading with my old Weston Master II meter, so I guessed 1/4 at f/2 and came out on top. If you have a tripod (which I didn't) this is a kind of situation in which exposure bracketing is advisable.

Meter Stretching: the White Card Method

Because many meters—built-in or separate—aren't very sensitive they register poorly or not at all in dim light. In many cases you can get around the problem by using the so-called white card method in which a piece of white cardboard (for example, the reverse side of a Kodak Gray Card) is used as a substitute for the average tone of a subject (see page 29). Since it is white it will reflect quite a bit more light than the subject itself, perhaps enough to register on an insensitive meter. However, it can only represent the average tone of your subject in an indirect way.

Now, if you hold the gray side of a Kodak Gray Card (see page 28) in front of a subject so that the same amount of light falls on both card and subject, the gray will actually represent the average tone of the subject very well. Thus you can take a reading from the gray and get a very accurate exposure for your subject. Indeed, this is a classical way of determining exposure and the reason for the existence of Kodak Gray Cards.

Obviously, a white card won't represent this average tone very well at all—it is much too light—unless we throw in some kind of a metering factor, which happens to be 5. The factor of 5 is derived from the fact that a white card reflects 5 times as much light as the average tone of the average subject (most things happen to fit well in the average subject category).

When you decide to use a white card you must compensate for the fact that it isn't very average in tone. Do this by dividing the ASA speed of your film by 5 to get its "white card speed" and set this new speed on your meter. The factor is now included so that a white card reading will represent the average tone of your subject on your meter, provided that you hold up the card in the correct way.

The card should be held in the same plane as your subject. For example, if you are photographing a standing woman it should be held vertical to the floor, which will make its surface par-

allel to her. And the card should be held up in light of the same intensity as that falling upon the woman. Usually, the card should be almost touching her, but if the area is very evenly lit you can get a good reading when five or ten feet away from her. Distance doesn't matter at all as long as your subject and card are receiving light of the same intensity.

Let us go back to the factor and see how it would work with a specific film, say Tri-X (ASA 400). Dividing the speed by 5 gives you 80, which you set on your meter. Then read the white card, set your camera, and take your picture. Once the factor has been set into the metering system you no longer have to think about it.

Do not confuse the white card method with the sighting method mentioned in a previous section. When using a white card for the latter technique you don't divide the film speed by 5. Then the card actually represents directly the average tone of a subject, because you tilt it until there is a tonal match. However, when you use the white card method (this is its traditional name) the card will look considerably lighter, so a conversion factor is required. If it doesn't look lighter you are either reading a white subject or doing the reading incorrectly.

• Film and Developer Combinations for Film Speed Pushing

In the chapter on sports photography you read that film pushing should only be considered as an emergency measure because it generally leads to image degradation, especially with contrasty subjects. But when the emergency arises it may be the only way of getting your pictures, especially at night.

It was also suggested that you stick to just two developers for speed pushing black-and-white films—D-76 (diluted 1:1) and Acufine. Though this recommendation still holds, you may wish to know about other popular developers and the speeds they are said to be capable of producing with various fast black-and-white films. There is

Coming out of my pub I could hear a fight nearby rather than see it clearly. Not wanting to get my ears beat off in a fight among strangers, I ventured a hand-held shot from where I was standing—I second at f/2 (the maximum speed of my lens). When I saw the print later I discovered that it had been a drunken man giving two equally plastered women a hard time. The point is that you can get pictures even if you can barely see.

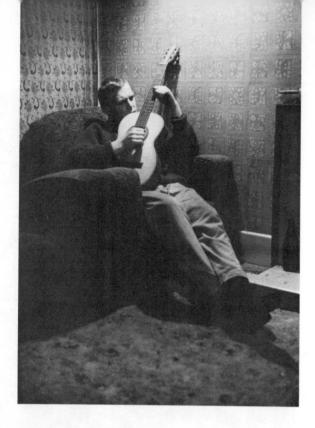

Though the party was going strong he was sitting in a corner by himself in light so dim I could hardly see him, but I got his picture anyway. Dim light need not impede your photography, especially if you do exposure bracketing or use a supersensitive light meter such as the Gossen Luna-Pro.

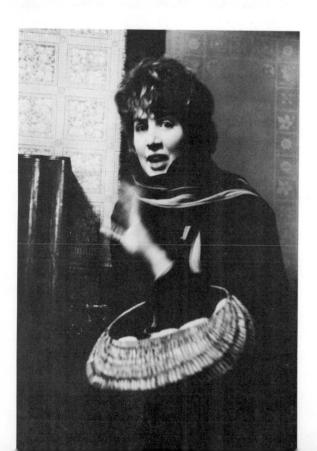

also more information on push speeds for color films.

In the following material I included wherever feasible the developer dilutions, temperatures, and developing times. However, there are cases in which it would be better for you to get your data from the information sheets that come with the developers listed, usually because the processing instructions are lengthy. In a few instances the data simply wasn't available to me, but you can work them out for yourself by running tests (see the chapter on sports photography, p. 117).

Fuji Neopan SSS (rated at ASA 200)

Ethol T.E.C. (1:15)—ASA 800—21 minutes at 70F

Ethol UFG—ASA 640—7 minutes at 70F Ethol Blue (1:30)—ASA 1000—7½ minutes at 70F

GAF 500 (rated at ASA 500)

Acufine—ASA 1000—73/4 minutes at 68F Diafine (two-bath)—ASA 1000

Edwal FG7 (two-bath)—ASA 1000

Ethol UFG—ASA 1000—41/4 minutes at 70F

Ethol Blue (1:30)—ASA 800—7 minutes at 70F

H & W Maximal Developer—ASA 1000— 8 minutes at 68F

Ilford HP-4 (rated at ASA 400)

tion B at 75F

Microphen—ASA 650—5 minutes at 68F Acufine—ASA 1600—8¾ minutes at 68F Edwal FG7 (1:15)—ASA 2400 Ethol T.E.C. (two-bath)—ASA 1000—5 minutes in Solution A, 4 minutes in Solu-

Even in the dim light I could see that she was pretty, so I snapped a slow shot of her. How slow is indicated by the blur of her hand as she waves hello to her friends, who also happened to be my friends.

Ethol UFG—ASA 800—51/4 minutes at 70F Ethol Blue (1:30)—ASA 1200—8 minutes at 70F

H & W Maximal Developer—ASA 1250— 8 minutes at 68F

Ilford HP-5 (rated at ASA 400)

Microphen—ASA 3200—18 minutes at 68F, 12 minutes at 75F; ASA 1600—12 minutes at 68F; ASA 800—8 minutes at 68F

D76 (full strength)—ASA 1600—15 minutes at 75F; ASA 800—11½ minutes at 68F

Kodak Royal-X Pan—roll film, cut film, and film packs—(ASA 1250) DK-50—ASA 5000 (?)

Kodak Tri-X (rated at ASA 400)

D-76 (1:1)—ASA 800

Acufine—ASA 1200 and higher—51/4 minutes at 68F

Diafine—ASA 2400

Rodinal (1:50)—ASA 6400—22½ minutes at 68F

Edwal FG7 (two-bath)—ASA 3200

Ethol T.E.C. (two-bath)—ASA 1000—4 minutes in Solution A, 3 minutes in Solution B at 75F

Ethol UFG—ASA 4000—9½ minutes at 70F

Ethol Blue (1:30)—ASA 2000—6¾ minutes at 70F

Ethol 90 (1:10)—ASA 2000—9 minutes at 70F

H & W Maximal Developer—ASA 1250— 8 minutes at 68F

At the Beaux Arts Ball in Birmingham, England—the floor covered with broken bottles and everyone whooping it up. Anne kicked off her shoes and did a wild barefoot dance in the glass, sustaining not a scratch. In the dim light I had to use a very slow shutter speed (1/4 or 1/8 probably), giving us this blurred movement.

With strong spotlights there was enough light for an exposure of 1/30 at f/5.6 on this movie set. Shirley Eaton running through her lines before the cameras started to roll. In a lighting like this, read the highlights on the face and double the exposure you get. Equally good, take an incident light reading with the meter aimed halfway between the light source and where your camera will be positioned.

Kodak 2475 Recording Film (rated at ASA 1000)

DK-50—ASA 3200—8 minutes at 68F

Acufine—ASA 3200—73/4 minutes at 68F

Ethol T.E.C. (two-bath)—ASA 5000—7 minutes in Solution A, 6 minutes in Solution B at 75F

Ethol UFG—ASA 6000—16½ minutes at 70F

Ethol Blue (1:30)—ASA 2000—10 minutes at 70F

Polaroid Type 107 (rated at ASA 3000)

Polaroid Type 57 (rated at ASA 3000)

Color films

Fuji Fujicolor F-II (rated at ASA 400) Kodak C-41 chemicals—ASA 1600 Fuji CN-16 chemicals—ASA 1600

Kodak High Speed Ektachrome, tungsten (rated at ASA 125)

Kodak E-4 chemicals—ASA 500 Unichrome chemicals—ASA 640

Kodak Ektachrome 160 Professional, tungsten (rated at ASA 160)

Kodak E-6 chemicals—ASA 640

Kodak Ektachrome 200 Professional, daylight (rated at ASA 200)

Kodak E-6 chemicals—ASA 800

At this writing I don't have push data for Kodacolor 400, though it will surely push as far as Fujicolor F-II and possibly even further.

The preceding material is designed to tell you how far you can push films and still get printable negatives and acceptable color transparencies. However, manufacturers vary considerably in what they see as printable or acceptable. And your methods of taking exposure readings may be quite unlike theirs. You should therefore run a test on any film and developer combination that you wish to use (see the chapter on sports photography, p. 117).

By now you should have seen that the main problem in available light photography at night is to get the correct exposures for various lighting situations. Though this chapter may puzzle you in places, you should stick with it until you have everything figured out. Thereafter, photography at night shouldn't give you much difficulty.

PAINTING WITH LIGHT

We think that we see *things*, but we don't. Our eyes can see only *light*—light that is reflected, transmitted, or emitted by things. Thus to see a thing means only that we are aware of the light coming from it; beyond that we have no visual contact whatever with it. Take the sun, for example—except for its light we wouldn't even know of its existence.

Photography is the art of using light to form images and applying chemistry to make them permanent. No light—no pictures. But we take such things for granted and do not think about light very much. We easily forget that photography as such is based entirely on the magical things that light can do. Not what we can do—what light can do. However, to be a photographer who is not acutely aware of light is like being a symphony conductor who has never heard a musical instrument. Such a thing is possible, no doubt, but who would do it by choice?

The chances are that you are *not* acutely aware of light at this point. If you are only concerned with having enough of it to correctly expose your film you have hardly started on the long and glorious path to photographic excellence. You must learn to *see* light, and then you will really be getting somewhere. Fortunately, there are things you can do that will give you a lot of help. For example, you ought to work with an interesting technique called painting with light, in which you use a light source as if it were a paint brush.

Though light sources of almost any size can be used for painting, it is advisable (and a lot of

fun) to start with flashlights. Small as they are, they are extremely effective and, of course, very inexpensive compared with other photographic light sources. You can make very fine pictures with them. Most important, they make you very much aware of light when you are using them.

• The Gist of It

The idea of painting with light is very simple, though it hasn't even occurred to most people. You simply set your camera on a tripod in front of something you wish to photograph, then turn off the room lights so that everything is pitch black. Next, you open the camera shutter and keep it open, using the "B" setting. When the room is coal black you can leave it open for hours and nothing will happen to your film. Finally, you switch on a flashlight and start moving the light pattern over some of the things that are in front of your camera. When you are finished you close the shutter and turn on the room lights again. That's all there is to it—you have shot your picture.

If you like you can do the same kind of thing outdoors at night. Using larger light sources you can paint large buildings, streets, and so on.

• Darkness and Light

When you use a flashlight in a darkened room only a part of the room is illuminated, especially if you hold the light close to your photographic

PAINTING WITH LIGHT

subject. When thus surrounded by darkness the light pattern stands out clearly as light and nothing else, which makes it easier for you to be aware of light as such. In comparison, it is difficult to be even vaguely aware of light as light in a fully illuminated room. We are so used to this condition that we no longer know how to pay any attention to it.

The flashlight is a miniature spotlight, and the nature of spotlights is to draw attention to light as such. Though this is mainly due to the surrounding darkness, another important factor is that we

are unaccustomed to spotlighting in everyday life. Thus its unusual quality helps awaken our sleeping eyes.

Considering our terrible dependence on light, it may seem strange to be told that you hardly see it at all. In the sense that seeing involves awareness, this is true nevertheless. Thus you should consider the technique of working simultaneously with darkness and light as a golden opportunity to awaken yourself. Furthermore, you should look at the simple flashlight as a very effective piece of photographic lighting equipment.

In the picture on the left we see how one does painting with light with a hooded flashlight, though it is done in a room that is entirely blacked out. Below the caption we see the results of the technique, a rather eery picture like an illustration for a Gothic novel. It certainly doesn't look like the hallway illuminated in the usual way.

I just stood still and splashed the light around (from a flashlight) for ten or fifteen seconds. The camera (with a 19mm lens) was on a tripod with the shutter held open by my homemade remote shutter tripping device. Except for the flashlight, the hallway was entirely blacked out.

Above we see a hooded penlight held in the position in which it will be used for painting with light. Both the penlight and I will be within camera range, but it won't matter. The hood will prevent the flashlight from being visible to the camera, and so little light will reflect on me that I too will be invisible. On the right is the picture made by painting. Each picture was traced around with the penlight, then given a burst of light in the middle.

White eggs on a white mount board and two pictures made by painting with light, showing how much both the eggs and the mount board are changed with this technique. With ordinary photographic light sources there is no way of getting these effects.

Holding the Shutter Open

For painting with light your camera must have a provision for holding the shutter open-either a "T" (time exposure) or a "B" (bulb) setting. The setting most frequently found on cameras nowadays is "B," so we will deal with that (there is no problem with a "T" setting anyway). With the camera set on "B," depressing the shutter release with a finger or cable release opens the shutter, which stays open until the shutter is released. Though you can use one hand to keep the shutter open and do your lighting with the other, this ties you to your camera, which can be very inconvenient. It is desirable to have some kind of a device that will hold the shutter open while you rove freely around the room doing your painting.

Such a device, powered by small rubber bands, is illustrated in the chapter on self-portraits, p. 89. Though originally designed as a remote release for making self-portraits, it works equally well for holding the shutter open when it is set on "B." It stays open until you lift up the top section of the release device. Since for painting with light you both open and close the shutter in absolute darkness, you don't really need a gadget this sophisticated. With masking tape, a couple of short sticks, and rubber bands you should be able to rig up something—a simple gadget to hold down the shutter release button. You could probably even use a small C-clamp or its equivalent.

Fortunately, there is still an easier and cheaper way to keep the shutter open when the "B" setting is used. Buy the kind of cable release that has a little lock-screw on it—it costs as little as two dollars. Then you depress the plunger, activate the screw, and the shutter stays open until you loosen the screw again. It's dead easy.

Selecting Your Flashlights and Batteries

Though you can get by with a single flashlight it is much better to have three sizes—one with two

D batteries, one with two AA batteries, and a light with *one* AA battery. The flashlights must be especially prepared for use (next section).

The large flashlight (two D cells) is used for large subjects—a whole room, for example. The smaller lights are good for such things as still life setups, creative print copying, and portraiture.

Oddly, the biggest problem is in having too much light to work with, which is why a light with just one AA cell is recommended. The thing is that you have to have at least a second or two of painting time (which you can count under your breath) in order to be able to control your exposures. Since your light may be within an inch or two of (or even touching) your subject, it may be just too bright.

If you have a lens that will stop down to f/32 or smaller, this will help a lot, but most cameras stop down only to f/16. Thus it is fortunate in a way that flashlight cells fade so fast—with a few partly shot batteries on hand you can get light dim enough for almost any purpose. Though you can accomplish much the same thing by using a fairly slow film such as Plus-X Pan or Verichrome Pan (both ASA 125), it would be better to stick with a fast film such as Tri-X (ASA 400). You see, you may wish to make certain pictures in which your lights are at a considerable distance from your subjects.

In addition to faded batteries you should surely have fresh ones, the so-called alkaline energy cells being the best. Though they cost a lot more than regular cells they also last a lot longer. Thus their rate of fading, which can constitute an exposure problem, is held back quite a bit.

Preparing Your Flashlights

Unfortunately, flashlights project very irregular lighting patterns that have to be smoothed up by diffusion, which is easy enough to do. Though diffusion reduces the light intensity by about 2 stops, we have seen this doesn't matter—we have more of a problem with too much light than with too little of it.

The easiest way to diffuse a flashlight is to tape strips of Scotch Magic Transparent Tape over the end of it—one layer is enough. This brand of tape is made with a matte acetate base (so you can write on it), which diffuses light extremely well. The light pattern that results is very smooth and even.

Now, flashlight heads often bulge out, so that they give off light sideways as well as forwards. The result is that when you are painting with the light source within the picture area (say, with your hand right in front of the camera) the sideways light will reach the film, making dark spots and streaks. Since it is often desirable to use a flashlight within the picture area, the sideways light should be eliminated. Do this by taping a cylinder of black paper around the head of the light, allowing it to protrude about ½ inch. However, you should diffuse the light first. A flashlight thus shielded won't make light streaks if it is held sideways to your camera or pointed slightly away from it when it is within camera range.

Making Exposure Readings

Painting with light poses certain exposure problems, one of them due to the fact that flashlight batteries—large or small, regular or alkaline—start to fade rapidly as soon as you begin using them. However, once you know this happens it doesn't have to be a problem at all; all you have to do is take a fresh light reading just before making each picture. In contrast, if you use the same reading for, say, six shots you will probably underexpose the last of them, perhaps badly.

A reading should be made in a fully blackedout room, with only the flashlight turned on. The easiest way is to take an incident light reading, though it requires that you have a separate meter with an incident light sphere or attachment, for example a Luna-Pro, Metrastar, or Sekonic L-218 Apex CDS. You hold the light source at the same distance from the meter as it will be from your photographic subject, aiming the

My father Judge Hattersley and his favorite piece of sculpture. On the top we see my hand and hooded penlight in the positions they will occupy during one of the several required exposures. As you see, they are well within the picture area. On the bottom is the picture made with the painting technique. Note how different the portrait and the sculpture look.

brightest part of the diffused light pattern right at the incident sphere. The reading will give you the exposure you should use with the light held at this distance from the subject—if you intend to hold the flashlight stationary or move it around in tight circles.

However, if you intend to move the light pat-

PAINTING WITH LIGHT

tern through a considerable distance you must increase the total exposure time so that each illuminated part of your subject receives the required exposure. It is usually safe to simply guess the necessary extra time, especially when you use exposure bracketing.

Built-in meters pose a slightly more difficult problem, because they usually aren't very sensitive to light, and the technique to compensate for this is quite awkward, though effective. With a relatively weak light source such as a flashlight, you can increase the effective sensitivity of such a meter by taking white card readings (see the chapter on p. 155). Though people don't usually take white (or gray) card readings with built-ins, it is only because they don't know about this re-

markably accurate way of determining exposures. A little awkward but very good.

Remember to divide the film speed by 5 and to set the resulting "white card speed" on your camera. For example, ASA 400 would be converted to 80, which is the number you use. Now, open the lens all the way, say to f/2. Since you will be reading light of rather low intensity you want as much of it as possible to get into your camera from the white card. Hold the flashlight in your left hand, the camera in both hands (see illustration), and take a reading from the card. The flashlight should be the same distance from the card as it will be from your photographic subject.

Unless your camera has automatic exposure controls that cannot be operated manually, it

differe			T		I	Ι
Light-to-subject distances	3 in	6 in	1 foot	2 feet	4 feet	
flashlight with 1 AA cell	indicated exposure times	1 sec	4 sec	9 sec	1 min	4 min
	adjusted exposure times	2 sec	10 sec	32 sec		
flashlight with 2 AA cells	indicated exposure times	1 sec	1 sec	5 sec	12 sec	1 min
	adjusted exposure times	2 sec	2 sec	13 sec	25 sec	
flashlight with 2 D cells	indicated exposure times	1/15 s	1/4 s	1/2 s	2 sec	7 sec
	adjusted exposure times	1/15 s	1/4 s	1/2 s	5 sec	20 sec

probably has a "match-needle" system. That is, when the meter needle intersects a certain mark or indicator your camera is then set for the correct exposure. You get the needle to move into the correct position by experimentally setting your camera on various shutter speeds, until one of them does the job. Start with the slowest speed and work your way up.

In this manner you will get the correct exposure but not the exposure time and f-number that you will actually use. The time (shutter speed) that you get directly by reading is too short for any painting with light, so you have to convert it. That is, you have to find a much longer time (and a much smaller aperture) that will still give you the correct exposure.

We will see how this worked with an actual reading made with a built-in in a Nikkormat loaded with Tri-X (ASA 400), with 80 set on the camera as the white card speed, with the aperture set at f/2. The flashlight had two brand-new Ray-O-Vac AA Alkaline Energy Cells. It was positioned 6 inches from the white card. The correct exposure for this light when used for painting at this distance came out to be 1/60 second at f/2, which of course wouldn't give us sufficient time for painting. However, we can get an exposure time of 1 second (and still the correct exposure) by stopping down to f/16. Due to the reciprocity effect (which we will get to in a moment) we would actually use 2 seconds, which is even better.

I hope you have read my other books in this Doubleday series for beginners in photography, so that I don't actually have to tell you how I moved from 1/60 second at f/2 to 1 second at f/16 without changing the correct exposure. But maybe you haven't read the books and are more of a beginner than I have assumed. So I'll explain. The commonly encountered f-numbers are 1.4, 2, 2.8, 4, 5.6, 8, 11, 16, 22, 32, 45, 64, and 90, though most cameras leave off at f/16. Each number represents an area of the adjustable hole made by the iris diaphragm mechanism (aperture). The largest hole (called both the maximum

aperture and the lens speed) is on the left (above) and the smallest hole on the right. As we move from left to right the areas are progressively cut in half with each jump. Conversely, as we move toward the left they are progressively doubled.

Thus stopping down means to progressively halve the size of the hole that light must pass through in order to reach the film. However, if we double the exposure time at each step the total amount of light that gets through (the exposure) will remain the same. Let us return to the f/2 from which I started my Machiavellian maneuvers. Moving from f/2 to f/16 the area of the aperture is halved 6 times. To compensate for this I merely doubled the original exposure time (1/60 second) 6 times, ending up with 1 second. If you have trouble halving or doubling fractions, look at your camera or exposure meter, where the numbers are all printed in the correct order.

The foregoing paragraphs are not as much a detour as they may seem. Whatever your level of advancement in photography, it is time for you to memorize the common apertures (given above) and the common shutter speeds, which are 1, 1/2, 1/4, 1/8, 1/15, 1/30, 1/60, 1/125, 1/500, and 1/1000 seconds. Write all these numbers down and carry them in your wallet or purse. Unless you can learn to easily perform the kind of conversion just demonstrated you will be unduly restricted in your photography. If necessary, figure out conversions with pencil and paper.

To return to white card readings made with built-in meters. They are excellent for increasing the effective sensitivity of meters that register poorly or not at all in rather dim light, though sometimes even a white card won't help. It is easy to take a reading if the illumination is even, but the light pattern from a flashlight is bright in the middle and dim on the outside. The thing to do is move the light around to get the highest reading you can at whatever distance you have chosen. Remember that the light-to-card distance and the light-to-subject distance should be the same.

A white doll on a white background illuminated by room light and the same setup lit by a moving hooded penlight in a darkened room. We can see that the second picture is very much more dramatic.

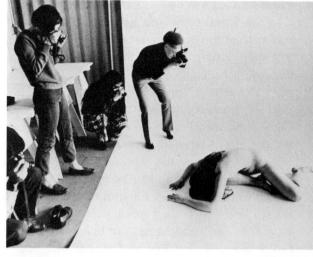

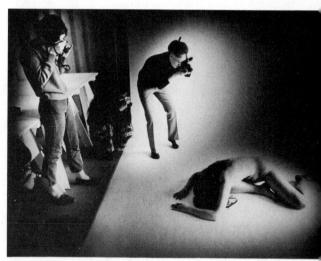

A straight copy print of a picture of some of my students at The School of Visual Arts and a copy print made from a copy negative made with three separate exposures with a hooded flashlight. In the second print we get the effect of spotlights, though they were obviously not used for the original picture.

A hand photographed by painting with light.

I took various positions in a darkened hallway, shining the light on my own face at each one. The camera was on a tripod, of course, the shutter remaining open for the whole sequence. The picture probably belongs in the chapter on ghosts, this being a multiple ghost.

Two versions of a magical john lit with a flashlight. In one the room light was turned on for 1 second, the other being done in total darkness except for the flashlight.

• Compensating for the Reciprocity Effect

The reciprocity effect relates to what happens to photosensitive materials when they cease to obey the so-called law of reciprocity, which we needn't discuss here. For our present purposes it is sufficient to say that when exposure times are long (or very short) the average film doesn't respond as much to an exposure as we would expect it to. For example, if your meter says that the correct exposure for a certain film and photographic subject is 1 second at f/16 you would naturally expect the meter to be right. However, the film will actually need 2 seconds (twice as much time), because with longer exposures it progressively loses much of its effective speed. Thus if your meter says 10 seconds the film begs for 40, and if the reading indicates 100 the film requires 1200 seconds, or 20 minutes. Failing to give the extra exposure time will lead to badly underexposed negatives. However, we need the extra time for painting anyway, so we welcome and use the reciprocity effect rather than worrying about it.

The following chart gives you some approximate exposure time corrections for the reciprocity effect, though they are accurate enough for our needs. Indicated exposure times are those you work from meter readings; you might call them uncorrected times. Adjusted exposure times take the reciprocity effect into consideration. The figures given here apply to 2475 Recording Film, Royal-X Pan, Tri-X Pan, Plus-X Pan, Panatomic-X, Verichrome Pan, and certain other films. However, you have to work out your own figures for high contrast and special purpose films.

(Ideally, you should cut the film development time 10 per cent for a 2-second adjusted exposure time, for the reciprocity effect increases image contrast with long exposures—and cutting the developing time reduces it again. For a 40-second adjusted time the cut should be 20 per cent, which is substantial. However, you can ignore the developing time cuts when painting with

light, because you will be working with spotlighting, which is very contrasty anyway. That is, you both want and expect a lot of contrast.)

Compensations for the Reciprocity Effect

Indicated exposure times	1	2	3	4	5	6	7	8	9	10 sec
Adjusted exposure times	2	5	8	10	13	18	20	25	32	40 sec

Adjusted times are the ones you actually use in making your pictures, of course. The most convenient range is from 2 to 10 seconds, shorter times being too hard to work with and longer ones tedious. The way to arrive at an adjusted time within the recommended range is to take an exposure reading and figure out which f-stop would go with an indicated exposure time falling between 1 and 4 seconds. Then you simply convert this time to an adjusted time, using the chart. For example, from a reading you work out an indicated exposure of 2 seconds at f/16, which translates to an adjusted exposure of 5 seconds at f/16.

You will probably find yourself using mainly f/16 when you are using your flashlights within 12 inches or less of your subjects. If you get a reading that is too high (say, 1/4 second at f/16) use a smaller flashlight, switch to partly worn out batteries, or use a greater light-to-subject distance.

A Flashlight Exposure Chart

If you don't have an exposure meter, built-in or separate, you can still do this project—provided that your camera has a "B" setting and that you have constructed a gadget for holding the shutter open. You merely use the chart on page 178, in conjunction with exposure bracketing.

You may have noticed that you have been getting a mental workout in manipulating exposure figures, which you should learn to do in your head—or at least with pencil and paper. Learning to do this will considerably improve your command of the photographic medium. However, if you are temporarily tired of such computations you may find it a relief to use a chart.

In the chart above, indicated exposure times are the kind you work out after taking meter readings. Adjusted times, which are the ones you should actually use in shooting your pictures, take the reciprocity effect into consideration. Tri-X is the film recommended for this project, though other films (including color) will work quite well if you make adjustments for their ASA speeds.

The times were given for f/16, because you will probably use this aperture setting most. However, if you wish to use your lights at quite a distance from your subjects you can open up the lens quite a bit. For example, by opening up to f/2 you would get an *indicated* exposure time of 4 seconds (instead of 4 minutes at f/16) with a one AA cell penlight at 4 feet. This would give us a 10-second adjusted time, of course. For the betterment of your photographic education, work out how I arrived at these figures.

To obtain the charted data I made incident light readings from three flashlights with a Gossen Luna-Pro, a very reliable but not infallible instrument. The batteries were all Ray-O-Vac Alkaline Energy Cells that had never been used until the readings were made. The lights were all diffused with strips of Scotch matte acetate tape and were hooded with cylinders of black paper. The closer you can come to duplicating these conditions the more accurate your exposure will be when you follow this chart. However, batteries do fade rapidly—even alkaline ones—so you should consider using exposure bracketing as a safeguard.

Review the information on exposure bracketing in the chapter on p. 155. When your batteries are brand-new, bracket with 3 exposures that are 2 stops apart—under, normal, and over—obtaining

the normal exposure from the chart. After a light has been turned on for a total time of 5 to 10 minutes you can stop shooting underexposures with it, because the batteries will have faded quite a bit by then. Continue making 3 shots, however—a normal and two overexposures that are 2 stops apart. Even when the cells are rather far gone this should bracket the correct exposure easily enough. It will also compensate for errors in timing exposures by counting and for mistaken estimates of the light-to-subject distance.

You may have noted that there are some peculiarities in the flashlight exposure chart. For example, the flashlight with two AA cells produced the same reading for both 3 and 6 inches, which doesn't seem to make sense. And the light with one AA cell produced the same reading at 3 inches as the one with two AA cells. Since these results were repeatable, I attribute them to the way the flashlights were designed rather than to metering errors. Whatever be the case, you are safe in using these data, provided that you also do exposure bracketing. Incidentally, professional photographers tend to do a tremendous amount of bracketing, so you can see that the technique is highly regarded.

Handling Your Lights

Though you paint with light in a totally blackedout room, it is safe to use your flashlight itself to give you enough light to see what you are doing. For example, you can cover the end of it with your hand, turn it on, and let just enough light escape through your fingers to guide you to your subject-you actually need very little of it. Another trick is to hold the light midway between the camera and your subject and pointed either crosswise to the lens axis or down at the floor; then turn it on. Maintaining this crosswise relationship to both the camera and the subject, move the flashlight to the position at which you wish to paint with it. Then point it at your subject, count out the exposure, and swing it away again. With the light pointed at the floor, move

back to your camera and close the shutter. The extremely small amount of light that falls on a subject from a flashlight in the crosswise position has a negligible effect on the picture, because flashlights are very directional, even when diffused.

You can light several parts of a single subject one at a time, covering the light or turning it crosswise between individual exposures. If you wish, you can turn off the light after each exposure, but you may then get disoriented in the dark.

A light that is moving will produce quite different effects than a light held stationary. With moving lights you can get an endless variety of lighting patterns in your pictures. You can also get shadows with very soft edges, if you wish. In comparison a stationary light produces a round or elliptical light pattern and tends to create shadows with very sharp edges—the greater the light-to-subject distance the sharper the edges.

A copy print made from a copy negative made in the usual way (with flat light) and a copy print from a copy negative made by painting on the original print with a hooded flashlight. We get the effect of spotlighting.

It is useful to make one or more dry runs before shooting a picture. Turn out the room light and see what effects you can get with your flashlight, then use the ones that look best. This preview technique will also help you get a better idea of what light does, which is one of the main reasons for painting with light in the first place.

A Serious Business

Because you can get all of your lighting equipment for less than ten dollars, you may not take this chapter seriously. In this consumer society, things are not held to be of any consequence unless they are very expensive. Please unburden yourself of this illusion, for it will limit your progress.

Perhaps you should think about Edward Weston, one of the greatest photographers who ever lived. He used equipment that today's average advanced amateur wouldn't even store in his dog house, much less use for making pictures. Yet time and again Weston used this "junk" to make pictures that have gone down in history. Another great photographer, Eugène Atget, also worked

with extremely simple means. Many others have followed the same path. The point is that it isn't the equipment you have but what can be done with it that makes the difference.

Flashlights are real junk—anyone knows that —but they are also splendid instruments for developing your awareness of light and for making splendid pictures. Furthermore, solving the exposure problems involved will contribute substantially to your understanding of photography as a science.

In shooting the pictures the leaves were lit from behind, one after the other, the entire exposure sequence taking about two minutes. In an entirely darkened room I lit my wife's face first from one side, then from the other. The picture hardly flatters this beautiful woman, but it does suggest some of the possibilities of the technique.

1: 19mm

2: 28mm

3: 55mm (a "normal" lens)

4: 135mm

5: 200mm

A series of pictures of the same scene shot from a single viewpoint with lenses of different focal lengths. As you see, the wide angle lenses compress a lot of visual data (visible things) into the picture area and make this little world seem much larger, more spacious, than it actually is. The telephoto lenses eliminate much visual data and compress the world from front to back until it seems strangely lacking in depth, with distant things appearing oddly near to faraway ones. In the text we see that using such lenses must surely have a psychological effect on the users and suggest new ways for becoming aware of one's own eyes and using them better.

WHAT LENSES DO

One of the fascinations of photography is in using lenses of various focal lengths, or perhaps the zoom lens, which has a built-in range of focal lengths. Many people play with lenses, but do they actually stop to figure out what they are accomplishing with them? Up to a point, yes. Anyone can see, for example, that a telephoto lens will make distant things seem closer or that a wide angle lens can distort things or make small areas seem much larger than they are. And everyone knows that telephotos make it possible to take pictures of people without their being consciously aware of it. Fair enough—these things are important in photography—but lenses do much more than this.

In this chapter we will deal with the things that lenses do—or seem to do—but not in terms of lens optics, which is a special study in itself. Instead, we will explore the idea that lenses of various focal lengths offer us different ways of seeing, recording, and responding to reality and that the lens used in making a picture has a considerable influence on the way people react to it. Lenses will also be looked at from a metaphysical, or occult, point of view, because they do many things that can't be explained in ordinary terms. Finally, I will say a few words concerning where lenses fit in when photography is considered as a language, which it most assuredly is.

Though this book is primarily about *how* to do things, there are times when you should ask yourself *what* you are doing. Indeed, we are entering

an age in which the *what* of photography is becoming very important. A good start toward answering this question of what photography is up to is to take an imaginative look at what lenses are up to—what do they do?

Telephoto Lenses

You know, of course, that telephoto lenses reach out and bring distant things near—with a long-enough lens you can park the moon in your own back yard. From watching baseball on TV you know that with a telephoto the distance between things is greatly compressed, so that when a pitcher winds up he seems to be standing on the batter's big toe. When you can see the ball it seems to be traveling at a very leisurely rate, which just isn't the truth of the matter.

Have you noticed the tableau quality in the telephoto image, especially in still pictures? A kind of frozen feeling, unreal and seemingly staged. Live creatures often look like puppets, carefully stuffed and anchored in place for an eternity. Even sports pictures, with all the action that they record, have this frozen tableau quality. Though much of it is due to high shutter speeds, the telephoto lens is also responsible.

Have you probed your fascination with the idea of sneaking portraits at a distance with a telephoto? Cowardice may be one reason for doing it, because most of us are afraid of confronting people close-up—but that is too obvious

an answer. There must be others, too. For example, people who are at a distance and not consciously aware of being observed change somehow, become much more their real selves. At least we have grounds to think that they do.

So we may wish to capture their reality on film, for very good reasons. It happens that we must use the realities of other people in order to define our own. Experiencing others helps us define such things as self, sanity, good, and evil, so it is understandable that we would wish to see them well. But there is a great problem in seeing people accurately, for when we are close to them and they are aware of being observed, they defensively slide into various roles (fictional selves) that they are long accustomed to playing in the presence of others. However, when we view them through binoculars or telephoto lenses they don't play these defensive roles. They still play rolesall of the time—but at least they are private roles rather than public and are not so defensive. We can see them more for what they really are.

Earlier in the book I said that people at a distance always know when you are photographing them, though not necessarily at the ego level. They know by a process of unconscious telepathy shared by the entire human race. Remember, this unconscious knowledge can also move into consciousness and often does. The push button for this shift is mainly your attitude: if you telephotograph a person for negative, contemptuous, put-down reasons, conscious or unconscious, he may alert himself to what you are doing, cross the street, and punch you in the nose. On the other hand, if he unconsciously respects your reasons he will let you photograph as much as you like and will continue to reveal that side of his secret self that you prize so much.

We don't usually connect telephoto lenses with distortion, though they distort just as much as wide angles do. We just don't notice it, that is all. However, they distort only in the sense that they show us things in a perspective that we are not ordinarily aware of, which is a very good way of defining lens distortion. The perspective itself

conforms to all the rules. A part of the presumed distortion by telephotos is the near and far distance compression, or shrinkage, already mentioned. Another factor is that things decrease less in size than we would expect them to as they move away from us. The smaller the angle of coverage of the lens the less the decrease.

Perhaps with a hypothetical lens with no angle at all there would be no size decrease at all. Thus we could line up a sugar lump in New York with one on Alpha Centauri and have them come out exactly the same size in a photograph. Furthermore, they would appear to be in exactly the same place. Though we now have no such lenses, we are getting closer to it every day. However, with the lenses we do have, near and far things of equal size tend to hold that relationship in pictures. In a baseball picture, for example, the batter is nearly the same size as the pitcher.

Selective focus is still another possibility with telephoto lenses. That is, you can select the thing you want to come out sharp in a picture and let the background (or foreground) go completely out of focus. Or you can have sharpness in the middle distance and have both foreground and background out of focus. Selective focus is mainly used to get rid of, or tone down, things that you don't want clearly delineated in pictures, though it is also used for the soft feeling that it gives to out-of-focus areas.

Telephotos (usually from 90 to 135mm) are often used for portraiture, with the explanation that they give a better facial perspective than so-called normal lenses do. Mainly this means that telephotos don't make noses look too long—but neither do normal lenses. A more likely excuse is that a long lens prevents the photographer from getting too close to his subjects. The value of this extra distance is explained in a concept developed by Ken Heyman, a well-known professional (see page 32).

Heyman says that each person has an invisible emotional defense perimeter, an imaginary circle that he draws around himself. As long as no one penetrates this perimeter he feels safe, whereas intrusion creates anxiety or anger. Now, the problem with using a normal lens (e.g., a 50mm on a 35mm camera) to make a head shot is that you may have to violate your model's territory. His resultant anxiety may give rise to visible facial tension, rather frantic role-playing, and the appearance of being thoroughly miserable—things that don't look good in portraits. Thus increasing the subject-to-photographer distance by using a telephoto makes good sense.

Let us now go outdoors for a moment to consider the contrast problem with longer telephoto lenses. Due to atmospheric haze, even small amounts of it, the contrast between distant things may drop to almost nothing. Certain optical effects also contribute to this problem. To bring back the contrast you can develop your film from 50 to 100 per cent longer than usual or shoot your pictures through a red (haze cutting) filter.

Or you can simply use the flatness as a part of your pictorial designs. Perhaps the easiest solution is to simply photograph things that are closer to you.

Pictures taken with a 19mm lens and a 200mm, the former seeming gross and distorted. It is gross only in the sense that many people will dislike it, like the mating dance of a slime puppy, and distorted only in the sense that the perspective is unexpected. However, this is the way Bob Turner actually looks if you look at him with one eye from a distance of six inches. That is, the perspective as such is not distorted. In comparison, the picture made with the 200mm lens is very comfortable to look at. Though Bob's head has been compressed or flattened considerably from front to back this is very difficult to see and not at all disturbing.

Though the grass and trees were probably greatly "distorted" by this 19mm lens picture, there is no easy way to tell that they were—so we don't notice anything odd at all. So it looks like a "normal angle picture" showing the way things "really are" to the eye, though it has actually made this little world seem very much larger. For example, I was standing nearly on top of the privies, though they seem to be a considerable distance away.

In our efforts to understand our own eyes better we should study the effects of lenses, for the eye can do anything that a lens can do, no matter what kind of a lens it is. Initially, we should study the wide angle lens, for its effects are most obvious to us. In this picture made with a 19mm lens, for example, you can tell that this wooden pier can only be about eight feet long. However, it looks very much longer, let us say feels that way. It would appear the same way to wide field vision (see text) when seen directly at the location where I found it.

• Wide Angle Lenses

Perhaps the most obvious things about a wide angle lens is that it will include more of a scene or interior setting than will a normal lens and that it can apparently distort perspective considerably, though the perspective is actually normal. What is sometimes not noticed is that this inclusion can make things look considerably larger than they usually appear to be. The ordinary appearance of things can be explained by the way our eyes function.

Though our eyes actually take in a good deal, only the center of vision (foveal) is sharp, the rest being so fuzzy that we pay little attention to anything within it except movement. The result is that we live in a rather small visual world that is approximated only by the reality seen by a normal lens—but not a wide angle. The latter is psychologically a world expander, however, because it gives us the effect (in pictures or through the camera viewfinder) of having vision that is entirely foveal, or sharp. This in turn permits us to see the world as looking considerably larger than usual. It seems larger in height, width, and depth.

No doubt this has a profound psychological effect on people who use wide angle lenses, for by simple acts of will they can more than double the size of the familiar visual world. Certainly, this appeals to the common desire to be one with the gods, to be all-powerful. Similarly, shrinking or compressing the universe with a telephoto lens must also be felt as godlike.

Yes, wide angle lenses seem to expand the world, making it look wider and deeper. Oddly, as it gets steadily larger the objects in it get progressively smaller. On the other hand, telephotos seem to shrink the world, making it narrow and shallow. Strangely, as it gets more compressed the objects in it get larger. Such things surely have a psychological effect on people.

Another odd thing about wide angle lenses is that they create a strange physical tension in your eyes when you look through them with the help of a camera viewfinder. Though the sensation can't be described with accuracy, it is like having our eyeballs sucked out into the world. You can definitely feel this pull on your eyes if you are on the alert for it. Psychologically, it may represent your effort to encompass a larger than usual world with your eyes. Or it may come from a conflict between two opposed desires, both of them very basic. They are the desire to see much and the desire to see little.

This pulling effect can sometimes be experienced when you are looking at pictures made with wide angle lenses. Such a picture may seem to draw you into itself, as if it were some kind of a visual magnet. You may get the feeling of entering into another world, as represented by the photograph. In comparison, you are more likely to feel excluded from pictures made with normal or telephoto lenses. Though such feelings are subtle, they most certainly have a psychological effect.

With wide angle lenses the possibilities for socalled distortion are very obvious, and one may have a compulsion to play with them a lot. In a sense, to distort something is to re-create it, so the God syndrome comes into play: "I will recreate the world to my own liking." Since distortion is usually associated with ugliness (the unfamiliar seen as ugly), using it is also a way of getting revenge on reality, of holding it up to profound contempt.

We call it perspective distortion, but it really isn't. Perspective just happens to work that way, but we are not ordinarily aware of all the strange things that it does. Thus the so-called distortions of lenses often aren't distortions at all but things we could also see with our own eyes if we knew how to see better, which is something we can train ourselves to do.

Thus another reason for playing with "distortion," which is made easy with wide angle lenses, is to get a better idea of the capabilities of our own eyes. Remember that telephotos distort (appear to change things around) just as much, but

that this may be more difficult to see. Because we frequently use our eyes as if they were telephoto lenses (psychological projection of vision), we are very familiar with the telephoto effect (up to a point) and therefore don't think of it as distortion. In fact, we just don't think of it at all. Though in peripheral vision we also use our eyes as if they were wide angle lenses, we are aware of this mainly on the unconscious or semiconscious level. Thus telephoto lenses and vision offer us few surprises (distortions), while wide angle lenses and vision offer many.

Even with the help of lenses, it is difficult to become aware of the wide angle capabilities of your eyes, because only the center of vision is sharp. Furthermore, your ego identifies very strongly with this sharpness, relegating unsharp peripheral vision to a state of semi-oblivion and surrender control of it to parts of your mind that are not easily accessible to you. Even so, it is possible to become much more aware of your wide angle eyes.

Wide angle lenses can help, because they can give you a preview of what may be possible for you. Learning how to look at things without focusing is another help. You should practice this in dim light when you are fully relaxed, trying not to think about the things within your field of vision. This is because thinking and focusing usually go together, and you should try to separate them. This is much easier said than done, of course.

Another trick—also a tough one to learn—is to intentionally make your vision passive, rather than active. That is, instead of projecting it outward into the world (tightly focusing on things is a sign of this), let the world come into your eyes in whatever way it wants to come in. Don't look for things; just let them come to you. Women, who as a rule see much better than men, often find this trick relatively easy, but for the average man it is extremely difficult.

When you are using unfocused and passive vision the world won't look very sharp, but you will be astonished at how much more you see that

Though this girl has a very handsome, normal, and healthy body a 19mm wide angle lens has made it look all out of proportion and ugly. However, this is very normal perspective for both wide angle lenses and wide angle vision, which we have yet to develop in any great numbers. Our fear of this presumed distortion probably helps inhibit this development. Overcoming this irrational fear of ugliness (of the unexpected) should help us free our vision.

way. Persuading your ego to temporarily give up its desperate hangup on sharpness and sharp focus will open up a whole new world for you. Now, this hangup should be looked at briefly.

The ego's powerful attachment to sharpness may be the main reason we see a very limited reality instead of one infinitely complex, which is both good and bad. The attachment and resulting simplification of life contribute to personal and racial stability, which are highly necessary, but they limit us to perceiving a very small part of what is actually happening. Perhaps the modern fascination with the things that lenses will do indicates an unconscious racial desire to leave comfortable stability behind in an orderly way and to search for a more expansive reality. We may be using our photography, which includes all of television, the cinema, and all photographs reproduced in the graphic arts, to lead us to our innate capabilities in visual perception.

This would fit with the notion that photography per se is a giant analogue of the innate perceptual capabilities of man, filtered down to us piecemeal from the higher consciousness of the race, and intended for our use in expanding our awareness to (and beyond) the limits now described by what photography can do. We will come back to this idea later.

Let us return to the idea that the ego's identification with (attachment to) sharpness prevents effective use of the wide angle capabilities of our eyes. If photography is indeed a perceptual analogue of man, then our wide angle lenses clearly tell us of abilities we have not yet learned to use. Using such lenses and experiencing pictures made with them help lead the way, but we are doing other things, too.

One of the things we do to expand awareness is create certain compensatory physical defects in ourselves. For example, to counteract an undue attachment to sharp focus (which is apparently a major psychological affliction in itself) we deliberately develop specific eye defects, usually (but not always) relatively minor. Since such an idea sounds highly improbable, we will turn to the fields of medicine and psychology in search of a solid foundation for it.

Advances in psychosomatic medicine have made it seem likely that all (or at least most) physical defects and ailments originate in the mind. This includes visual defects, of course. That is, due to decisions made in our unconscious minds we intentionally afflict ourselves in a wide variety of ways. Since disease of any kind whatever seems to have no purpose, it is no wonder that we tend to see the unconscious mind as a repository—admittedly vast—of superstition, stupidity, and ignorance. If this is true the notion of compensatory (and possibly necessary) defects just won't hold water. Then the explanation of our suffering would be that we are basically too stupid to stop inflicting it upon ourselves.

When we turn to the psychologists for enlightenment we find many of them tacitly supporting the idea that the unconscious is primarily a reservoir for discarded mental and emotional garbage. However, some do not, including the Jungians, who have discovered that the minds of all people link together in the so-called racial unconscious, which is a vast repository for all human thought from the beginning of the race up to the present. This means that, at a certain level of being, a single person shares the intelligence of all mankind. Furthermore, this intelligence is accessible to what we call the unconscious mind, which is really not unconscious at all. In truth, it is acutely aware of a vast number of things that we have never even heard of on the conscious level. We erroneously call it the unconscious simply because we have little conscious access to it.

The truth is that we are immensely more intelligent on the so-called unconscious level than we are in consciousness, which is ruled by the childlike ego, a rather recent development in man. To the super-intelligent and super-conscious part of ourselves that we ignorantly call the unconscious, all suffering has both meaning and purpose. Ailments and defects, all intentionally created, are intended for very specific curative, educational, or compensatory purposes. It is like the young doctor I met who cured a patient of deadly tetanus (lockjaw) by inflicting him with malaria, which would destroy the tetanus organisms. When the tetanus was gone the malaria was treated with relative ease. Had the patient unconsciously afflicted himself with malaria we would have the exact pattern of what goes on in man all

the time: he creates inner afflictions in order to heal himself physically, mentally, and spiritually.

The promised foundation has been sketched. Though brief, it lends credence to certain ideas presented here, for example, the notion that photography (which includes all of television, the cinema, still photography, and the visual press) is an analogue of innate human visual capabilities, a vast self-teaching machine intentionally passed down to us from the higher reaches of the racial intelligence. Its objective: to teach us how to see. If our minds are indeed linked at a certain level, such a possibility shouldn't seem unlikely. This foundation also supports the supposition that we may intentionally create our ocular defects in order to counteract our bad visual habits, for example, an undue attachment to foveal awareness, or sharpness. That is, we may be inwardly intelligent enough to create our afflictions for very good reasons, though we may not be conscious of what they are.

Let us return to lenses for a moment. A while back I said that the wide angle lens is an analogue describing the eye's innate capability to function consciously for wide angle (broad field) vision but that the ego's attachment to sharp focus (to foveal awareness) permits broad field vision only on the unconscious or semiconscious level. The wide angle lens shows us that such an awareness is both possible and wonderful, and gets us accustomed to the idea of eventually developing such vision. By itself, however, it can't overcome our self-limiting attachment to foveal awareness, which has yet to be recognized as a serious psychic impairment. Thus stronger measures are needed.

Thus we return to the notion of compensatory eye defects that we may intentionally create in ourselves, some of which seem to be designed to wean the ego from its desperate attachment to strictly foveal awareness. They do this by simply making sharp focus impossible under certain conditions so that the ego can learn to do without it, at least temporarily. And without the sharpness the conscious visual field is broadened, for we

can no longer lock our attention into foveal awareness to the exclusion of everything else. Though wearing glasses should ostensibly return us to the state of attachment, they don't really work that way. On the contrary, by frequently bringing our attention to the ways in which we use our eyes they help us erode the attachment, which is largely dependent on our not being aware of what our eyes do or of how we use them. Thus glasses as such are a part of the treatment for foveal attachment.

Though you may make your eyes defective mainly to counteract foveal attachment, there may be many other reasons for drawing your attention to your eyes in this manner. For example, you may be inclined to always see things in exactly the same way, which actually means not seeing them at all. Or you may have a serious mixup between memory and seeing, so that instead of really seeing things you are merely remembering them—and memory is always faulty, you know. Or you may use the visual world as a constant distraction from your spiritual duty to pay sufficient attention to the inner you. Eye defects of various kinds would tend to break up such habits. Though such notions aren't a part of the world as seen by Sigmund Freud, they are nonetheless very serious psychic and spiritual problems.

It may seem strange that a discussion of lenses should dwell so frequently on eyes, but lenses as such are simply substitute eyes. Put it this way: lenses are about eyes. Furthermore, to talk about lenses without mentioning eyes is to miss the whole point of photography, which is mainly a tool for our search for self-knowledge. In terms of both what it is and what it can do, photography is a mirror of man, as he is and as he can be. Thus it is wise to consider lenses as a study of eyes.

As you have seen, it is necessary to wade in rather murky waters when you ask what lenses really do, because the question boils down to what they do for us, which has never been explored. And you have apparently been asked to

believe in some very improbable hypotheses, though this isn't quite so. Truly, all I ask is that you hold both belief and disbelief in suspension until you can figure everything out for yourself. However, one notion needs further explanation, because it is seemingly so absurd that suspending disbelief in it is nearly impossible. It is the idea that attachment to sharp focus (to foveal awareness) may be a serious limitation and psychic defect—who ever heard of such a thing? It seems to suggest that it would be better to be half blind than to have good vision.

Not so. It is surely better to have good vision -provided that you use it properly. Otherwise, one or more corrective defects might be in order. To cover this subject properly we should have a long book entitled Sins We Commit with Our Eyes, using the word sin in its ancient meaning (to sin meant to make a mistake, usually a spiritual one). The list of ocular sins is long and includes such things as voyeurism, visual aggression, distorting visual reality, visual possession, using your eyes in the service of fear, anger, or contempt, insisting on seeing only negative things, and refusing to see all that you are capable of seeing. Though these are sins of the spirit they nevertheless have physical correctives. We will take up only the last one, which relates to the problem of foveal attachment, or an addiction to sharp focus.

Remember that the fovea is the only part of the retina that forms sharp images and that the ego can become attached to them—to sharpness itself, as it were. Now, the problem with attachment to anything whatever is that it tends to blind you to everything else. Thus it is a form of partial suicide, even if we don't recognize it for what it really is. A person with this addiction pays too much attention to images in the foveal part of the retina, where things can be focused sharply, and hardly any attention to unsharp images in the periphery of the retina. Since the fovea will sharply register only a small fraction of the visual information streaming through the eyes, the foveal sharpness addict in a sense refuses to see all that

he is capable of seeing. That is, he excludes from conscious awareness most of what he confronts with his eyes.

• Sharp and Unsharp Foveal Images

It could be said of many people that they focus too much. Though the fovea will register sharp images, we shouldn't always use it for that purpose. When our eyes aren't focused, which should be much of the time, the fovea registers images that are semisharp to fuzzy. At the same time the conscious field of awareness expands considerably. In effect, we begin to approach a type of wide angle seeing exemplified by the wide angle lens. Though unsharp, the images can adequately stimulate a great many kinds of awareness, and that is really their essential function. We should use our eves to serve awareness, not our awareness to serve our eyes. The unfocused eye, which sees well enough for a great many purposes, permits an expansion of awareness to a greater visual field.

However, an addiction to sharpness can lead us to constantly focus on things, which severely constricts the visual field and excludes most of visual reality from awareness. We might call this single-pointed vision and say that the person addicted to it always sees the tree but never the forest.

• The Fear of Unsharpness

There are numerous reasons for an attachment to sharpness, one of them being the fear of blindness. To put it simply, we equate unsharpness with incipient blindness, even though we experience unsharpness all of the time. True, we need the sharpness, and not being able to create it may indeed be a prelude to blindness, though it usually isn't. But we also need the unsharpness, which has a wide variety of functions. The fact that we are unaware of most of them, plus the fear of blindness unless we are almost constantly aware of sharp images, contribute greatly to the hangup.

With the help of lenses of various kinds it is easy to prove to yourself that you are afraid of unsharpness. For example, try wearing someone else's glasses and note the nausea it causes. Or try some rather extended periods of looking through the viewfinder of a single lens reflex camera without focusing the lens—same effect. And print some pictures with your enlarger lens out of focus—again you will feel the nausea, which is simply a fear reaction.

In order for us to take possession of our natural visual heritage, this fear of unsharpness must be overcome, for it shuts off our awareness of most of the visual data that comes to us through our eyes. Since these data are embodied in unsharp imagery, we are simply afraid to see them. Fortunately, it is possible to use photography to help undermine the fear. For example, the many intentionally out-of-focus pictures that you see nowadays have this psychological function, though you may not like them. If you are alert, your dislike may lead you to your fear, and an abnormal fear will tend to disappear once it has been well seen. Even if they don't lead you to your fear, such images can help you, because they help get you used to the idea of unsharpness as something that can be harmless. After all, the pictures don't bite you, do they?

Another help comes from using a single lens reflex camera, the most popular kind nowadays. Every time you focus the lens you unconsciously reassure yourself that unsharpness doesn't necessarily exclude sharpness, that you can have both. This is true of the camera, of course, but, more importantly, also true of yourself. You can have them one at a time or both at once, depending on where your attention is fixed. There are also certain lenses with which you can get both at once.

Now that I have mentioned this fear of unsharpness it is up to you to discover it in yourself and eliminate it. You will find that it is a very powerful fear indeed, because it is the fear of blindness in disguise. Considering its strength, it is no wonder that we permit ourselves so little

awareness of the unsharp peripheral events in our own eyes. Indeed, fear as such is the main limiting factor in human awareness of any kind. Thus we are afraid to "see" what we see.

Zoom-and-Unzoom Lenses

If wide angle lenses describe a human capability for broad-field visual awareness that is used too little, zoom lenses describe the same capability when they are unzoomed (racked inward). The reason for our present inability stems largely from the previously described attachment to sharpness (to sharp foveal images).

The zoom lens describes rather well what we do when we focus sharply on something. In effect, we severely narrow our field of awareness and zoom our attention outward to the thing we are interested in. Though the eye's magnification doesn't substantially change, as it does with zoom lenses, it might just as well. The psychologically important factors are attention and exclusion, not magnification. When we focus on something (project ourselves out to it, as it were) we exclude everything else from our attention, severely limiting the field of awareness. We apprehend this process as magnification, though it isn't usually. However, it could be, for that is another capability of the human mind.

This limiting capability is very important, of course, for it enables us to visually cope with reality one thing at a time. Without this ability we would simply be overwhelmed by the unfocused and undifferentiated visual data streaming in through our eyes from an endlessly complex visual world.

Thus zooming a lens outward describes a survival capability of man, but what happens when it is unzoomed? (notice that its very name—zoom—indicates only one of its main capabilities). Well, unzooming describes an innate human capability that we haven't realized yet, though a few people have it in considerable degree.

To help you visualize what you are about to read, try to imagine a lens that hasn't yet been in-

vented, one with a zoom range of about 15 to 200mm. This would give us coverage varying from a very wide visual field to a very narrow one and is roughly analogous to what our eyes will do. That is, the visual intake of the eye approximates such a range, though conscious awareness does not.

When unzoomed down to 15mm our hypothetical lens would maintain its awareness, so to speak. That is, it would continue to "see" everything in front of it, clear "proof" of this being the sharp image produced at 15mm. In the case of a lens we can say that the proof of awareness is sharpness—we can use any metaphor we like. However, we unconsciously apply the same idea to ourselves, making a permanent wedding of the two qualities.

This is not so good. In human beings, acute awareness (visual or any other kind) may have little to do with sharpness, because awareness as such (a faculty of the mind) can transcend all the perceptual mechanisms. Thus when we unzoom ourselves (which is like a lens unzooming itself out of focus) we should be able to maintain awareness of the whole visual field down to about 15mm, but the fact is that we don't. That is, most of us don't. When sharp focus disappears most of our awareness goes with it.

Yes, we disconnect all or most of our conscious awareness when we unzoom, surrendering the use of our eyes to unconscious forces (which happen to be aware all of the time) and occupying ourselves mainly with our own thoughts. As our eyes unzoom we simply disconnect the visual world, except for paying fragmentary attention to it. This capacity is, to be sure, a very important one, because it makes it possible for us to separate ourselves from exterior reality in order to think about it and assess our relationship to it.

Thus the ability to disconnect ourselves mentally from the broad visual field and its enormous supply of distracting visual data is both good and necessary, but like eating hot fudge sundaes, we like to overdo it. At any rate, using zoom lenses or experiencing their effects on television gives us the idea of trying to keep ourselves plugged in

when we unzoom and encourages attempts to do it. Since the experience of photographic unzooming is quite exciting, it suggests to us that maintaining awareness while unzooming our visual attention might be at least as rewarding.

This disappearance of awareness with sharpness is automatic and if noticed at all is thought to be normal. Yes, it is normal enough but also abnormal in the sense that it excludes other possibilities, which is something that habits very often do. The fact that a visual process is automatic doesn't make it divine. Indeed, human beings can automate themselves to do an endless number of things, normal, abnormal, and in between. In the case of maintaining conscious awareness of a broad visual field, it is normal to do it and equally normal not to-we can permit ourselves to do both. The two states-awareness and nonawareness-have quite different functions, and both should be given their due.

Earlier, I said that one of the primary purposes of photography is to help us gain conscious possession of our innate perceptual capabilities, an assumption surely open to debate. However, I will stand by it without outlining arguments against myself (a part of the so-called academic method), letting others disagree if they wish. Now, from what you have read so far you should suspect that this notion assumes a literally enormous human perceptual potential (on the order of what Jesus told his disciples: "Haven't I told you that you are gods?"). Obviously, your author has positioned himself well out on the limb. Though we are still far from realizing this potential, we are certainly making great haste to develop one of the primary tools with which to lead ourselves to it-the tool being photography, which is progressing in astronomical leaps.

Now, gaining free access to an enormous potential can't be done in a day. Indeed, if it were actually possible it would lead only to madness. Things must be done in turn in an orderly progression, day by day and year by year. We must prepare ourselves for them gradually. One of the first things in learning to see better, for that is really what this chapter is all about, is to learn how

we see *already*. To get started on this it is necessary for us to get our own attention by stripping the veil from automatic visual behavior in order to learn what it actually consists of. When the veil has been lifted we know *what* we do and *how* we do it and find ourselves in a position to consciously modify our behavior and direct it toward a diversity of ends. Otherwise, we are helpless to change ourselves, human robots blinded by self-automation.

So what can the zoom lens and its effects do for us on this basic level?—forget for the moment the interstellar horizons of innate perceptual capacity. Why, it can draw our attention to the strong parallel between zooming a lens and zooming attention, and to the strange disparity when we unzoom both. Becoming aware of what we do with our eyes, even to this limited degree, is a tremendous leap in the right direction.

• How Large Is Photography?

Though I have called photography per se a system with which we are leading ourselves toward our innate perceptual capabilities, I have said little about its scope except to say that it includes television, the cinema, still photography, and the picture press. Thereafter, I concentrated on just a few of the abilities that will be ours in the future, for example, broad-field awareness. Such a severe delimitation was necessary for clarity and at least a modicum of believability. However, we have reached a point where we should see photography's enormous scope.

In its most basic definition, photography is the storage and communication of information by means of radiant energy. This definition immediately moves us into such fields as electron microscopy, radio astronomy, tensor mathematics, plasma physics, plamoid chemistry, mirror optics, systems analysis, trace element chemistry, hydraulics, microminiaturization, computer design, surfactant chemistry, electronics, business reproduction, theory of numbers, and so on. We find that science, industry, business, government, the military, and the space program depend heavily

on photography. In fact, they all might collapse without it.

Photography as most of us experience it—mainly through television—describes capabilities that the public as a whole is nearly ready to realize. The sciences listed above, and many that were not mentioned, describe innate abilities that will, for most of us, come into flower much later.

• From Science Fiction

If I were to make the improbable assertion that $E=mc^2$ is a variant of E=IT (the law of reciprocity), saying that both explain what photography is really all about, this would surely get us nowhere. You surely don't have the slightest idea of what I am talking about, nor could I ever explain it to you.

At this point you don't need scientific (or pseudo-scientific) hypotheses, but your gray cells do need to be awakened and stimulated. Thus we will turn to science fiction, which has this as its primary purpose. The following entirely fictional material should give you an imaginative idea of what photography might really be up to, what lenses do being but a part of it. Some of it may even be true. As part of the game I will be as convincing as possible, writing as if I were telling the whole truth and nothing but the truth.

In the universe, all possibilities are probable; and everything that can be thought of is a possibility. Thoughts are *things* of infinite duration. Literally everything is real, including nothing. In reality, everything is happening at once. Thus can we describe the limits of science fiction.

All thoughts since the beginning of things still exist, stored, as it were, in the so-called Akashic Record. In the fairly near future there will be a photographic machine, controlled telepathically by the mind of its operator, for-obtaining Akashic readouts. For the very first time we will have an accurate picture of the history of Man. From the beginning it has been written second by second, and we will finally have conscious access to it.

The typical camera of the future will not require film. Instead it will employ a cubical mer-

cury mirror, one such mirror lasting its owner a lifetime. This cube will have a memory, so to speak, and used in a single simple camera will produce both still and motion pictures, including sound. The photographer will get readouts in his brain by holding the cube to his forehead and concentrating his will on the things he wishes to recover from his past. Other people who wish to inform him about their pasts will simply lend him their memory cubes. There will also be readout machines for this little mirror, which will be about the size of a pea. Oddly, one of the main functions of the cube will be in training people to take command of their will.

There will be a machine that will convert a single still photograph into a movie of any desired length showing what happened to the things in the still picture before and after it was shot. There will be no time limit to the coverage; if desired, the movie will extend into the infinite past, into the infinite future, or both. The future will be expressed as probabilities.

The cameras we already have that "see" in the dark by means of invisible radiant energy and/or electronic amplification are preludes to equipment with which we will lead ourselves to the conscious ability to do much better than this without any mechanical help at all. In doing this we will only be learning what we already know, which is usually the case in education. Information soon to be recovered from the Akashic will clearly prove that the ability to see well in absolute darkness was developed long ago in our racial history, then put aside for a few millennia while we worked on developing other talents, including daylight vision. However, an ability fully developed is never really lost again but stored in our genes and passed on through heredity. Thus night vision merely needs to be reawakened, which photography is already helping us do.

A favorite lens of the future will be a perfect sphere, flexible and liquid-filled. Due to reactions between submicroscopic amounts of gold and fluorine, which otherwise exist at quite different levels of reality and fail to react together, the liquid will be highly responsive to light pressure, thought pressure, sound, and gravity. With the understanding gained in developing this lens we will banish trachoma and most other eye diseases from the face of the earth. The lens, which will be given as a toy to children, will be used mainly as a training instrument for conscious telepathy. As we are learning that vastly complex language art we will use the lens for such things as turning thoughts into pictures, converting data from the Akashic from the sound form into the visual, making permanent or temporary records of events in both the past and the future, and learning to understand the true nature of light (it is by no means what we now think it is).

Using a knowledge of language brought to us through experiencing photography in its many present and future ramifications, we will rather easily teach the blind to see, for it will be discovered that blindness is primarily a linguistic problem. Even people who entirely lack eyes will develop excellent vision. The very same visual language art will be used to communicate clearly and easily with autistic children.

There will be a photographic device, worn like glasses, that will enable us to see, usually one at a time, an infinity of worlds that exist parallel to our own. Some of them are very much like ours, others utterly different. Training with the device will help us remember an ability learned long ago. Eventually, the trainee will be able to see other worlds without mechanical help. He will also be able to enter them at will.

The electron microscope prophesies a time when we will have consciousness of our own bodies at all levels down to the subatomic. Actually, we already have this consciousness in full force, but it is locked up in that higher aspect of consciousness mistakenly called the unconscious. When we are ready for it, this ability will shift to the ego level.

By this time we will realize that ego conscious (being awake) has been a form of deep sleep from the very beginning. However, with the shift our egos will awaken, and consciousness will actually be consciousness for the first time. To prepare ourselves for a shift of such magnitude

(which would be disastrous if it all happened at once), we will have a variety of photographic devices to help us gradually overcome our fear of looking into our own bodies, this fear being very powerful. With these gadgets, some of them already in existence, we will be able to comfortably examine ourselves piecemeal. Eventually, we will be able to put everything together without being shocked into catatonia by our own enormous complexity and diversity.

Very shortly we will discover that our efforts to teach photography to small children have been badly misdirected, because we have been asking them to do the wrong things. A child should be asked to take pictures of fairies. In the future we will get children started by asking them to record through projections instead of exterior reality, and they will find this quite easy to do. Since photosensitive silver compounds in use today are also thought-sensitive, children's photography on this level is already a possibility, though qualified teachers are lacking. However, we do need materials more sensitive than silver and will surely have them before long.

Through advances in trace chemistry and the chemistry of essences we will discover the element that we need. However, we will mistake it for a compound and call it helium sesquidioxide (an impossible compound of helium and oxygen), though it is actually an organic form of molybdenum. This is the most thought-sensitive element we will ever discover and the most powerful catalyst as well. Indeed, in extremely minute quantities it will catalyze image formation in certain base metals, which will take the place of silver in photography.

Though molybdenum has several organic forms we are mainly interested in helium sesquidioxide, which we will "grow" in molybdenum breeders by means of certain readily available organic substances and sound vibrations, mainly the wavelength G below low G. The key information leading to this technology will be provided by perfume chemists studying both garlic and the geranium blossom, each of which contains one of the organic forms of molybdenum.

With this powerful thought-sensitive element we will develop films and papers that will cost us next to nothing, so that our children will be abundantly supplied. A roll of film costing about five cents will produce either black-and-white or color pictures and will record either thought projections or exterior reality. The emulsion will be a peanut oil derivative. The camera, now foreshadowed by the Polaroid Land camera, will cost about two dollars. It will have a liquid lens. Models for older children will employ mercury mirrors.

The new equipment and materials will be used mainly for preparing children in a very direct way for conscious telepathy. As they are learning to project thought forms onto film they will also be learning to project them to one another. Most will start this training before the age of two. In truth, photography as it is today is already a training system for conscious telepathy, but its methods are still indirect.

By the time direct teaching is possible, photography will have developed far enough as a language to provide us with a framework for making sense of the telepathic experience. Otherwise, many would experience telepathy as chaos and be in serious danger of insanity. With small children, however, this is not a great problem—provided that they have good teachers. Already, photography as it is today is teaching the teachers.

So this is a taste of pure science fiction as it applies to photography. Take it seriously or not —it's up to you. But at least permit your gray cells to be stirred up a bit.

Just a Beginning

As you have seen, this discussion of lenses, which expanded to include photography in general, has barely touched on the subject. Thus you can spend happy years figuring the rest of it out for yourself. Don't underestimate photography—and don't overestimate it either. Whatever you do, try to accept the possibility that there may be purpose underlying a cultural force of such magnitude.

This rather strange picture could be used in meditation as a symbol of the hidden and unexplored self—if you can manage to think of yourself as a battered and beached lobster pot. Or you could just call it an artistic creation and let it go at that; many serious photographers would agree with you.

WHAT PHOTOGRAPHY CAN DO FOR YOU

Now that you have read most of this book and doubtless taken a billion pictures it is a good time to hear what photography can do for you. Had I told you earlier you wouldn't have been ready to listen. If you are a relative beginner, this chapter will help you look ahead a little bit. If you are more advanced it will help you review your experience and determine how far you have come.

You have probably discovered that it is very easy to get hooked on photography. If not, you soon will. Some people feel rewarded to find themselves hooked, but others have qualms about it. Is it a good thing? Yes, I think it's a good thing. I have taught photography to more than four thousand people and have yet to see one who wasn't substantially benefited by it, which is saying a lot for the medium. It has been kind of a hobby of mine to learn how many uses people will make of photography, and I discover more each day. Its personal usefulness seems to be nearly endless. This would explain why so many people regard it as a kind of gift from the gods.

If you are a beginner you will soon find your-self in unfamiliar territory, but don't let that worry you. Things will be explained simply and clearly, so that you will probably find that you have a taste for the unknown. Photography is a mysterious magical art, anyway, as you may have guessed from the preceding chapter. It is good to understand this from the beginning.

Though the things that photography can do for you actually overlap quite a bit, I am going to tell

you about them one at a time, now and then repeating things said in earlier chapters. This should make for easier reading and can help you form your personal perspective of the whole subject, photography. It can also help you decide what kind of an involvement you want with it.

An Aid to Memory

Everyone knows that photography helps us remember those whom we love. The fact that it has grown into a huge industry is based squarely on this truth. Remove this memory factor and photography would soon wither away, but since a divorce of photography from the memory problem is one of the things in the universe least likely to happen, there is no point in worrying about it.

Taking family pictures to bolster future memories should be the easiest kind of photography there is. All you have to do is take lots of them. It doesn't matter a bit whether they are aesthetically good, bad, or indifferent. However they come out, they will still do their job in bringing back warm memories. A well-made picture will have no more value in this respect than a poorly made one.

Oddly, those who do best by their family memory files are often those who know the least about photography. These are the people with their inexpensive plastic camera equipped with flash-cubes. They know barely enough to get the film,

or film cassettes, into their cameras properly, and the flash cubes seated so that they will fire.

Beyond knowing how to depress the shutter release when the picture is framed in the viewfinder, these people know little else about what they are doing. But they do know what they want to remember, and that's what really counts. The technical or aesthetic quality of their pictures just doesn't matter to them, nor is there any reason why it should.

People with more experience in photography often have trouble in making memory-file pictures, many of them soon giving it up as a bad job. They want to make "good" pictures and to look good while they are making them. Though wanting goodness is surely a virtue, the desire to create it is easily taken over by the ego and used for ego purposes. And we can project our egos into photography, too, though it usually takes a while to reach this point.

So the advanced workers, believing that their egos are being displayed and publicly tested, feel that they have to come off like hotshots, both in their way of shooting and in their finished pictures. They can't take ordinary snapshots but feel impelled to produce "art," whatever that is. When you try that you may seriously impair the memory stimulation functions of your pictures; all you will remember is what your own ego was experiencing, which is only a part of what was going on. Instead of being the thrill it should be, looking back through your pictures becomes an orgy of embarrassment for your ego.

And you know how families are about egos! Why, the family could even be defined as the social grouping in which egos are given the hardest possible time. Thus a person who has advanced far enough in photography to identify his ego with it is really asking for a hassle, silent but deadly, when he brings out his camera. Small wonder that so many soon give up on family photography.

In itself, this projection of the ego is not a bad thing. Indeed, it is a spiritual opportunity, in that it can guide you toward seeing what your ego is up to. If you want to be an angel you have to separate your ego from all of its disguises, then bruise and batter it into line—which you can do with photography, if you like. But ego projection, for all that you can learn from it, does make simple memory-file shooting very difficult. How can you make simple snapshots when your ego insists that you have to become the greatest photographer who ever lived?

So you can see certain advantages in being naïve about yourself and photography: you can easily make memory pictures that are relatively undistorted by your own egotism. A monkey could do it too, but don't let that thought disturb you. It just happens that monkeys are greatly superior to people in some respects.

Many people lose their photographic innocence, then struggle for years to get it back, usually without success. There is even a so-called school of serious photographers devoted to this pursuit, and a few of them seem to have come close. It is a very rugged road, however, so let this be a warning to you. If you enjoy simply snapshooting around—family, friends, interesting places—you might be wise to let well enough alone and not dig into photography too far. There is no reason why you shouldn't cling to your innocence in this particular area. Lord knows, you have to give it up just about everywhere else.

Perhaps the best defense for your innocence is to stick strictly to the how-to-do-it side of the medium and stay very carefully away from the why side. If you start asking why, as we are doing in these last two chapters, you will soon learn that photography can be a very heavy game indeed. If heavy life games are your meat, hop to it, and be sure to help yourself to the gravy. But if you want to just snapshoot around happily, play it dumb—good and dumb. One of the most important things I ever learned in my life was when and how to play dumb, so I pass this secret on to you. Passing yourself off as a koala bear could even save your life some time, and I kid you not.

You may feed your need a rationale to bolster

you in your snapshooting innocence. Try this one: the only kind of photograph that people entirely believe is the snapshot. With other kinds they are intuitively aware that they are looking at ego projections, not reality as the race has agreed to see it. As for the memory question: there is no better way to assemble a fantastic memory-file than to be a productive, flat-out snapshooter. You will really capture your family and friends, not just self-centered projections of yourself. Thus going back through your pictures in later years will be an immensely gratifying experience.

Involvement in a Creative Process

In our constant efforts to improve, heal, and create ourselves there is no better tool than a lively involvement with a creative art. The artistic history of mankind stands as a testimony to this. Artists and poets have long been considered those who have reached the farthest in self-evolution, in the search for human perfection. But we don't have to get grandiose about this: even those who have merely dabbled have usually found their lives improved.

It is the innate nature of human beings to be creative, and this process should go on all the time, night and day. Creation is our business, you might say, even if we don't know for sure what we are creating. It is life, it is movement, it is human nature and need. Indeed, we even create ourselves; and it is our spiritual responsibility to do the best job of it that we can.

In the business world there are many people who think they do us a favor by making individual creativity unnecessary, and we in our naïveté believe them. Thus we have number painting, screw-together sculpture, and a myriad of plastic parts waiting only a touch of model cement. The general idea of do-it-for-them has proliferated and expanded in every conceivable way, so that many of the arts have been nearly spoiled for the public.

But not photography. Though the spoilers have been at work since the beginning of the medium, they have never managed to get a big enough bite of it to do any real harm. So we have an unspoiled medium to work with; thank the Lord for that. Whatever small damage was done is rapidly being undone. Though the do-it-for-them philosophy is very much with us in things like automated cameras, it is unlikely to do any real harm there. Indeed, it will mainly lead people further into personal creativity with the medium.

The protective shield for photography has always been the fact that people basically want to make their own pictures, not someone else's. Though many have been led into imitation, the majority are no longer interested in it. The do-it-for-them concept is surely a part of photography, embodied mainly in equipment and materials, but it is not likely to get out of hand. People resist it after a point. For example, it would be possible to market a little kit containing processing chemicals and exposed paper; develop the paper and you get an original print by a famous photographer.

Certainly this has been thought of more than once, but I can't imagine the public really going for it. For better or for worse, the majority wish to make their own pictures and couldn't care less for pictures by the famed. Such things guarantee that photography won't turn into a sterile medium, though you can use it that way if you insist. The nibblers are all around us, to be sure, trying to turn photography into a hobby for idiots. But if they were going to make any real progress we would have seen signs of it by now.

One of the protections against being forced or led into imitation is people's innate contempt for photographs made by others. The existence of this attitude is illustrated by the little success even our finest photographers have had in selling original pictures and portfolios. I have seen literally thousands of splendid photographs that the public wouldn't pay a nickel for. People just don't want them; they want their own pictures.

Unfortunately, this contempt that people have extends to themselves and to the medium itself. The feeling is that photography is a nothing art

for nobodies. Though people experienced in photography worry about this they shouldn't, for it is an important part of photography's self-protection system. The professional spoilers won't deign to meddle with something they consider so unimportant. And the contempt goes away in time, so that people involved with photography can learn to appreciate one another's work. In the meantime, photography is kept unspoiled for them, protected by its overwhelming ordinariness, shielded by the contempt that so many feel for it. Incidentally, this is the only time in my life that I have had anything good to say about contempt. It is like saying that Satan accidentally does good in this world.

Another protection for the medium is that the spoilers, grammarians, and do-gooders just don't know what to make of it. It is like the halfwit Eskimo hunter confronted for the first time by an African elephant. He doesn't know whether to shoot it (which end?), forget it, or invite it home to tea.

So you have an unspoiled medium to work with. If you still find yourself happily making pictures, bringing them home from the drug store, or making your own prints, you are well ahead of the game in terms of what photography can do for you. You are functioning as people were intended to: creatively. You are bringing new things—images—into existence and reacting to them in a fruitful way. Though you may not feel like a great *artiste* in photography, this doesn't matter a bit, for the process of creation itself is the thing. You are now working on the cake, and the frosting can come later.

Nonverbal Talking to Yourself

When we are children we are all experts at talking to ourselves, but as we grow older we tend to treat this lively and useful inner communion with skepticism and cynicism. As our egos develop they muddy up the water so much that we can't trust what we hear when we are talking to ourselves, so more and more we tend to deny our-

selves this inner reverie. But we feel the loss deeply.

Few realize that there are kinds of inner dialogue that can more or less sidestep that accomplished spoiler, the ego. Photography can be used in such a communion and very often is. However, we then listen to pictures with our emotions, not

Say you are interested in photography as a visual language and wish to consider this picture as a statement of how you feel about things. This is a legitimate way to use your imagination. Well, how do you feel? Pretty negative, I would say. Again, feeling this way and seeing your negativity symbolized in a picture is a legitimate choice, though it is not especially good for you.

our intellects, sometimes trying to translate what we feel into words, usually not. With or without words, we know that there is real communication going on, because we can *feel* it. And this communication has value. As we gradually learn to trust our feelings this knowledge becomes a certainty. Women are usually best at this, because

Poets sing of grass and bumblebees, but to me grass is mainly something to cut and bumblebees to run from. Well, photography can help you heighten visual perception, so this particular grass began to take on majesty and lyric form. Enough of that: let us say I merely noticed, for a change, that tall grass is kind of pretty.

they haven't spent their lives denying the very existence of their emotions.

Psychologists have provided us with some useful descriptions of the human self, which they see as a multi-level entity. Except for the ego, which dominates so-called consciousness, all the other levels are carefully hidden, though they are striving constantly to express themselves. As a way of continuing its domination over consciousness (which has turned it into a form of sleep), the ego constantly blocks expression from within, ordinarily doing a very thorough job of it.

However, when we get involved in creative work such as photography there is just too much going on for the ego to keep track of, so that higher and lower levels of the hidden self can sneak their messages through and give them expression in pictures. They are usually in the form of rather obscure visual symbols which we can feel but not understand verbally, though a verbal understanding is possible. This obscurity is necessary for outwitting the ever-vigilant ego, which was at one time called "the wolf of consciousness."

Thus our photographs are always full of symbols designed to catch our attention and help us consciously share knowledge from the higher reaches of our own minds. However obscure these symbols may seem, at one level of the self we know exactly what they mean, or we wouldn't have bothered to use them in pictures. To that super-self erroneously called the unconscious, everything whatever is a symbol, and the meaning of all of them is available to it through the racial memory. So you see that it has an abundance of symbols to draw upon and that there is no way whatever to avoid them when you make photographs. The fact that the ego is not aware of this vast languaging capability is one reason that the "unconscious" can sneak its symbols (very carefully selected) past the ego and into pictures.

With our minds (mind and ego aren't the same thing) we can step around our egos and open ourselves to what the symbols selected by the unconscious are trying to tell us about ourselves. Remember that on one level of self we already know what they mean, so the process identifying them and deciphering them is not as terribly difficult as it might seem to be. Furthermore, the symbols selected are ones the ego is almost ready to be aware of anyway, often in the sense of being prepared to take it on the nose.

In some pictures the meaning is much closer to the surface than in others. You can often identify the more accessible types by your feelings about them, using the emotional extremes as indicators. For example, if one of your pictures makes you feel either very exhilarated or very upset you may be sure that it embodies a message, often an important one, that you are very nearly ready to be aware of. Now, your ego very definitely doesn't want to hear it, yet at the same time it does want to—for a very good reason. You see, messages from the inner you strengthen your ego and help

If you are a junk addict like myself this nostalgically corroded bicycle frame may bring back sweet memories of happy hours spent wandering up and down the beach looking for interesting flotsam and jetsam. Or it may remind you of the day your new bicycle was stolen and you fell down the back stairs and broke your elbow. Take your choice, sweet memories or sour.

it expand and improve itself. Even so, the inner conflict goes on almost continuously.

One of the ego's problems is that it is definitely finite, while the self as a whole is infinite. Thus the ego is deeply terrified of being swallowed up in the immensity. That is, we are very afraid of ourselves, and well we should be. A sudden confrontation with his or her own immensity would be enough to give anyone a permanent case of the ravels. However, the manner in which we use art forms such as photography make it very certain that such confrontations will take place very gradually. The symbols delivered to the ego in pictorial form are chosen with very great care by the higher self so as not to be too overwhelming, because for its own sake it must strive to keep the ego healthy and intact, despite the endless crimes that the ego commits against it. Crimes against the self, as it were. For all its famous foolishness and stupidity, the ego is a high spiritual part of a human being. It just needs to learn a few things. For a reasonable perspective, think of it as mainly like a baby or small child, not so much like a willful adult criminal.

So you see that our pictures can have a lot to tell us, because there are many levels of the self speaking through each one—unless they are entirely blocked by the ego, which can happen. But listening well to oneself is a very high art not easily learned. It can only be mastered by learning to listen well to others, and you know how that goes. Since you are interested in photography, you should learn to listen well to what people say about pictures. Many people work very hard at this kind of listening.

That people intuitively know the royal road to the self is through others helps explain the enduring popularity of photography classes, seminars, and camera clubs. What people have to say about pictures—or the fact that they say anything at all—can be extremely hard to take, but people interested in photography sense the good in such groups and manage to stick it out.

My advice, then, is to join or help form such a group, with the primary goal of learning to listen

well to other people in all the ways they communicate—with words, pictures, gestures, yawns, coughing spells, silences, sneezes, or whatever. One reason to follow this advice is that people will very frequently tell you very accurately what you are trying to tell yourself in your pictures. Thus when your ego blocks such knowledge, as it is very prone to do, you can get it from someone else.

Like dreams, your photographs can tell you who and what you are. Unlike dreams, they do not fade away and disappear, or get changed and distorted in memory. Photographs are telegraph lines to parts of the self that are much greater than the so-called consciousness that you know of. For both beginners and more advanced photographers this material on reading pictures ought to be spelled out a bit, so this is what I will do.

• How You Really Feel About People

One of life's problems is in keeping track of how we really feel about other people, because there is a lot of suffering, conflict, and confusion involved in not knowing. Recently, for example, I have been working with one of the country's finest portrait photographers, whose attitude toward his subjects is making him utterly miserable. He thinks he sees them coldly and cynically, but this is by no means the truth.

If you were to look at a group of his portraits you would almost instantly see that he adores the people he photographs—all of them without exception. I doubt if it is possible to love people more than he does, yet he actually thinks he despises them and condemns himself deeply for this. So it is left up to others to tell him the truth, which we are doing as swiftly and convincingly as we can. His life should then be considerably improved.

Helped by others, it is not all that hard to tell from your pictures what you think of people. This is because they function as mirrors when you are photographing them, reflecting back to you your own attitudes, emotions, and prejudices.

Though it isn't true, you could say that this picture shows accurately how I really feel about people, that I see half of them as crazy and the other half bogged down in despair. Well, this may be true enough, but it's not my way of seeing them. Or you can just call this a mildly nutty picture and let it go at that. Incidentally, if you want to know how your author actually sees people, look at the pictures in this book.

Since people are entirely unconsious of doing this they do it with great honesty and incredible accuracy. The reflections are messages from their super-intelligent higher selves. Because the human face is immensely more pliable than generally supposed, it makes a splendid tablet on which to write such messages.

In effect, when you photograph someone you ask him or her, "Who am I? How do I really feel? What are the main psychic problems confronting me?" You invariably get the right answers, though they may be hard to decipher—because your ego does its best to mess things up by making the messages in your pictures obscure to you. Even so, with the help of others you can get a very complete and informative reading on almost any portrait you can make.

(When members of a discussion group analyze a picture they seldom find its message right away,

for this takes time and patience. Moreover, they must tentatively assume that the message is indeed there, which is a difficult assumption to make for people unversed in the ways in which the unconscious mind expresses itself. And much of the discussion is banal, irrelevant, and egocentric. Even so, the wheat can be winnowed from the chaff—by people of patience and good will.)

It needn't be said that people on an ordinary level often find it difficult to work together. Perhaps the important thing to realize, however, is that at the higher levels of self they are very cooperative indeed, though not consciously aware of it. These levels account for this helpful mirroring which people do for one another. This goes on all the time, whether or not you are making photographs. Thus if you are uncertain as to how you feel (unhappy, confused, angry, frightened, etc.), all you have to do is look at the people around you; their faces will tell you—provided that you will permit yourself to be aware of what your eyes are trying to tell you.

But sometimes we definitely don't want to see what faces tell us, not on the ego level at any rate. I once had a student, whom I will call Bill. who had the hardest time getting his own attention. A very productive photographer, he brought in dozens of new people-pictures every week, and every one of his subjects looked very angry. They were all trying to tell Bill-and he was trying to tell himself—that he had a very serious problem with repressed anger. Unconscious forces in himself, helped by similar forces in others, were trying to draw his attention to the difficulty so that he could begin to deal with it on the conscious level. Thus his pictures inundated him with the fact of his anger, contrary to his ego's wish to shove the whole problem under the carpet. If I had a nickel for every Bill I have had as a student, I would be a wealthy man today.

One reason why this mirroring works with such great accuracy is that at a higher level of the self we are all accomplished telepaths. Thus at this level you can make it very clear to others what you want them to mirror back to you for your ego's enlightenment, egos not being telepathic yet. The mirror images will be excellent, though your ego may not wish to see this. If you don't like this explanation, which is a little far out, try to come up with a better one. If you have been around in photography it is hard to escape the fact that mirroring does indeed go on, and it can hardly be accounted for in an ordinary way. Stir up your gray cells and see what you can figure out.

What Others Think of You

A few people use photography as a way of getting a better idea of what others think of them. Though this is a painful way to use the medium, it helps us along the arduous path to self-discovery. However, the mirroring makes interpretation difficult. How can you tell whether you

I would call this a really rotten picture, frankly, and it reminds me most of anger and fear. Ugly as it is, making such a picture can be useful, for it can help one track down the sources of these terribly negative and destructive emotions. Perhaps you don't get my imagery: try thinking of the charred driftwood as a brain cell rotted by anger and fear. Pretty lousy, what?

are looking at people functioning as mirrors or, instead, coming across as themselves? I can't give you an easy answer for this, because they do both things at the same time but in different proportions, which makes it difficult to sort things out.

Nevertheless, we can look at our pictures of people and get some pretty good clues concerning how they see us. We do this mainly by feel rather than intellection, so people who have strangled their feelings won't get very far. Fortunately, there are surface clues that we can look for, such as tensions in the eyes, mouth, neck, and shoulders of the person (or portrait) we wish to read. The hands communicate a good deal, as does posture. Consciously, people try not to communicate to you. On the ego level, they usually don't want you to know what they actually think of you. Impelled by higher forces in themselves, however, they are constantly giving them-

Now, you can use photography to increase your awareness of beauty. For example, every night for years I lay on the bed reading and could have seen this pretty little tableau (set up by my wife) had I bothered to look beyond the ends of my toes. But I rarely did, until one sweet day I got out my camera and decided to really look at what my wife had done to our apartment. I found it utterly charming.

selves away to anyone who knows how to see. It is human destiny that people will eventually get to know one another well, so this is the general direction we are taking, despite ourselves (egos).

There is an ancient truism that makes interpretation a little easier: like begets like. For example, if you think a person a fool your attitude will breed similar thoughts in him or her with respect to you. If you then make this person look like a fool in a photograph you may be sure that you have made a self-portrait written on another person's face. This kind of thing happens all the time, incidentally, because like begets like is one of the higher laws of psychology, a law that never fails.

I remember a student who brought me a picture he had made of his best friend's father. He was terribly happy when I saw that he was portraying the older man as extremely egotistical. Though I was considerably less blunt than he, his fiendish delight disappeared when I told him that his subject undoubtedly reciprocated this attitude and that the picture showed this clearly. That is, the father saw the young man as an extreme egotist. It was a case of egotist vs. egotist.

So, if you want to know what people think of you, just figure out what you think of them. Having pictures of them will help a lot because they won't bite you and can't talk back when you are talking to them. As a guide for analysis, remember this rule: the characteristics that disturb you most in others are ones you share with them, though you may not be aware of it. If self-knowledge is one of your goals in life, photography can help you a lot—but it won't always be easy.

• Fear of Others

Quite a few people use photography to help them uncover, analyze, and dispel their fear of others. They do this mainly through making pictures of their friends and acquaintances, whom they also inexplicably fear. But the fear of friends isn't so strong that it can't be worked on and dispelled.

Just looking at people up close, and thinking the thoughts that naturally occur, can help a lot. However, we need an excuse for such close proximity, which photography readily provides. And people see no harm in having their pictures taken, so they don't make an issue of it. Finally, the very act of photographing someone gives the photographer the psychological position on strength, which helps him greatly in holding himself together.

It may seem strange that merely taking pictures of people will help you overcome your fear of them, but that's the way it works. Few people are able to verbalize what is happening to them as they photograph, though they usually know they are frightened. People who are determined to deal with their fear just dive into portraiture and wade their way through it, no matter how hard it is on the gut. Please don't construe this as a kind of masochism, because it is far from it. Indeed, it is a pathway through fear to the other side, which is a horse of a different color.

If you are an everyday coward, as most of us are, you might consider specializing in portraits of your friends and acquaintances for a while. You can even tell them what you are going through, and it may help a lot. Your camera gives you the only excuse you need for what you are doing, and your subjects are unlikely to question it. Indeed, they are just pleased to know that you want pictures of them, for it is a very nice compliment.

• Actively Experiencing a New Language

For unknown reasons there has been a great upsurge of interest in photography recently. Most obvious in Japan, where nearly everyone has turned into a photography nut, it is also making itself felt in this country and elsewhere. I would say that this interest has largely to do with language and the fact that photography, especially in television, has finally reached the point where it is

functioning fully on the linguistic level. If this is true, it means that photography has become a cultural necessity, just like the spoken and written languages.

Earlier, I said that photography is unconsciously, but very skillfully, being used to prepare us for conscious telepathy. In itself it is becoming the exterior form of the language of telepathy. It is well known that people are fully telepathic on the higher levels of the "unconscious," but nearly forgotten that talents such as this can also shift levels, even into so-called consciousness. Considering all that is happening in the world of photography (which in its linguistic applications includes television, the cinema, still photography, amateur photography, the picture press, and so on), it shouldn't seem unduly strange that we might be unconsciously preparing ourselves for such a shift, even in the near future. Of course, this would help account for the unexplained surge of interest in the medium.

Photography's long period of development as the teachable form of the language of telepathy has been vitally necessary, and it must continue to develop at a constantly accelerating pace, into the distant future. The long years are necessary, because a true language is an organic growth arising slowly from the thought patterns and perceptions of those who use it. For them, it must be an all-encompassing mirror, though they may not be able to see themselves in it. Now, this developing language of telepathy is apparently destined for all the nations. As such, it must have the enormous breadth and flexibility that will make it an effective tool for coping with every conceivable linguistic event, both in exterior reality and in the human mind. Since everything that can be thought of is such an event (a symbol), you can see that a language is no small matter.

This developing language of telepathy (photography) must take within itself all the written and spoken languages, which photography (television) is rapidly proceeding to do. For example, in American TV we have both types of language represented in full force, though the written lan-

guage is only implicitly present. However, since written words in the English language stand very explicitly for sounds, this kind of presence is quite adequate for our linguistic needs in terms of telepathy. This bringing together of pictorial, written, and spoken languages is also happening in many other nations, of course.

When telepathy is mentioned people generally look stupid and obviously haven't the slightest idea of what it is and what it would do for (or to) us. Fair enough, nobody really knowsunless he or she is a telepath. But imagine having a television set in your head, broadcasting programs from Lord knows where, with somebody else selecting the programs, doing the tuning, and obviously trying to communicate something to you. Now imagine six sets going along in your head at once, one of them following your best friend at the supermarket as she looks over the vegetables, another taking you on a guided tour of your own pancreas, a third showing you a burning passenger liner in the Mediterranean, and so on. Well, this is kid stuff, I suspect-for telepathy could be immensely more complicated and confusing than this. For example, you might have a helluva hard time even keeping track of who you are. At any rate, with such things going on in our heads we would need some kind of a linguistic structure that we could use to get everything sorted out, which is where photography comes in. It is coming along very well in its development in that direction. I can't say that I worry about our telepathic future (if it actually comes about), but I at least find it interesting. Indeed, if we need a language for telepathy, why then we will have it when we need it. The human race has better survival capabilities than some people suppose.

Let us now consider photography-as-a-language on a more down-to-earth level, letting the future take care of itself for a while. As a teacher for many years, I've put in thousands and thousands of hours working with groups in photography. Seminar stuff, mostly, where people come together to talk about their work. Years ago it used to be such a terrible grind for the teacher, because no one had a word to say. The teacher himself had to make up all the meaning that got attached to the pictures, fighting each point with the students, who were certain that photography didn't mean anything at all. Everyone thought that, including most professional photographers. I'm telling you, it was really hard on the gut, trying to convince all those people that their chosen lifework actually had meaning. Can you believe that they preferred to think it did not? Such is the perversity of man.

Well, quite a change has taken place since then. The groups you meet with now actually think that photographs can mean something (praise the Lord!) and that it is fully worth one's while to try to decide what it is. I have sometimes read about the group of famous literati who used to meet at the Hotel Algonquin in New York-Dorothy Parker and her crew. Frankly, I doubt if the discussions would hold a candle to the ones you can now get into with groups of photographers in almost any part of the country, although there are also groups in which pigheadedness and banality predominate. But the good ones-vive la différence, I say. We have even reached a point where people can be teachers of photography without sacrificing their sanity, solar plexi, and left hind legs.

These present-day groups usually have a terrific time together, though it can get very heavy, too. However, they tend to take the heaviness as part of the learning process and learn to suffer through a good deal of it without backing off. Indeed, many of the youngsters thrive on heavy and ask for as much of it as the group can give. In this sense photography groups are a lot tougher nowadays, much more inclined to suffer hearing people out than they used to be. Listening is very heavy duty stuff, you know. In the old days the big thing was for people to chop each other up and play the old "I win, you lose" game.

So this is what is open to you nowadays: if you work hard to make your pictures communicate something you can actually find people who will

work equally hard to determine what it is. Since this can be a very heavy business, it means that they will even willingly suffer for you. And often your pictures will get through to them like the Red Ball Express, which is a wonderful experience. How nice to know that you have communicated well! Furthermore, you will almost invariably learn that your pictures say much more than you thought, which is equally rewarding. To be able to communicate fills a deep human need, and when it involves a new language you are mastering, like photography, it is outright thrilling.

A thing that happened in young people's music is also having a strong effect on photography. A few years ago the kids decided that all people should be permitted to make music, even if they sang off key or sounded like aardvarks in heat. Let people do their own thing, was the slogan. This was one of the most brilliantly revolutionary developments of the century. It meant that everyone could make music and not be criticized, not just the brilliantly gifted.

Fortunately, the very same young people brought this idea into photography, where it still has a powerful influence. Though there are still a few laceration specialists around, they no longer run the whole show. In a contemporary group the majority no longer huff and puff to tell you how bad your work is. Instead, they wait patiently to tell you what it communicates to them, if that is what you want. This is one of the recent developments that seems to portend a telepathic age. In such an age a person's communications will have to be heeded (just try keeping him out of your head!), even if they aren't spectacular and important. Furthermore, this patience with others that we seem to be seeing more of nowadays will be of great importance should the race decide to shift into the telepathic mode. Make no mistake of this: we will do it if and when we decide to do it.

And if we don't? Well, things will be a lot more simple. As Grandma said when she jumped into the washing machine, "It would have been easier not to!"

What Things Look Like

When we are little we are very interested in what things look like and spend endless days soaking it all up. But as we move out of our teens many of us lose all interest and never get it back. Not caring what the world looks like is a deadened state of mind which contributes greatly to the general malaise that afflicts so many. You might even call it a psychological illness.

Fortunately, photography is a powerful tool for regaining an interest in the appearance of things. It presents reality to us in such a magical way that we find it nearly impossible to resist. When an image comes out of a Polaroid camera or pops up in a print tray it really gets to us, excites us. Only a very dull character can ignore such blandishments. And the magic continues to work through many a year.

So if you find that your visual world has lost its spice, photography may be the very thing for you. If you are already involved in it consider yourself lucky. Compare yourself to the millions for whom the world is just a vast monotony of nothingness and count your blessings.

Heightened Visual Perception

It is not only possible to regain interest in the visual world but to learn to perceive it with an intensity never before experienced. For example, you may now think that the super-intense "fluorescent" colors are the liveliest ever—for they are extremely bright—but did you know that it is possible to see nearly all man-made colors that clearly? It is a wild and wonderful experience, to be sure, and some fortunate people see that way most of the time.

Some see the world as much brighter and cleaner than others do, sometimes to the point where they have to wear dark glasses to bring it down to a bearable level. You would be mistaken to think that people wear shades only if there is something wrong with them. Often, dark glasses

In the text I suggest that you can use photography for coping with such things as fear and anger, and I have my own special way of doing it—with pigs, of which I am extremely fond. When my brain feels like a badly burned roast and I feel like condemning the world to perdition, I think of photographing pigs and how much fun it would be to do it. Or even having a pet pig (a small one). It works amazingly well.

mask very superior sensitivity and awareness, for the very people who see brightly also see much more of the visual world than others do.

Now, the practice of photography moves one gradually but surely in the direction of heightened visual perception—and there is much more to it than has been suggested in this book. It is like moving into a new and unspoiled world—the fresh and vital world of childlike perception.

You don't especially need signs and guideposts for this journey. Just take your pictures and follow them where they lead.

Awareness of Time and Space

Through working with literally thousands of photographers I have learned that they are fascinated by time and space, though I am unable to tell you why. The space part is easy enough to figure out, because all photographs embody space illusions of some sort, subtle or gross. We find positive space, negative space, shallow space, deep space, nonspace, or a mixture of different kinds in every picture. I've personally played endless hours with visual space and consider myself well-versed on the subject, but what about time? What has time got to do with pictures?

Talking to other photographers hasn't explained time. They can't seem to verbalize what they are up to, though their enthusiasm is communicated strongly enough. Most of them don't even try to translate from photography into words, yet they may be right. Perhaps photography, a nonverbal language, is a good way of intuiting time, not intellectualizing it. Though we are doing our best to translate all of photography into words, and vice versa, there will always be large and important areas that just aren't translatable. Perhaps time is one of these.

Oddly, photographers often relate pictures of stairways to time. Equally odd, some of my students have told me that when they are tripping or stoned on pot they can see movement in still pictures, and when we have movement we have time. Well, you figure it out.

I have observed that people need little experience in photography before becoming enchanted with time, and that they don't seem to mind pursuing their interest on a purely intuitive level. They seem to relate time to tone and space, but communicate such ideas mainly by pointing, waving their hands, and shrugging, rather than by verbalizing. Whatever is going on, we seem to be racially involved in a growing awareness of some kind, which would help explain the enthusiasm for time and space in photography. It also seems clear that if you are interested in time and space you will find photography rewarding.

Insights into Visual Communication

When we speak of the visual communication world we are usually referring mainly to television, which is a form of photography. We list TV first simply because it takes up more of our time than any other visual medium.

TV and still photography are undoubtedly more closely related than anyone supposes—if we knew more about the nature of time we could probably see this quite clearly. Even without this understanding, people in droves are intuiting the essential oneness of the two forms of the medium. As you will see, this would help explain the tremendous growth of interest in still photography.

Let us see what happens to people in this socalled visual world. For years we passively submit to a daily bombardment of TV images, only vaguely aware of how the visual language works. Eventually we reach the point where we feel ready to see the whole thing as a language structure and to become fully aware of how it functions. Intuitively, we grasp the fact that the grammar of this language is outlined best and most simply in still photography, so this is where we turn in search of understanding. Fortunately, all we learn from stills relates very directly to our experience of television.

Some general comments are in order. Nowadays, students have a much better idea of where they are going with their photography than they used to have. Many have established their goals even before starting school. Perhaps the most common goal is this: to put it all together, this vast puzzle of the so-called communication world. Some put it this way: "I want to find out what the hell TV has done to me," which means approximately the same thing.

Well, TV (photography) has done much more to us (actually, for us) than anyone suspects. As we've just seen, it drives people into a study of the visual language, which happens to be a good thing. Furthermore, it prepares them very well for this study, though the people in television certainly haven't had this in mind. Even so, the actors, producers, cameramen, directors, advertisers, and so on have served us well, mainly because they have had to. In order to stay in business (hold their viewers and sell them things) they have had to use the visual language with very great care, which is all that really counts. In comparison, the garbage they produce and the shenanigans they pull hardly matter at all.

Back to cloud nine for a moment: television per se is a gigantic teaching machine handed down to us piecemeal from the higher consciousness of the race for use in preparing ourselves for conscious telepathy, which demands that we have a language proper to it. The basic grammar of this language is embodied in still photography (as well as in TV and the cinema), giving us easy and economical access to it. People interested in photography may be mainly preparing a language for the future. On the other hand, the racial shift into telepathic consciousness could come soon and suddenly, overnight as it were. In this case, learning the grammar of the visual language could be seen as an unconsciously motivated step toward preserving sanity against the tremendous impact of telepathic consciousness. And, of course, you can see this whole paragraph as hogwash, if you like.

Well, anyhow, back to Mother Earth for a while. For all their experience with images, people still have a lot to figure out concerning what makes visual communication work. So many of them are doing it; simple as that. Photography was just sitting there waiting for them, including thousands of fine teachers who just weren't available a few years ago-and thousands of fellow students with the same interest in sorting everything out and putting it all together. I would say that the setup is nearly impeccable—much to my surprise. This doesn't mean that learners won't have very heavy ups and downs, but such things are an important part of the growing experience. And if the situation looked too good we should be worried.

A development of special interest is that many of the people using photography to figure out the visual communication thing for themselves aren't asking for help. By themselves, or with a friend or two, they sail right into it, asking and answering all the questions for themselves. On a cultural level their ability to function independently is a very good thing. If we are indeed close to a shift or awareness levels (which is only an hypothesis) there just aren't enough teachers to help everybody, despite their great increase in numbers in recent years. But not to worry. My crystal ball (filled with hot chicken soup) says that TV itself is doing the major part of the teaching job, though few seem to suspect it.

• Hidden Levels of the Self

A few years ago if you told someone he had levels of himself quite unknown to him he would just sit there like a constipated oyster with not even a "So what?" expression on his face. I ought to know, because I have the world's record for the number of times I've told people this (Guinness Book of Records). But I'll never get

To me there is much time in this picture as well as space. The little girl running through her grandma's chicken yard carries me back to the days I spent on my grandma's farm, happy, carefree days. And age is also in the battered house and chicken coops, even in the ground strewn with oyster shells. And chickens are a gas, really such groovy little dumb creatures.

really used to those oysters sitting there without a burp.

Things have changed a lot in the last few years, and the average kid knows very well about these hidden levels and has done everything he could think of to gain access to them. This is what the Drug Scene was all about, of course, and explains why Don Juan reigned so long as America's Guru-in-Chief. After racking themselves up with the hard ways of trying to make higher contact with themselves, many of these kids have turned to gentler and more gradual routes, such as music and photography. There they can experience enough to keep themselves as spaced out as they like.

Essentially, being spaced-out means to be in contact with your higher self or with someone else's, which also happens now and then. It can also mean contact with a lower self. Many of the young—and their elders too—have become addicted to being spaced-out for its own sake and make no effort whatever to learn anything from it. But there are a few real heavy types who do want to learn.

Now, these real heavy types, many of them in photography, really want to put the whole thing together by figuring out, bit by bit, what is actually going on in themselves, why, and how it all works. These heavies are very strong people, though many of them are young. They will invite emotional punches in the gut that would fracture an elephant, then come back for more. Despite the suffering that it entails, they *really* want to learn about themselves, in fact consider it their spiritual duty. With this I totally agree.

We will see how the heavies use photography. If you assume hidden levels in yourself expressing themselves somehow through your photography you will not look at your pictures in the same way as people who don't make this assumption. They may assume that they completely understand their own photography, while you see yours mainly as a puzzle to be unraveled. As you look at your work you constantly ask yourself, "What does this mean? What am I trying to tell myself,

if anything? What am I really trying to communicate to others? And on what level?"

For a person aware of the existence of hidden levels of the self, looking at a picture becomes a subtle form of listening, too. As you look you listen to your own thoughts, trying to stay aware enough to pick out the ones that don't sound especially like you. These are the thoughts that may originate in your higher self. But don't be too sure of this, because your ego would like to take over this act and can peddle some very fancy blarney when it wants to. With time and patience, however, you manage to sort out which message comes from where. Best to stay alert for ego twinges, incidentally-for they are often caused by thoughts emanating from a higher level. Though the ego also shafts itself now and then, you can usually tell when this is happening.

Earlier, I said you can learn most about how to listen to yourself by learning to listen to others, so don't neglect this vital part of your education. Oddly, the harder a person is to listen to the more you can gain from forcing yourself to do it. This sounds like looking for misery, and in a sense it is, but it really cleans out the psychic channels. There is a trick to it, however: while your "friend" is putting you up the wall, very carefully banish all negative thoughts and attitudes from your mind and think only positive things with respect to him or her. This is a difficult task, but you can learn to do it with time and patience. If you use this "trick," listening will cleanse you. If you don't your suffering is wasted, turned into cheap food for egotism.

Perhaps you don't see any point in self-discovery; many people don't. If so, it is probably because you have no idea of how utterly marvelous the whole human self is, even your self. Seers have often pointed out that the human idea of gods is actually descriptive of an ordinary human self in its wholeness, and that is saying a lot for it. So if you should actually manage to discover yourself you are going to be onto something large and wonderful far beyond what you can now even imagine. Since your pictures can be a royal

highway to this unknown self, why not learn to listen to them? Once you start listening to them your inner self will put more and more into them for your uplift and education.

Meditation While Printing

Quite a few people have noted that printing can be a form of meditation and that they enjoy this meditation deeply. It sounds deadly serious, but it doesn't have to be: you just let your mind wander wherever it wants to, which you probably do anyway. Given this chance, your mind can have a good time, because it loves to wander around.

Silly as it sounds, you might try talking to the people in your pictures when you are alone in the darkroom. Will yourself to believe that the real people (not the images) actually hear you, because in some far reach of the racial mind they probably do. And if they don't it doesn't matter. This provisional and temporary belief, imaginatively entered into as an act of will, can make printing portraits a real gas, especially if you really let yourself get carried away with your conversation. Memories will flood in by the ton and insights into your relationships with people will follow each other in rapid succession. So talking to pictures is a dumb thing?: do it anyway. Call it an exercise in imagination.

Pictures give you something to focus your attention on almost effortlessly, and the technical details that must be attended to provide exactly the right amount of distraction, which is very useful. In this case, distraction is a state of mind in which the ego is sufficiently sidetracked by technical matters to keep it from constantly interfering with whatever is going on in your head. Thus occupied, it will relax some of its desperate grip on the conscious mind and permit it to wander fruitfully. This productive wandering we call meditation. Don't tell your mind where to wander—that is your ego speaking. Just let it think whatever it thinks.

There are lots of formal ways of meditating which you can look up in books on Eastern

religion and philosophy. However, they are not well adapted to the Western mind and can lead you around the barn or get you into serious trouble. They might even lead you to persuade yourself that you are a somebody. Better stick to your own style of meditation, whatever it may be, and just wing it. Let every printing session be a play, with you the director, stage manager, and all the actors. It surely won't make you any crazier than you already are.

A Harmless Experience with Power

One of man's biggest problems is to learn how to handle power, even small amounts of it. It is said that power corrupts and that absolute power corrupts absolutely (Lord Acton). In international relations and our own government we see enough of this to accept it as a truism. Power is dangerous and not something to be fooled with blindly. However, learning how to handle it safely is an important step in human evolution. We also need the experience of power now and then to convince ourselves that we aren't quite as helpless as we are prone to think. Indeed, a normal human being is a real powerhouse, though his powers are held in stasis. Thus our main need for the experience of power is to learn to safely take possession of our own powers. But power can be a deadly thing.

One of the safe ways to experience power is in the practice of art, as people have learned through the ages. Those who can make good pictures have a strong effect on others, and that is what power mainly is. Though art can be misused it ceases to be art when it is. Most of us sense this and intuitively avoid such distortion, for the desire to be a true artist is very strong in us. The effect we mostly strive for in our work, insofar as it concerns others, is to open up people's heads and hearts to what we are trying to say to them. And getting through to them is power, a good kind of power. We assault them with our pictures, in a sense, and a by-product of this is a gradual but certain expansion of their perceptivities,

which is a good thing. With it comes a breaking down of some of the communication barriers that hold people apart.

But we don't have to assault people all the time: we can woo them with lyricism and beauty. Here is where the real power is anyway, and we don't have to worry about the personal dangers of misusing it. Power used poetically is the glue that holds whole civilizations together, for it is not the nature of poets, whatever be their media, to misuse power. They use it only to heal. Only when man learns to use power poetically, learns to heal himself, can he come into possession of his own power. Let us come down from the stratosphere for a moment. When you personally make a picture that people really dig you will know what power is. And your chances of experiencing this power with your photographs are getting better and better, because the public is getting excited about photography and willing to look at what it does. This willingness is with us now for the very first time.

• Expanding Your Awareness of Beauty

It is said that seeing beauty is a basic biological survival function and that this defines the nature of beauty. Roughly, if a thing is edible, kissable, or wearable we call it beautiful and seek to possess it for our good health. But there is more to human existence than gross biological survival. We must also consider mental, emotional, and spiritual survival and come to understand that anything that contributes to them, in ourselves or others, should also be considered beautiful. We must also learn that it is extremely important to become aware of this beauty, that this awareness itself is a survival function.

We can turn to Islam and find a splendid formulation of the "beauty problem" from the spiritual point of view:

"God is Reality.
God is Beauty.
Thus to see God
We must see Reality as Beauty."

The problem, of course, is to learn to do this. And the eat-kiss-wear formula won't take us very far.

Fortunately, being really involved with any art form, photography included, gradually (yet dramatically) expands one's awareness of beauty. This is a natural by-product of trying very hard to see and understand. The beauty that we thus learn to see could be defined as follows:

Anything well seen is beautiful; And anything well understood is beautiful.

Now understand this: though learning to see reality as beauty is one of our deepest human needs it is also a very long and tough row to hoe. However, if at this point you are already hooked on photography you have probably begun to suspect that it can provide you with most of the hard workouts you need. If you don't try to avoid the necessary suffering (the ego must be tamed), it can take you far along the road to beauty and reality.

Expressing and Overcoming Repressed Anger

One of our greatest problems is repressed anger, which generates negative energy that is destructive both to self and others. Because it is repressed (pushed into the unconscious and confined there), we usually don't know why we are angry or even that we are. Thus our self-ignorance makes it difficult to cope with anger or even to see that we have a problem.

The negative energy generated by anger must be released or expressed, or it will eventually wreak havoc in our minds and bodies. However, it should be done in such a way as to convert negative energy into positive, because straightforward expression of unconverted negative energy is itself destructive. We see its grim effects in various neuroses and psychoses, bodily ailments, and societal maladjustments.

Merely expressing and converting repressed negative energy doesn't go far enough, for the anger that gives rise to it remains within us as a continuing source of physical and psychic infection. The repressed anger itself must be deprived of its many disguises and driven out into the open where we can see it clearly. Once well seen it will go away, often forever.

Now, the artist has purposes that the public doesn't see in his or her art, the main one being self-discovery. An important part of this is the recognition, use, and elimination of repressed anger. Our knowledge of hidden anger is at first intuitive: we feel its presence without actually knowing what it is. At the same time we sense that it is a powerful motive force that can be used for struggling with ourselves (our egos) as we strive to create art. This struggle converts much of the negative energy of anger into positive energy and eliminates some of the anger itself. The next step is to see this hidden anger in all its dimensions, so that it will entirely go away.

Learning to see repressed anger clearly is one of life's great challenges, for it is very well hidden indeed. You might say that it is buried in a mountain of symbols, each one designed to distort the anger's true nature or to even deny that it exists. However, this mighty mountain of self-deceit exists at a superficial level of the unconscious, and there are higher forces of the "unconscious" (the super-self, so to speak) that are always ready to help us pull it down by helping us understand what it actually is.

Roughly, what we must learn to do is listen to ourselves. This includes listening to our pictures, which invariably embody messages from our higher selves. With time and patience we can construct from these messages an accurate picture of our buried anger, finally free of disguise. But when we reach this point we are in for a big surprise: the problem is not anger but fear. Anger is nothing but fear in disguise. Once recognized for what it truly is, anger is much easier to cope with.

Now, I have known literally hundreds of people who were using photography as a primary tool for discovering anger, converting its negative energy into positive in the form of art, and trying to eliminate it altogether. Used in this manner, photography is a *very* heavy business, but many people find the goal worth suffering for. One reward, incidentally, is to tap into energy sources that are much greater than anger ever could be.

• Not the Half of It

It is truthfully said that a life in art is a means for creating oneself—the artist slowly awakens and turns himself into art. This is a very large order to fill, of course, but time and patience availeth much. Though the end may be far away, the knowledge of where we are headed gives us hope.

As both an art form and a language, photography is a splendid tool for conscious self-creation or self-evolution. It can take us to far horizons, provided that we use it well. Since art and language are very large subjects, this chapter isn't the half of what photography can do for you. However, it should stimulate thought and observation.

Conclusion

This book for beginners tells you how to do a few things in photography. Furthermore, it provides you with a basis for personally discovering whether they are really worth doing. I hope you find it useful.

This tragic little picture works powerfully as communication, reminding us forcefully of the male condition—hung up on barbed wire by the you-know-whats. Well, Eddy Mole wasn't actually hanging from anything, but he sure put on a good act. Anyhow, a photograph can be language—that's the point of this whole story.